The Image of Christ

Supported by The Jerusalem Trust and The Pilgrim Trust

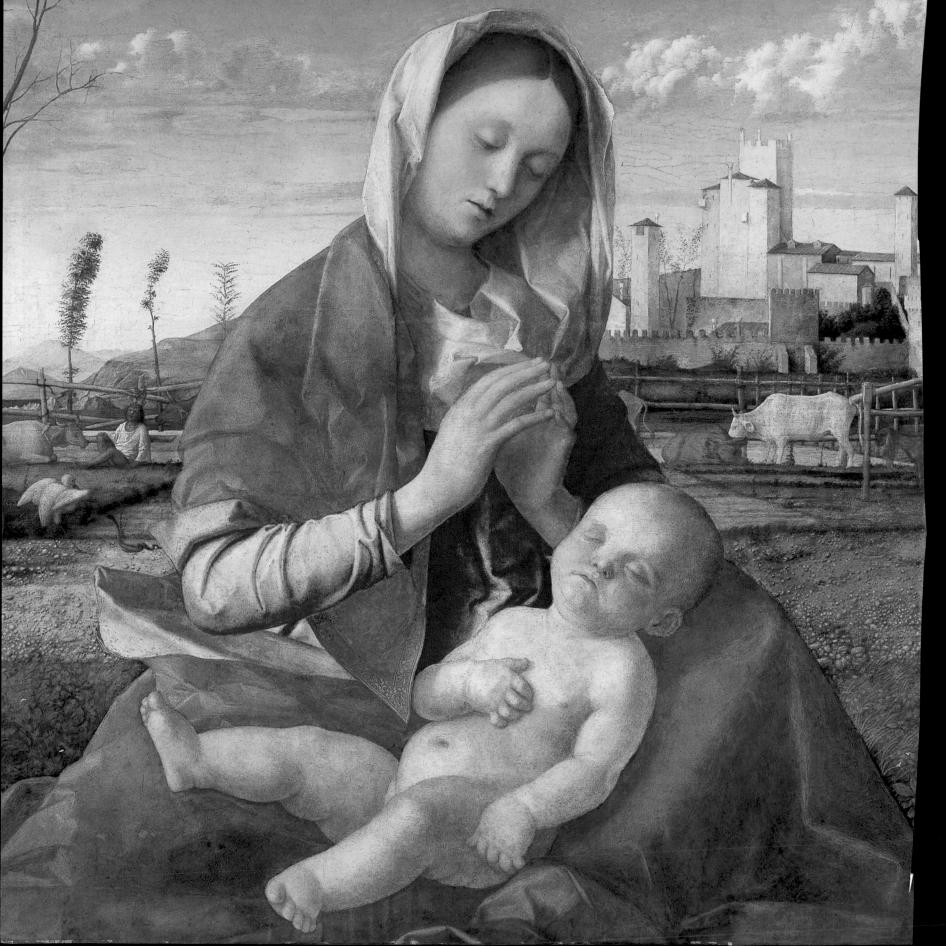

The Image of Christ

Gabriele Finaldi with an Introduction by Neil MacGregor and contributions by Susanna Avery-Quash Xavier Bray Erika Langmuir Neil MacGregor Alexander Sturgis

NATIONAL GALLERY COMPANY LIMITED, LONDON DISTRIBUTED BY YALE UNIVERSITY PRESS Supported by The Jerusalem Trust and The Pilgrim Trust

This book was published to accompany an exhibition at The National Gallery, London 26 February – 7 May 2000

© 2000 National Gallery Company Limited Reprinted 2000

All rights reserved. No part of this publication may be transmitted in any form or by any means, electronic or mechanical, including photocopy, recording, or any storage an retrieval system, without the prior permission in writing from the publisher

First published in Great Britain in 2000 by National Gallery Company Limited St Vincent House, 30 Orange Street, London wC2H 7HH

ISBN 1 85709 292 9 525459

British Library Cataloguing-in-Publication Data A catalogue record is available from the British Library Library of Congress Catalog Card Number 99-076293

MANAGING EDITOR Caroline Bugler Designer Sarah Davies Assistant Editors Mandi Gomez and Tom Windross Picture Researcher Xenia Geroulanos Indexer Anne Coles

Printed and bound in Great Britain by Butler and Tanner, Frome and London

All biblical quotations are taken from the Authorized Version (King James) Bible unless otherwise stated Provenance and Bibliography for individual entries is given on pages 208–212

Authors' abbreviations: Susanna Avery-Quash SA-Q Xavier Bray XB Gabriele Finaldi GF Erika Langmuir EL Neil MacGregor NM Alexander Sturgis AS

CONTENTS PAGE Christ carrying the cross as a Model for Painters. *Engraving by Theodore Galle from Johann David's* Veredicus Christianus (*The True Christian*), *Amsterdam*, 1603. Introduction by Neil MacGregor 6

- 1 SIGN AND SYMBOL 8
- 2 The Dual Nature 44
- 3 THE TRUE LIKENESS 74
- 4 PASSION AND COMPASSION 104
- 5 Praying the Passion 132
- 6 The Saving Body 168
- 7 The Abiding Presence 192

Provenance and Bibliography 208

General Bibliography 213

Photographic Credits 219

Lenders 220

Authors' Acknowledgements 221

Index 222

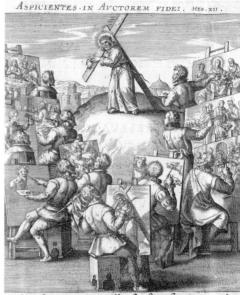

Christiani nomen ille frustra sortitur, qui Christum minime imitatur. D. August de ver. Christ.

Introduction

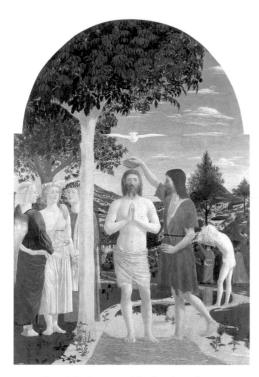

FIG 1 Piero della Francesca, The Baptism of Christ, 1450s. Egg on poplar, 167 x 116 cm. London, National Gallery, NG 665.

ALL GREAT COLLECTIONS OF European painting are inevitably also great collections of Christian art. In the National Gallery, London, roughly one third of the pictures – and many of the finest – are of Christian subjects. This is hardly surprising, for after classical antiquity, Christianity has been the predominant force shaping European culture. It is central to the story of European painting, preoccupying artists from Duccio to Dalí, inspiring some of the supreme masterpieces of all time.

Yet if a third of our pictures are Christian, many of our visitors now are not. And it is clear that for most this is a difficult inheritance. In part this is because the pictures, made to inspire and strengthen faith through public and private devotion, have been removed from the churches or domestic settings for which they were intended and hang now in the chronological sequences of the Gallery, not to the glory of God, but as part of a narrative of human artistic achievement.

Worse, addressing questions of slender concern to those of other – or no – beliefs, they seem to many irrecoverably remote, now best approached in purely formal terms. But this is surely to risk losing the heart of the matter: Piero della Francesca's *Baptism* (fig. 1) is of course a marvel of harmony and balance, an epitome of compositional values, but it was conceived as an exploration of the central mystery of the Christian faith – the total fusion of the human and the divine. It is also a theological triumph.

The aim of this exhibition and book is to focus attention on the purpose for which the works of art were made, and to explore what they might have meant to their original viewers. We have put some of the Gallery's religious pictures in a new context, not – as in other exhibitions – beside works by the same artist or from the same period, but in the company of other works of art which have explored the same kinds of questions across the centuries. A new neighbour for a painting allows us to have a different dialogue with it, and that usually leads to the discovery of a picture even richer and more complex than the one we thought we already knew.

Our focus is the Collection in Trafalgar Square, which ranges from 1200 to 1900, but we have borrowed over a much wider time range – from the early Christians to Graham Sutherland. Foreign lenders have been outstandingly generous, but we have tried to borrow mostly from the public collections of the United Kingdom. That we are able to put the exhibition on at all – and free of charge – is thanks to the generous support of The Jerusalem Trust and The Pilgrim Trust.

Rather than presenting Christ's life in art, the exhibition and book look at the difficulties Christian artists have had to confront when representing Jesus – God who became a man. They look not at the theological intricacies of the Incarnation, but at the pictorial problems it led to: deciding what Jesus looked like (for we have no records), how his suffering could be shown as not just personal but cosmic, how his human and divine nature could both be made clear at the same time. Biblical texts, commentators and mystics often solve this kind of problem by indicating the ungraspable nature of God through contradiction: he is both the Prince of Peace and the Suffering Servant, Saviour and Sacrifice, the shoep and the shepherd, the stumbling block and the cornerstone - paradoxes resonant and powerful in language, but almost impossible to paint. The word has universal authority, acknowledged and asserted from the beginning. The image is always individual and specific, forced to opt for one aspect only out of the many that we know exist. Two illustrations show the extremes of the problem and the extreme solutions advanced by different Christian traditions. In the seventeenth-century English Protestant church of St Martin Ludgate in the City, a Baroque Italianate altar houses not an image, but the Word of God – the Ten Commandments and the Lord's Prayer (fig 2). This is in every sense the authorised version of the faith of the Old and New Testaments, and a monument to that enduring anti-pictorial tendency which runs from the earliest Church to the Byzantine iconoclasts and the Protestant reformers: only the Word. The little print by Theodore Galle (contents page) puts the traditional Roman Catholic case in defence of representation. It pleads not just for the image, but for lots of images: artists try to paint Christ, just as Christians must try to imitate him, but every artist inevitably shows a different vision. Images are inadequate, but the answer is not to ban them but to multiply to infinity the opportunities for contemplation that they afford.

It is, in fact, the very difficulties Christian artists have had to resolve that makes it possible for these images to speak now to those who do not hold Christian beliefs. Christian artists confronted one great problem. They had to make clear that when representing an historical event – the life and death of Jesus – they were not just offering a record of the past but a continuing truth; we the spectators have to become eye-witnesses to an event that matters to us now. Theological concepts must be given human dimensions and if only words can tackle the abstract mysteries, paintings are uniquely able to address the universal questions through the intelligence of the heart.

In the hands of the great artists, the different moments and aspects of Christ's life become archetypes of all human experience. The Virgin nursing her son conveys the feelings every mother has for her child: they are love. Christ mocked is innocence and goodness beset by violence. In the suffering Christ, we encounter the pain of the world, and Christ risen and appearing to Mary Magdalene is a universal reaffirmation that love cannot be destroyed by death. These are pictures that explore truths not just for Christians, but for everybody.

Neil MacGregor Director of the National Gallery

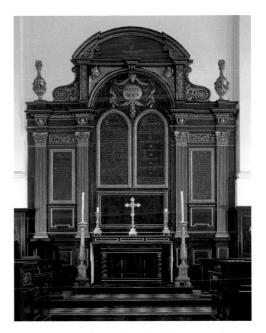

FIG 2 Altar and reredos with Commandment Panels, 1680s. St Martin Ludgate, City of London. The church was designed by Sir Christopher Wren,

1 Sign and Symbol

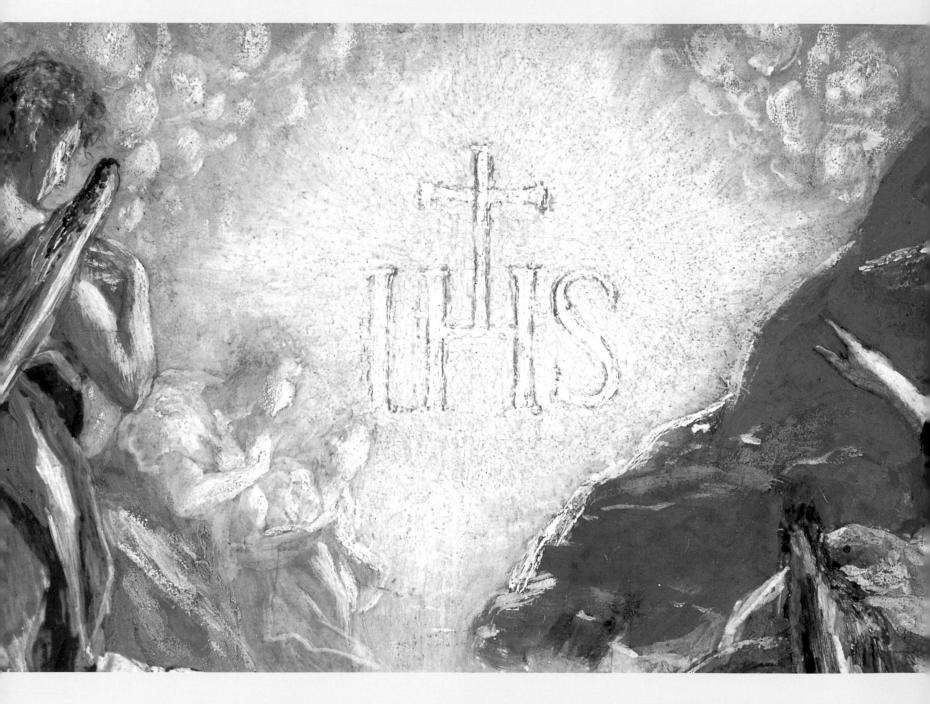

E ARLY CHRISTIANS DID NOT represent the person of Jesus, so much as the belief that he was the Messiah, the Anointed One – 'Christ' in Greek – the Saviour. As this belief was founded above all on Scripture, the written Word of God, the earliest images of Christ were also created out of written letter- and word-signs, or were visual translations of the verbal imagery of the Bible.

In the ancient world, such signs and symbols inspired awe. The name of God in the Hebrew Bible is so sacred it cannot be pronounced; its letters, YHWH, have a title of their own, the tetragrammaton, the Greek word for 'four letters'. Metaphors are used throughout both the Hebrew Bible and the Gospels to suggest that Godhead is so far beyond human understanding it can be apprehended only by analogy.

But if Christ's holy otherness could most forcefully be represented through signs and symbols, there was another compelling reason why early Christians did not attempt to portray Jesus's appearance. God's Second Commandment given to Moses on Mount Sinai forbids the making and worship of idolatrous images (fig 2). Since Jesus and his first followers were Jews, members of a culture hostile to images, no contemporary portraits of him were made. And the Gospels, written in the first century after his death, give no description of what he may have looked like.

Some hundred years later, Christianity had attracted many non-Jewish converts. Yet although the prohibition against images was relaxed, fear of idolatry remained. The early Church had no cult images of Christ – nor did Christians have churches, as we understand them, in which to place such images. They assembled in each other's houses to break bread together in memory of the Lord's Supper, celebrating their fellowship with Christ in expectation of his imminent return.

It was in designated burial places outside the city walls of Rome that the first Christian images were made around AD 200. As pressure of numbers grew, these areas were extended underground, producing many-storeyed catacombs – long corridors, lined with wall tombs stacked like bunk-beds, here and there widening into small rooms containing the graves of a single family or group. Pagans called them necropolises, cities of the dead, but to Christians they were cemeteries, dormitories where the faithful slept awaiting resurrection, when they would wake to join Christ in Paradise.

The marble slabs that sealed the tombs were inscribed with the names of the dead, proclamations of faith, and Christian emblems (cat. nos. 2–4); the vaults of the burial chambers were painted. This funerary decoration has nothing funereal about it, no indication of mourning, not even of fear of judgment – only affirmations of belief in Christ's victory over death. Beginning in the fourth century, when Christianity became the Roman state religion, the catacombs gradually fell into disuse, except as places of pilgrimage to the tombs of martyrs. Christians began to bury the dead inside purpose-built churches, in stone sarcophagi carved with similar images of trust and triumph.

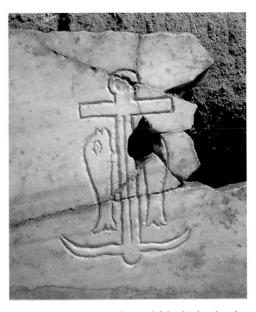

FIG 3 Cross-anchor and fish, *third or fourth century AD. Inscribed on a funerary slab in the catacomb of Priscilla, Rome.*

The instrument of Christ's victory, the cross, was seldom represented; early Christians were reluctant to depict the gallows on which common criminals were executed. In the catacombs, they showed the cross covertly, for example in the crosspiece of a ship's anchor, emblem of hope (fig 3). Accompanying the anchor, or as a sign within an inscription, we find the oldest symbol for Christ: the fish (cat. no. 4).

This is a visual pun based on an acrostic. The initial letters of the Greek phrase, Jesus/ Christ/ Son of God/ the Saviour, formed the Greek word for fish, *ichthys*. But there are many additional reasons why the fish became an enduring symbol of Christ. Its native element, water, recalls the waters of Baptism necessary for salvation. Edible fish occur in Gospel accounts read as allegories of the Eucharist: the multiplication of the loaves and fishes (MARK 6: 34–44), and the appearance of the resurrected Christ on the shore of the Sea of Tiberias (JOHN 21). By following Christ, the disciples became fishers of men (MARK 1: 17; LUKE 5: 10). In the fish, the initials of a declaration of faith became a word, the word a sign, the sign an image that recalls entire texts, giving rise to a host of allegorical interpretations.

But there is another, more abstract early Christian letter-sign: the monogram formed from the first two letters of his Greek title, *Khristos*, xP, transliterated as chi rho in the Roman alphabet. This monogram already existed among the pagans as an abbreviation of the Greek word *khrestos*, meaning 'auspicious'. It may have been for this reason, and not as a Christian emblem, that the Emperor Constantine first adopted it on the Roman imperial standard. But if the x of the monogram is turned sideways, it forms a cross; the reference is even more pointed when the chi rho is wreathed in a victor's laurel crown. Set between the letters Alpha and Omega, the first and last letters of the Greek alphabet, the monogram unambiguously represents Christ himself: 'I am Alpha and Omega, the beginning and the ending' (REVELATION 1: 8). Both the fish and the chi rho readily migrated from sepulchres to objects in daily use: lamps (cat. no. 12), tableware, amulets, brooches and rings (cat. nos. 9 and 10), even the coins of Christian emperors (cat. nos. 6 – 8).

From about the sixth century, the Greek chi rho monogram, or monogram of Christ, was displaced – though never replaced – by the Latin trigram, IHS, an abbreviation of the Greek *Ihsous* (Jesus), later interpreted as an acrostic of *Iesus Hominum Salvator* (Jesus Saviour of Mankind). Its veneration was popularised by the fifteenth-century Italian preacher, Saint Bernardino of Siena, and it was later adopted as the device of the Society of Jesus founded by Saint Ignatius Loyola in 1534. The Jesuits (for whom it also signifies *Iesum Habemus Socium*, 'we have Jesus for our companion'), still promote its use in the devotional practice of the Adoration of the Name of Jesus (cat. no. 14).

Early Christian artists drew on secular tradition not only for emblems such as the fish and the chi rho, but also when translating into visual form the verbal imagery of the Bible, notably the metaphors of Christ as the vine (JOHN 15: 1, cat. no. 20) and Christ the Good Shepherd (JOHN 10: 14–15; 27–28).

Vines, grapes and wine-making – symbolic of Christ's sacrifice and of the Eucharist (fig 4) – had long been associated with the Graeco-Roman god of wine, Dionysos or Bacchus, who had died, been buried, and rose again. As an emblem of the afterlife, they were already a staple of funerary decoration; Christian tombs can normally be distinguished from pagan ones by the chi rho monogram appearing among the scrolling vines.

The early Christian Good Shepherd, who lays down his life for his sheep, is indistinguishable, except by context, from shepherds in the idyllic pictures of country life painted in Roman villas. He is young and beardless, dressed in the short tunic of a farmlabourer. He usually carries a sheep across his shoulders, while other sheep stand trustingly by his side (cat. nos. 1–3).

But if Christ speaks of himself as the Good Shepherd, he is also the Lamb – the sacrificial animal of the Hebrew Bible, the 'Lamb of God which taketh away the sin of the world' in the Gospel of Saint John (JOHN 1: 29, 36). The image of the Lamb has a chequered history. Perhaps to avoid confusion with the Good Shepherd, the artists of the catacombs never represent it. In the triumphant fifth-century Church, it appears as the victorious Lamb of the Book of Revelation (REVELATION 17: 14). A Greek Church council in 692 forbade the depiction of Christ in animal form; but the practice continued in the West. Influenced by the new theology popularised in the 1200s by Saint Francis of Assisi, the sacrificial Lamb became the prime symbolic representation of the suffering Saviour (cat. no. 17).

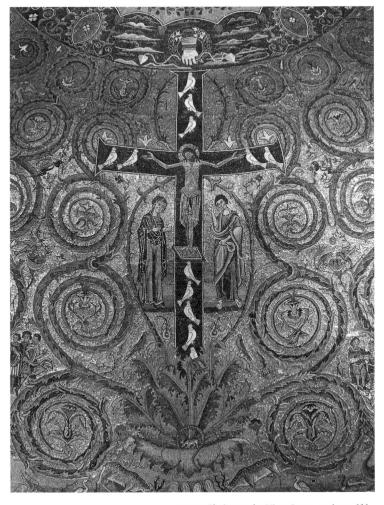

There is one biblical metaphor which largely eluded early Christian artists: Christ as the Light of the World (LUKE 2: 32; JOHN 1: 5; 3: 19; 8: 12; 12: 35). They hinted at it (cat. no. 12); they identified Christ with pagan sun gods; they pictured him with a golden halo, or clothed in the radiance and glitter of gold mosaic. But not until the fifteenth century did artists have the technical means – oil paint – of making the dark visible. And you can't picture light until you can show it dispelling darkness (cat. no. 15).

Artists continued to represent Jesus Christ through signs and symbols, even after an agreed likeness was established and it became permissible to portray him (cat. no. 16). Likeness brings us face to face with the man Jesus, enabling us to feel with him and for him. Words, letter-signs and metaphors do something else, for there has always been something uncanny and awesome about them: 'In the beginning was the Word'.

It is by combining the likeness of Jesus Christ with words, signs and symbols that art succeeds in depicting his dual nature: fully human and fully divine. *EL*

FIG 4 Christ on the Vine Cross, *early twelfth century. Apse Mosaic, Rome, S. Clemente.*

1 The Good Shepherd, Roman, fourth century AD

Marble, height: 43 cm., including base Rome, Museo Nazionale di Roma, INV. 67618

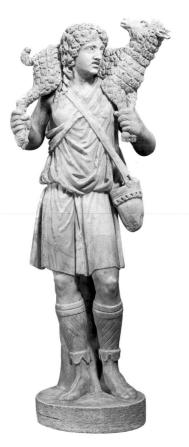

FIG 5 The Good Shepherd, *late third or early* fourth century. Marble, height: 100 cm. Vatican City, Vatican City Museums.

- 1 On Good Shepherd imagery, see Didron 1851: 1, pp. 337–41; Hertling/Kirschbaum 1960, pp. 223–24; Himmelmann 1980.
- 2 Vatican Collections, cat. no. 134.

12 SIGN AND SYMBOL

THE IMAGE OF CHRIST as the Good Shepherd is based on the metaphor that Christ uses of himself in the Gospel of Saint John: 'I am the good shepherd: the good shepherd giveth his life for the sheep' (JOHN 10: 11, 14–15). Christ's assertion was a claim to messiahship, since according to a prophecy of Ezekiel, dating from the sixth century BC, and well known to Jesus's contemporaries, God would raise a new and virtuous kingshepherd who, like King David, would lead his people and bring them to rich pastures (EZEKIEL 34). Depictions of the Good Shepherd became common from the third century AD, especially in the Roman catacombs, the ancient Christian cemeteries outside the city of Rome, where they appear in wall paintings and on sarcophagi and funerary slabs. The Good Shepherd images should not be understood as representations of the person of Christ but as visual renditions of the metaphor employed by him to cast light on his nature and mission.¹

The imagery of this sculpture is based on the parable of the Lost Sheep (LUKE 15: 4–5), which stresses Christ's special concern for sinners and for the marginalised, and highlights his saving activity:

What man of you, having an hundred sheep, if he lose one of them, doth not leave the ninety and nine in the wilderness, and go after that which is lost, until he find it? And when he hath found it, he layeth it on his shoulders rejoicing.

The sculpture shows a youthful and beardless figure wearing the short belted tunic typically worn by shepherds in the imagery of the classical world, and carrying a ram on his shoulders. The image of the Good Shepherd harks back to ancient Greek votive figures – known as *Kriophoroi* – of pagan worshippers bearing animals for sacrifice, and to representations of the shepherds in the pastoral themes of antiquity. Images of shepherds were employed in pagan funerary monuments to symbolise the peace of the afterlife, and these proved very amenable for use in a Christian funerary context (cat. nos. 2 and 3). The Roman sculptural workshops that produced sarcophagi and sepulchral carvings found it easy to adapt their patterns to the demands of a Christian clientele. Good-Shepherd imagery remained current until the sixth century, and its gradual disappearance after that may be due in part to the abandonment of the catacombs as places of Christian burial and the emergence of other types of image which focused more on the person of Christ.

The figure and pose of this sculpture are very similar to the celebrated free-standing *Good Shepherd* in the Vatican Museums (fig. 5).² It is not clear whether that sculpture and the one shown here were conceived from the start to be free-standing or whether they were cut away from sarcophagus reliefs in later times and adapted into independent carvings. The narrow depth and frontal presentation of this work would suggest that it was the latter. *GF*

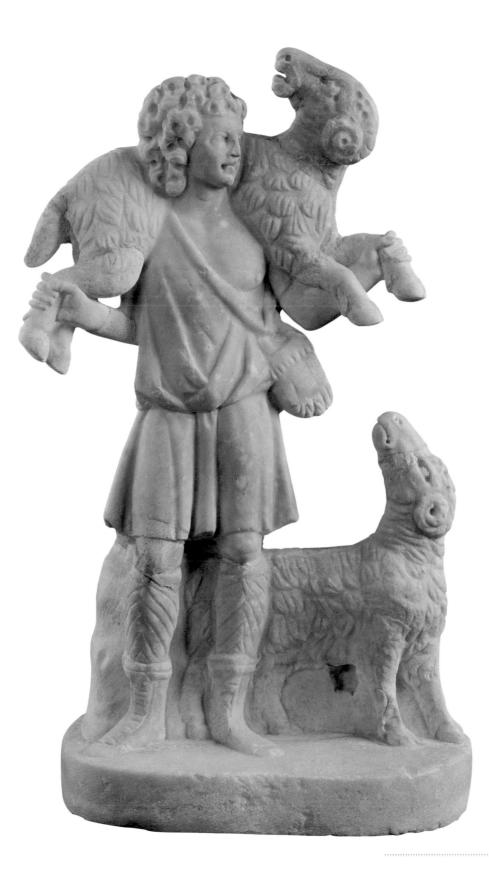

2 Funerary slab of Aurelius Castus with the Good Shepherd, Roman, third or fourth century AD

Marble, 34 x 83 x 2 cm.

Inscribed AVRELIVS CASTUS/ M VIII FECIT FILIO/ SVO ANTONIA/ SPERANTIA (Aurelius Castus, 8 months old. Antonia Sperantia made [this tomb] for her son) Vatican City, Vatican Museums, INV. 32457

3 Funerary slab of Florentius with the Good Shepherd, Roman, fourth century AD

Marble, 22.5 x 77 x 2 cm. Inscribed FLORENTIVS/ IN PACAE (Florentius [rests] in peace) Vatican City, Vatican Museums, INV. 32456

1 For further discussion see Hertling/Kirschbaum 1960.

2 Quoted in Marucchi 1910, p. 57.

14 SIGN AND SYMBOL

THESE TWO FUNERARY SLABS, together with that inscribed with a fish (cat. no. 4), come from the catacombs of Rome. Between the second and early fifth centuries, the Roman Christians established vast underground burial sites in the soft tufa stone, made up of networks of passages, often on several levels, with thousands of tomb cavities on either side. The catacombs took the name of the wealthy benefactors in whose land they were established, for example the Catacomb of Domitilla, a member of the Emperor Flavian's family, or of the saints who were buried in them, like the Catacomb of Saint Callixtus, Pope from 217 to 222. The funerary slab of Aurelius Castus (cat. no. 2) comes from the latter. From early times the catacombs were venerated as holy sites because they housed the tombs of the martyrs; they appear not to have been used, as has sometimes been said, for the clandestine meetings of persecuted Christians.¹

Most of the funerary slabs that were once used to close up the tomb cavities in the catacombs are unmarked but many bear the names of the deceased, often together with a pictogram or emblem relating to their faith or trade. A large group of these slabs was assembled in the nineteenth century for the Vatican Museums with the specific purpose of illustrating the practices, rites, imagery and beliefs of the early Christians. Many of them bear the image of the Good Shepherd, or the fish, and many more the monogram of Christ, often combined with the Greek letters Alpha and Omega, symbolising the eternal nature of Christ, as the beginning and the end. The inscriptions and images on the slabs are carved rather crudely and would have been filled with coloured wax or paint to make them more visible. Some of these fillings were renewed when the slabs entered the Vatican Museums.

The Good Shepherd appears frequently in catacomb murals and on sarcophagi and grave slabs because it was an image intimately bound up with the belief in an afterlife spent in the presence of Christ himself. The words of Psalm 23 (verses 1, 2, 4, 6) speak of God as a shepherd and were understood in the early Church to allude to the eternal life promised by Christ:

The Lord *is* my shepherd: therefore can I lack nothing. He shall feed me in a green pasture: and lead me forth beside the waters of comfort [...] Yea, though I walk through the valley of the shadow of death, I will fear no evil: for thou art with me [...] thy loving-kindness and mercy shall follow me all the days of my life: and I will dwell in the house of the Lord for ever.

A common prayer in the early Church was the one made for the deceased, that they should be led to heaven 'borne on the shoulders of the Good Shepherd' (*boni pastoris humeris reportatum*).²

In looking at the funerary slabs of these early Christians, the infant Aurelius Castus (cat. no. 2) and Florentius (cat. no. 3), individuals about whom we know nothing, we are struck by the simplicity and power with which they proclaim their faith. *GF*

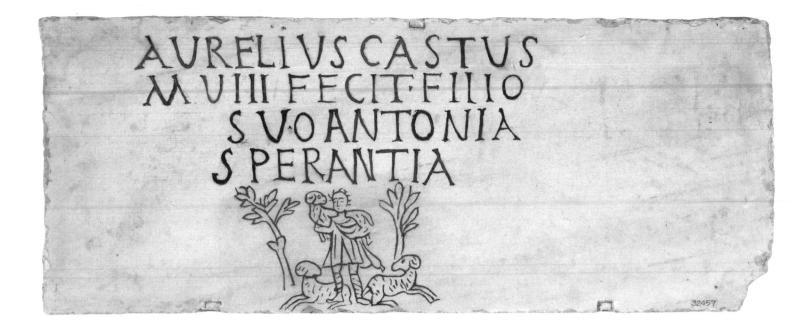

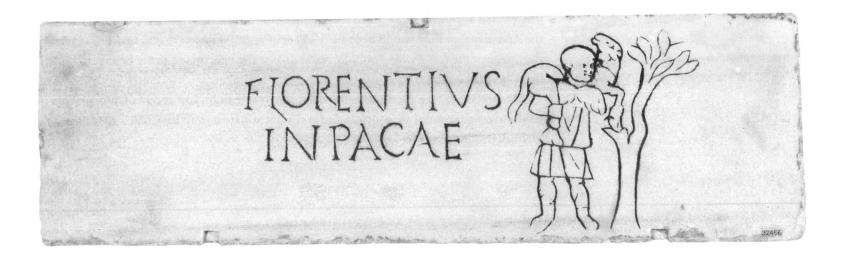

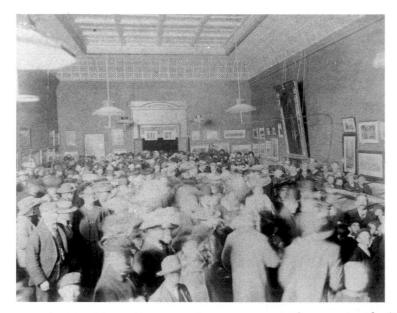

FIG 9 The Light of the World on view in the National Gallery of Victoria, Melbourne, Australia, February–March 1906. Booth Collection, University of London Library, Senate House.

7 Ibid., p. 417. 8 Ibid., p. 355. 9 Ibid., p. 358. 10 Maas 1984, p. 178. 11 Scott 1892: 11, p. 312.

34 SIGN AND SYMBOL

achieved much more besides; many people were deeply impressed by what they saw, including the writer and critic, John Ruskin, who on 5 May 1854 wrote to *The Times* of the first version (Keble College) that it was 'one of the very noblest works of sacred art ever produced in this or any other age'.⁷ One notable exception was the Scottish historian and philosopher, Thomas Carlyle. He was aggrieved that Hunt had painted Christ in a symbolic way, 'bedizened in priestly robes and a crown ... with ... jewels on his breast, and a gilt aureole round His head',⁸ rather than in a more realistic way, as the man who is recorded in the Gospel as 'toiling along in the host sun ... tired, hungry often and footsore ... His rough and patched clothes bedraggled and covered with dust, imparting blessings.'9

The *Light of the World* became the most popular representation of Christ in the English-speaking world and the St Paul's

version was sent by its agnostic owner, Charles Booth, on a tour of Canada, Australia, New Zealand, and South Africa between early 1905 and late 1907 (fig. 9). Along the way countless people saw it, many of them queuing for several hours and saying that they were deeply moved by it. A certain J. H. Roy from Dunedin in New Zealand, an employee of the Government Insurance Department, wrote after seeing the picture that, 'the vast crowd stood gazing in silent wonderment, and many in adoration, as though held by some irresistible magnet. I was, on viewing the wondrous face, impelled to uncover my head in reverence thereto.'¹⁰ The painting was reproduced and pirated in a variety of forms and the image was widely disseminated throughout the British Empire, acquiring the status of a Protestant icon. Hunt himself was keenly aware of its spiritual power and told his friend, William Bell Scott, that it was while painting the first version of the picture that he was converted to Christianity.¹¹ It is perhaps appropriate, therefore, that Booth's painting should have come to rest in St Paul's Cathedral in London, rather than in the Tate Gallery, where Hunt had originally hoped it would go as an example of high art. Hunt was buried in St Paul's Cathedral in 1910.

Ironically, the St Paul's version of the *Light of the World* which is the best known of the three, was only partly executed by Hunt. He embarked on this life-size version thinking that his original picture was deliberately being kept from public view by the dons at Keble College, Oxford, into whose hands it had passed. In order to paint it he made use of the second, smaller, painting (now in the Manchester City Art Galleries) as a guide which, as it turns out, was almost entirely the work of another artist, Frederick G. Stephens. When painting the St Paul's picture, Hunt had to rely, due to his failing eye-sight, on help from the painter Edward R. Hughes, a fact that he was careful to conceal for a number of years. *SA-Q*

17 The Bound Lamb ('Agnus Dei'), about 1635-1640

Francisco de Zurbarán (1598–1664) *Oil on canvas, 38 x 62 cm.* Madrid, Museo Nacional del Prado, INV. 7293

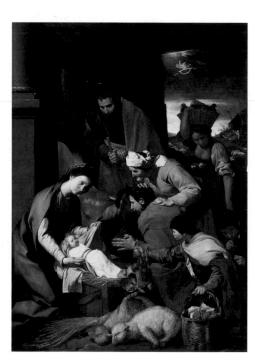

FIG 10 *Neapolitan painter*, Adoration of the Shepherds, *1620s. London, National Gallery, NG 232.*

- 1 San Diego Museum and the version sold at Sotheby's, New York, on 28 May 1999, lot 67, and now in the Museo de la Academia de San Fernando, Madrid (INV. 1417).
- 2 Quoted in Didron 1851: 1, p. 332.
- 3 Quoted in Paris 1988, p. 295.
- 4 Palomino (1724) 1986, p. 198.

A^{S WELL AS BEING THE Good Shepherd (cat. nos. 1-3), Christ is also the Lamb. John the Baptist, when he first saw Jesus approaching him at the River Jordan, cried out, 'Behold, the Lamb of God [*Agnus Dei*] which taketh away the sin of the world' (JOHN 1: 29). Zurbarán's highly naturalistic painting shows a young lamb with horns, lying on a stone slab, its feet bound with rope. By setting the brilliant white lamb against the dark, austere background, the artist has intensified the sense of the animal's physical presence. Although it could be considered a still life in its own right, this painting is intended to be interpreted symbolically, as an image of the sacrifice of Christ.}

The Old Testament offerings of an unblemished lamb came to be seen as a foreshadowing of the death of Christ, a sacrificial substitute for sinful mankind. Saint Peter, for example, makes the comparison explicit: 'ye were not redeemed with corruptible things ... but with the precious blood of Christ, as of a lamb without blemish and without spot' (PETER 1: 18–19). Such comparisons were influenced by the prophecies of Isaiah – often quoted in the Gospels and in the Acts of the Apostles – which speak of a suffering Messiah characterised as a sacrificial lamb: 'He was oppressed, and he was afflicted, yet he opened not his mouth: he is brought as a lamb to the slaughter, and as a sheep before her shearers is dumb, so he openeth not his mouth' (ISAIAH 53: 7–8). In his conversation with the Ethiopian eunuch, Saint Philip says explicitly that this passage refers to Christ (ACTS 8: 32), and Zurbarán too, in two of the six known versions of his *Bound Lamb*, makes the imagery explicit by including a halo on the lamb's head and the inscription '*Tanquam agnus*' (like a lamb), a paraphrase of Isaiah's words.¹

In early Christian sculpture and mosaics, Christ was frequently represented as a lamb. In later times there was a reaction against this kind of symbolic animal imagery and a Church Council held under Justinian II in Constantinople in AD 692 decreed that in future Christ should be represented only in human form, since 'the painter must, as it were, lead us by the hand to the remembrance of Jesus, living in the flesh, suffering and dying for our salvation and thus obtaining the redemption of the world'.² However, the wealth of imagery associated with the lamb, for example in the Book of Revelation (REVELATION 4–7) meant that it remained a popular visual image. A lamb bound as an offering often appears in paintings of the Adoration of the Shepherds, a direct allusion to Christ's forthcoming sacrifice (fig. 10). Zurbarán's removal of the bound lamb from such scenes and its stark presentation on an altar slab yields a particularly impressive image. He and his patrons were probably familiar with the writings of the sixteenthcentury Spanish mystic, Fray Luis de León, who explained in his *De los nombres de Cristo* (Of the Names of Christ) that when he was called 'Cordero', or Lamb, this signified his 'meekness of character, innocence and purity of life, and his fulfilment of sacrifice'.³

Zurbarán's paintings of lambs were widely admired. The eighteenth-century biographer of Spanish artists, Antonio Palomino, referred to a painting by him of a little lamb in a Sevillian collection whose owner was said 'to value it more than a hundred living lambs'.⁴ XB

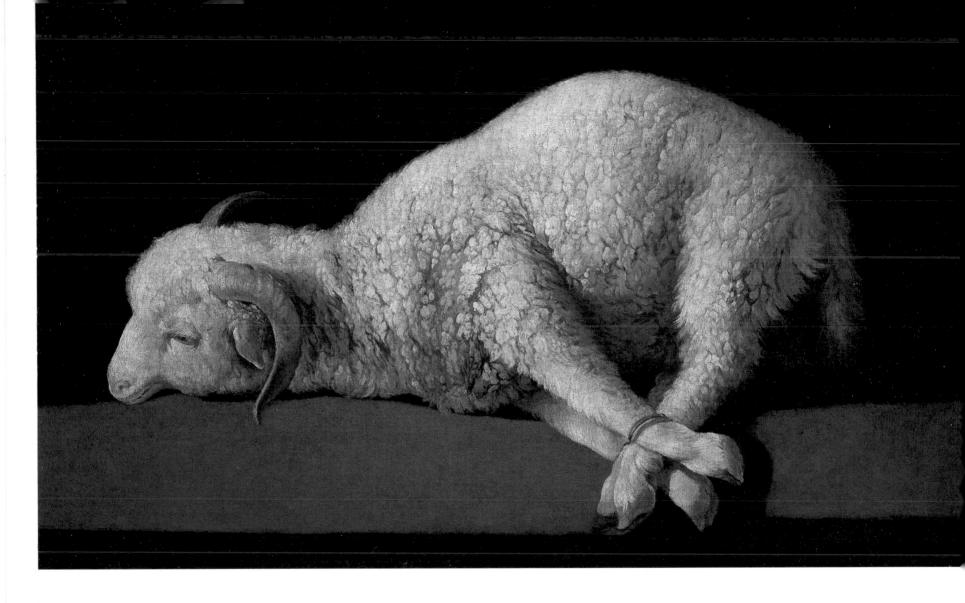

20 Christ Crucified on the Vine, about 1435

German, Middle Rhineland *Plaster, painted, diameter: 21.6 cm.* London, Victoria and Albert Museum, London, INV. 2569–1856 THE IMAGERY OF THIS CURIOUS plaster roundel derives from the text written on the scroll at its top: EGO SUM VITIS VOS PALMITES (I am the vine, ye are the branches, JOHN 15:5). Like so many others, the symbol of the vine derives from one of Christ's own metaphors, in this instance the famous passage in which he describes himself as 'the true vine' and his disciples the branches that 'bear much fruit' (JOHN 15: 1-8). The symbolism of the vine, however, does not depend on this passage alone. In the Old Testament the vine sometimes symbolises the blessings of the promised Messianic age,¹ and it was used in the early Church to stand for eternal life. Grapes were also a common symbol of the Eucharistic wine and hence of the blood of Christ.

Early images of Christ crucified on the vine, such as the famous early twelfth-century apse mosaics of San Clemente in Rome (fig. 4), derive from the association of the cross with the 'Tree of Life' described in the Book of Revelation (REVELATION 22: 2). The vine was just one of a number of different trees that Christ was shown nailed to, although its association with the Eucharist provided an added impetus to its use.² Some late medieval German sculptures of the crucifix, such as those at Doberan (Mecklenburg, Northern Germany) of about 1360, and at Saint Lorenz in Nuremberg (about 1450), show Christ's cross sprouting grapes in clear reference to the sacrament.

The Victoria and Albert Museum's roundel combines the established imagery of Christ crucified on the vine with the innovatory addition of the twelve bust length figures of the apostles in its branches. The apostles turn the image into a more direct illustration of the metaphor of the True Vine and make explicit the vine's symbolism as both Christ himself and the Christian Church. This seems to be the earliest known example in which the vine, cross and apostles are combined in this way. In a further imaginative development the artist of the roundel, again taking his lead from the words of the Gospel ('I am the true vine and my Father is the husbandman', JOHN 15: 1), has added the figures of God the Father and the Virgin tending the roots of the tree. On the left, God the Father – his halo inscribed with a cross – breaks the sods of earth with his hoe accompanied by the inscription PATER UMIFICAT (the father makes moist). The Virgin is on the right and waters the vine next to the words MARIA FECUNDAT (Mary makes fruitful). Above the figure of Christ hovers the dove of the Holy Spirit.

The roundel is one of a small group of similar objects with identical imagery. A second version – but without the frame – was recorded at Mainz, before it was destroyed in the Second World War. Another, also without a frame and unpainted, survives in Berlin and in 1986 the fragment of a fourth roundel was discovered in the monastery of Marienwohlde near Lauenburg (Elbe). A further version of the same scene survives cast on a bell of the church of Saint Rupert at Außerteichen (Carinthia, Austria). All these examples were probably cast from a metal mould but variations in size make it clear they were not all made from the same one.

1 For example, PSALM 80: 8ff.

2 On the Tree-Cross, see Schiller 1972: 11, pp. 135ff.

With the exception of the bell, the original functions of these objects remains uncertain. The fact that the Victoria and Albert Museum's example has an integral frame –

42 SIGN AND SYMBOL

E ARLY CHRISTIANS DID NOT represent the person of Jesus, so much as the belief that he was the Messiah, the Anointed One – 'Christ' in Greek – the Saviour. As this belief was founded above all on Scripture, the written Word of God, the earliest images of Christ were also created out of written letter- and word-signs, or were visual translations of the verbal imagery of the Bible.

In the ancient world, such signs and symbols inspired awe. The name of God in the Hebrew Bible is so sacred it cannot be pronounced; its letters, YHWH, have a title of their own, the tetragrammaton, the Greek word for 'four letters'. Metaphors are used throughout both the Hebrew Bible and the Gospels to suggest that Godhead is so far beyond human understanding it can be apprehended only by analogy.

But if Christ's holy otherness could most forcefully be represented through signs and symbols, there was another compelling reason why early Christians did not attempt to portray Jesus's appearance. God's Second Commandment given to Moses on Mount Sinai forbids the making and worship of idolatrous images (fig 2). Since Jesus and his first followers were Jews, members of a culture hostile to images, no contemporary portraits of him were made. And the Gospels, written in the first century after his death, give no description of what he may have looked like.

Some hundred years later, Christianity had attracted many non-Jewish converts. Yet although the prohibition against images was relaxed, fear of idolatry remained. The early Church had no cult images of Christ – nor did Christians have churches, as we understand them, in which to place such images. They assembled in each other's houses to break bread together in memory of the Lord's Supper, celebrating their fellowship with Christ in expectation of his imminent return.

It was in designated burial places outside the city walls of Rome that the first Christian images were made around AD 200. As pressure of numbers grew, these areas were extended underground, producing many-storeyed catacombs – long corridors, lined with wall tombs stacked like bunk-beds, here and there widening into small rooms containing the graves of a single family or group. Pagans called them necropolises, cities of the dead, but to Christians they were cemeteries, dormitories where the faithful slept awaiting resurrection, when they would wake to join Christ in Paradise.

The marble slabs that sealed the tombs were inscribed with the names of the dead, proclamations of faith, and Christian emblems (cat. nos. 2–4); the vaults of the burial chambers were painted. This funerary decoration has nothing funereal about it, no indication of mourning, not even of fear of judgment – only affirmations of belief in Christ's victory over death. Beginning in the fourth century, when Christianity became the Roman state religion, the catacombs gradually fell into disuse, except as places of pilgrimage to the tombs of martyrs. Christians began to bury the dead inside purpose-built churches, in stone sarcophagi carved with similar images of trust and triumph.

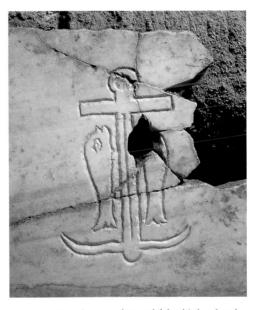

FIG 3 Cross-anchor and fish, *third or fourth century AD. Inscribed on a funerary slab in the catacomb of Priscilla, Rome.*

The instrument of Christ's victory, the cross, was seldom represented; early Christians were reluctant to depict the gallows on which common criminals were executed. In the catacombs, they showed the cross covertly, for example in the crosspiece of a ship's anchor, emblem of hope (fig 3). Accompanying the anchor, or as a sign within an inscription, we find the oldest symbol for Christ: the fish (cat. no. 4).

This is a visual pun based on an acrostic. The initial letters of the Greek phrase, Jesus/ Christ/ Son of God/ the Saviour, formed the Greek word for fish, *ichthys*. But there are many additional reasons why the fish became an enduring symbol of Christ. Its native element, water, recalls the waters of Baptism necessary for salvation. Edible fish occur in Gospel accounts read as allegories of the Eucharist: the multiplication of the loaves and fishes (MARK 6: 34–44), and the appearance of the resurrected Christ on the shore of the Sea of Tiberias (JOHN 21). By following Christ, the disciples became fishers of men (MARK 1: 17; LUKE 5: 10). In the fish, the initials of a declaration of faith became a word, the word a sign, the sign an image that recalls entire texts, giving rise to a host of allegorical interpretations.

But there is another, more abstract early Christian letter-sign: the monogram formed from the first two letters of his Greek title, *Khristos*, xP, transliterated as chi rho in the Roman alphabet. This monogram already existed among the pagans as an abbreviation of the Greek word *khrestos*, meaning 'auspicious'. It may have been for this reason, and not as a Christian emblem, that the Emperor Constantine first adopted it on the Roman imperial standard. But if the x of the monogram is turned sideways, it forms a cross; the reference is even more pointed when the chi rho is wreathed in a victor's laurel crown. Set between the letters Alpha and Omega, the first and last letters of the Greek alphabet, the monogram unambiguously represents Christ himself: 'I am Alpha and Omega, the beginning and the ending' (REVELATION 1: 8). Both the fish and the chi rho readily migrated from sepulchres to objects in daily use: lamps (cat. no. 12), tableware, amulets, brooches and rings (cat. nos. 9 and 10), even the coins of Christian emperors (cat. nos. 6 – 8).

From about the sixth century, the Greek chi rho monogram, or monogram of Christ, was displaced – though never replaced – by the Latin trigram, IHS, an abbreviation of the Greek *Ihsous* (Jesus), later interpreted as an acrostic of *Iesus Hominum Salvator* (Jesus Saviour of Mankind). Its veneration was popularised by the fifteenth-century Italian preacher, Saint Bernardino of Siena, and it was later adopted as the device of the Society of Jesus founded by Saint Ignatius Loyola in 1534. The Jesuits (for whom it also signifies *Iesum Habemus Socium*, 'we have Jesus for our companion'), still promote its use in the devotional practice of the Adoration of the Name of Jesus (cat. no. 14).

Early Christian artists drew on secular tradition not only for emblems such as the fish and the chi rho, but also when translating into visual form the verbal imagery of the Bible, notably the metaphors of Christ as the vine (JOHN 15: 1, cat. no. 20) and Christ the Good Shepherd (JOHN 10: 14–15; 27–28).

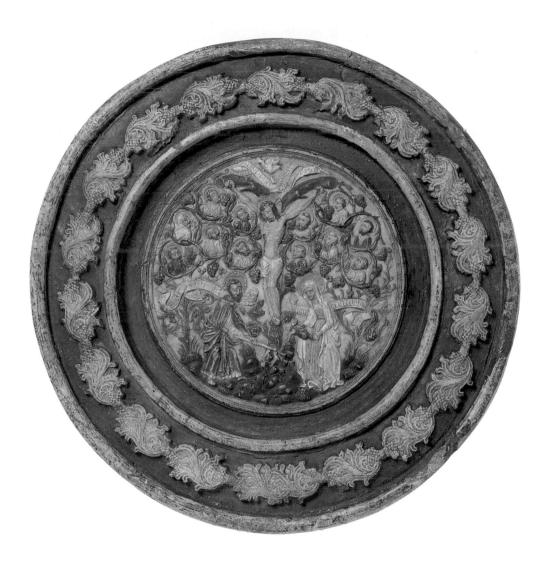

decorated with a vine – suggests it may have been an independent devotional image. That the fragment from Marienwohlde was discovered during the excavations of a Briggittine convent is surely of some significance, given how important the imagery of the vine was to that order. In one of the visions of Saint Bridget of Sweden (1303–73), Christ spoke to her of founding a new order in terms of planting a new vineyard. The vision is recounted in the prologue of the order's rule:

I will plant a new vineyard for myself, where vine branches will be brought to take root ... From this vineyard, many other vineyards will be renewed, which have been arid for long and they will bear fruit after the day of their renewal.³

The imagery of the roundel relates perfectly to this passage, but it is impossible to say whether all the surviving examples of the design were produced within a Briggittine context. *AS*

3 'Regula Salvatoris', quoted in Morris 1999, p. 161.

2 The Dual Nature

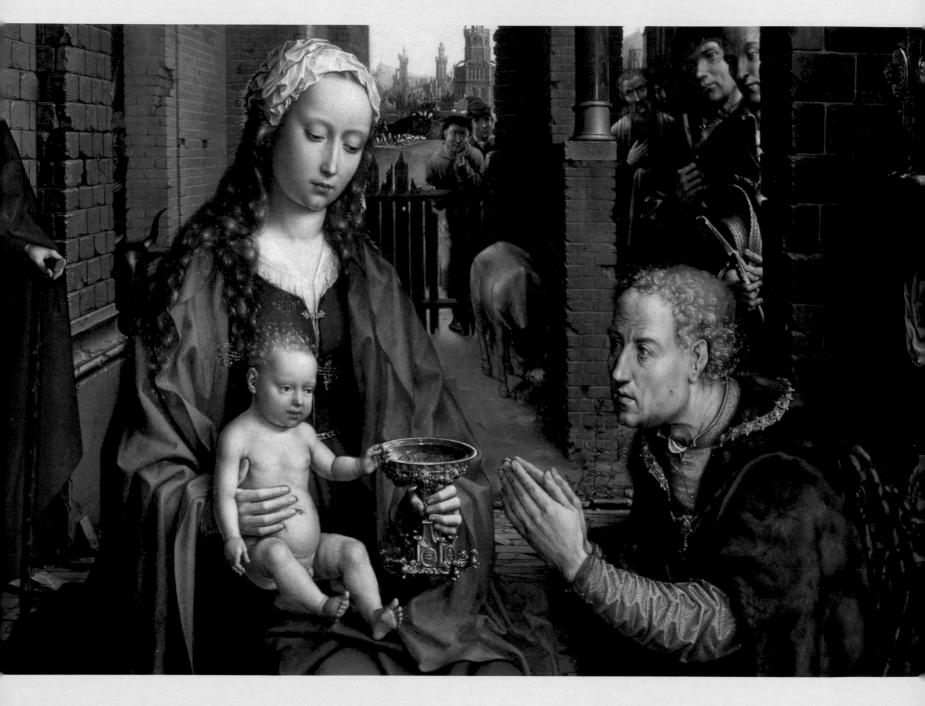

The MOST DIFFICULT TASK for the artist seeking to represent Christ is how to depict his dual nature: fully human and fully divine. The Book of Revelation tells us he is also Alpha and Omega, the beginning and the end. But as Christianity evolved from a minority religion to a State religion, and as both the powerful and the oppressed rallied under his banner, Christ came to embody further dualities: Victor and Victim; Saviour and Sacrifice; King of kings and 'despised and rejected of men' (ISAIAH 53: 3). Christmas is celebrated with joy, yet the Christ Child was born to suffer and die. The shepherds adored a Christ for the poor (fig. 12), and the Three Kings, a Christ for the rich. In order to engage fully with images of Christ, we need to understand which aspect they depict.

Duality is most readily represented in images of Christ's infancy, above all perhaps by the *Adoration of the Magi*, a favourite subject of early Christian funerary art (fig. 13). In the catacombs of Rome, Old and New Testament scenes record the past only to forecast the future: as Daniel was saved from the lions, the three Jewish boys rescued from the burning fiery furnace, the paralytic healed, and Lazarus resurrected, so would the dead buried here be raised again. In this setting, the Adoration of the Magi – the Epiphany, when the child's divinity is recognised by the peoples of the world – also points forward to future salvation. The Magi greet Christ at his first coming, as all believers will greet Christ in Glory at his Second Coming.

While the early Church stressed Christ's divinity, later theology – under the influence of a cloistered mystic, Saint Bernard of Clairvaux (1090–1153), and the popular preacher Saint Francis of Assisi (1182–1226) – focused on his Incarnation. The humanity of Christ is most apparent in the first and last moments of his earthly life, his early childhood and the events leading up to the Crucifixion: God choosing to be born, to suffer and die as a human being, in order to redeem our sins and purchase our salvation with his own body and blood. Since Christian art is above all theology in visual form, artists found different ways of depicting these two key themes of the Incarnation within a single image. The fif-

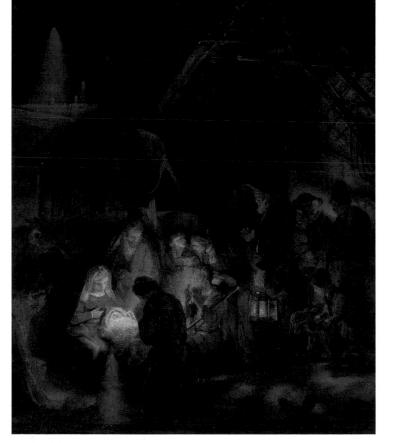

teenth-century panel attributed to Bonfigli rather naively juxtaposes the Adoration of the newborn Child with the Crucifixion (cat. no. 30). By the time this was painted, the Magi, the wise men from the East from the Gospel of Saint Matthew had been raised to royal status. In paying tribute to him, they show the Christ Child to be a greater

FIG 12 Rembrandt, Adoration of the Shepherds, signed and dated 1646. London, National Gallery, NG 47

21 The Heavenly and Earthly Trinities, 1681–82

Bartolomé Esteban Murillo (1617–1682) *Oil on canvas, 293 x 207 cm.* London, National Gallery, NG 13

Iefus Matris delicice, Iefus Patris folațium. Hieronymus Wierx fecit et excud. Cum Grutia et Privilegio. Buschere.

FIG 14 *Hieronymus Wierix*, The Return from the Temple (The Heavenly and Earthly Trinities), about *1600. Engraving*, *97 x 66 mm. London, British Museum.*

1 Mâle 1932, pp. 312-13.

48 THE DUAL NATURE

I N THIS WORK, almost certainly an altarpiece, Murillo has given visual form to the belief that Christ is both human and divine, earthly and heavenly. The Christ Child is placed in the centre of the composition, emphasising his role as the fulcrum of the 'Two Trinities'. Together with the hovering dove of the Holy Spirit and the figure of God the Father above, he is part of the Holy or Heavenly Trinity. In the lower half of the picture, together with his human parents, Mary and Joseph, he forms a part of the Holy Family sometimes thought of, especially in Counter-Reformation Catholicism, as the 'Earthly Trinity', the terrestrial counterpart of the Holy Trinity.¹ The painting demonstrates very effectively how the rhetoric of image-making can make a complex and profound theological notion accessible, persuasive and attractive.

Although this is not a narrative painting, Murillo's treatment of the *Heavenly and Earthly Trinities* is linked both compositionally and thematically to representations of the Return from the Temple recounted in the Gospel of Saint Luke (fig 14). When Christ was twelve years old Mary and Joseph took him to the Temple in Jerusalem for the Feast of Passover (LUKE 2: 41–50). As they returned home they realised that Jesus was not with them. They found him three days later in the Temple talking with the Doctors and astounding them with the intelligence of his replies. Mary said to him, 'Son, why hast thou thus dealt with us? Behold, thy father and I have sought thee sorrowing'; to which Jesus replied, 'Wist ye not that I must be about my Father's business.' With these words, Jesus declared his divine paternity, manifesting for the first time his awareness that he was the Son of God. Murillo's painting does not actually represent this Gospel subject (his Christ Child is anyway too young), but it draws out from the episode the was entrusted with a divine mission.

The Gospel states that Mary and Joseph did not understand what Jesus meant by his reply to them, but Murillo shows them in attitudes of adoration, recognising his divinity. Joseph kneels and looks directly at the viewer, inviting us too to adore Jesus. The rod he holds in his left hand relates to a story recounted by Saint Jerome (c. 341-420). He wrote that all Mary's suitors brought a rod to the high priest at the temple, but Joseph's was the only one that blossomed. This was a sign from heaven that he was chosen to be her husband. In Murillo's painting Christ stands on a piece of stone, perhaps symbolic of an altar, but maybe also intended as a reference to the difficulties of belief raised by the paradox of the dual nature of Christ. In the Gospel of Saint Matthew, Christ speaks of himself using a metaphor from the Psalms (118: 22-23), as the rejected cornerstone: 'Jesus saith unto them, "Did ye never read in the Scriptures, The stone which the builders rejected, the same is become the head of the corner: this is the Lord's doing, and it is marvellous in our eyes?" (MATTHEW 21: 42). Saint Paul in the Letter to the Romans contrasts the Gentiles' welcoming of Christ with the people of Israel's rejection of him, describing him as 'a stumblingstone, and rock of offence: and whoever believeth on him shall not be ashamed.' (ROMANS 9: 33 and 1 PETER 2: 4-8). XB

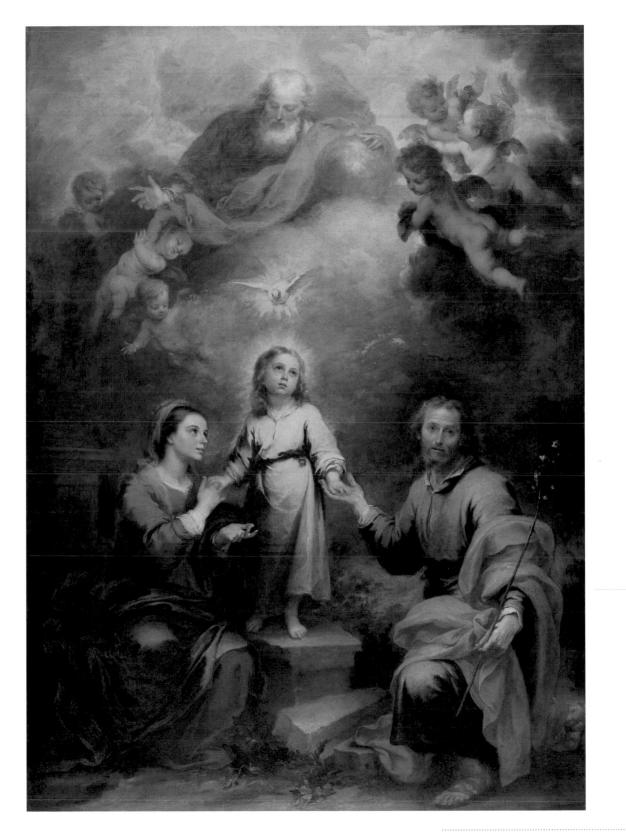

26 The Circumcision, about 1500

Workshop of Giovanni Bellini (active from around 1459, died 1516) *Oil on wood, 74.9 x 102.2 cm. Signed on a cartellino: 10ANNES/ BELLINVS.* London, National Gallery, NG 1455 CHRIST'S CIRCUMCISION EIGHT DAYS after his birth is an event commemorated in the Christian calendar on the first day in January. The Gospel of Saint Luke recounts that, 'when eight days were accomplished for the circumcising of the child, his name was called Jesus' (LUKE 2: 21). Circumcision, or the ritual removal of a male infant's foreskin, was the sign of the covenant between God and Abraham (GENESIS 17: 11-12) and was part of the religious laws given by Moses (LEVITICUS 12: 3). It remains an important part of Jewish religious practice. Like Baptism in the Christian Church, circumcision has traditionally served as a rite of purification, marking the moment of a male child's formal naming.

Bellini has conformed to the traditional representation of the subject showing the High Priest performing the act while Mary holds the Infant Jesus and Joseph and two other figures look on.¹ Christ clenches his fists, bravely bearing the pain. In undergoing the ritual as the law required, he demonstrated his readiness to submit to the law and to share in the human condition. Christ's circumcision was subjected over time to a variety of interpretations on the part of theologians who extended its significance and drew parallels with other episodes of his life. For medieval Christians, the event was significant as the first occasion on which the Redeemer's blood was shed, in a direct allusion to his coming Passion. Later, the Jesuits (who take their name from Jesus) laid special emphasis on the Feast of the Circumcision because of its association with the act of his naming.² Through the association between the naming of Jesus and the first shedding of his blood, the circumcision came to symbolise the moment in which God's plan of salvation for humanity, through Christ's sacrifice on the cross, began to be made manifest.

Paintings like this may have been commissioned by the members of lay associations, or brotherhoods, who perhaps had a special devotion to the name of Christ or to the relics of his blood, or even his foreskin. In the absence of any physical vestiges of the mature Christ's bodily presence on earth following his Ascension into heaven, relics purporting to be his foreskin were much prized in medieval times. Alarmingly, as many as fifteen such items are known at one time or another to have been the object of veneration in different parts of Europe. *XB*

1 On the iconography of the circumcision, see Réau 1957, 11, pp. 256–61; Voragine 1993, 1, pp. 71–78.

2 Even before the Jesuits, the Name of Jesus had been revered by figures such as Saint Bernard who claimed the name to be like 'honey in the mouth, music in the ear, and a cry of joy in the heart', Voragine 1993, 1, p. 72; see also cat. no. 14 in this catalogue.

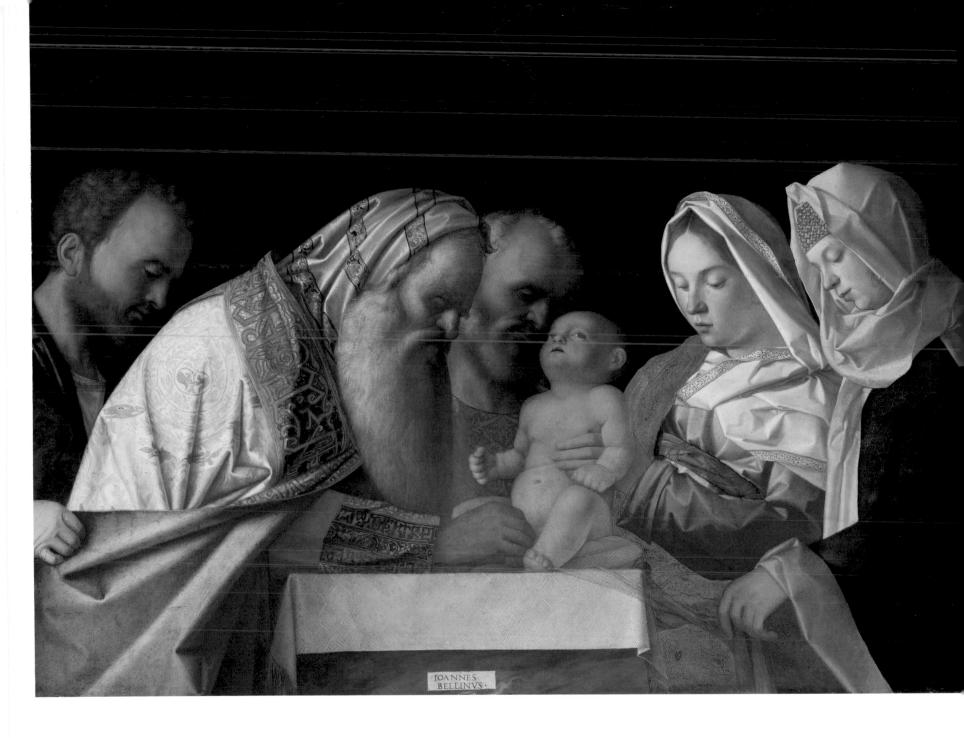

decoration of a capital above the eldest king shows the sacrifice of Isaac (GENESIS 22: 9–13), which was traditionally interpreted as a prefiguration of Christ's own sacrifice, while prominent in the background architecture is a column reminiscent of the one to which Christ would be bound and flagellated during the Passion. Gossaert elaborates a dense texture of symbolic allusion in this work to expound and explore the deep mystery of the person of Christ.

In their sumptuous costumes, the kings maintain a courtly and imperious dignity which may well have made the picture especially appealing to the succession of rulers or people of high rank who owned it. Albert and Isabella acquired it from the Benedictine Abbey of Geraardsbergen, east Flanders, and placed it in the chapel of their palace in Brussels (where there was a relic, a fragment of clothing of one of the Three Kings). It was later owned by Charles of Lorraine, the Governor of the Austrian Netherlands, and then by the Earls of Carlisle. Certainly the Epiphany was an event with which rulers in the past liked to associate themselves. Several chose to have themselves painted as one of the Magi. Various members of the Florentine Medici family appear in Botticelli's *Adoration of the Kings* (Florence, Uffizi), and 6 January was often chosen for kingly ceremonies. In early 1378, for example, Charles v of France met Charles IV, the Holy Roman Emperor and the latter's son Wenceslas, King of the Romans. *S-AQ*

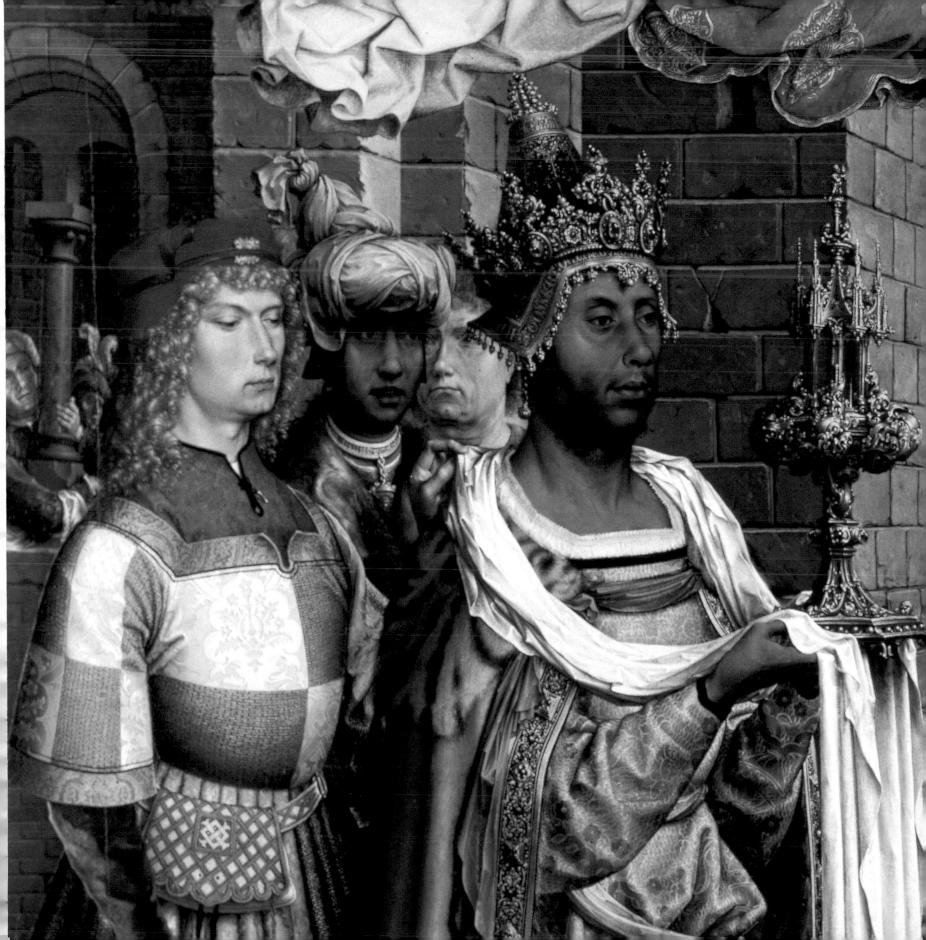

3 The True Likeness

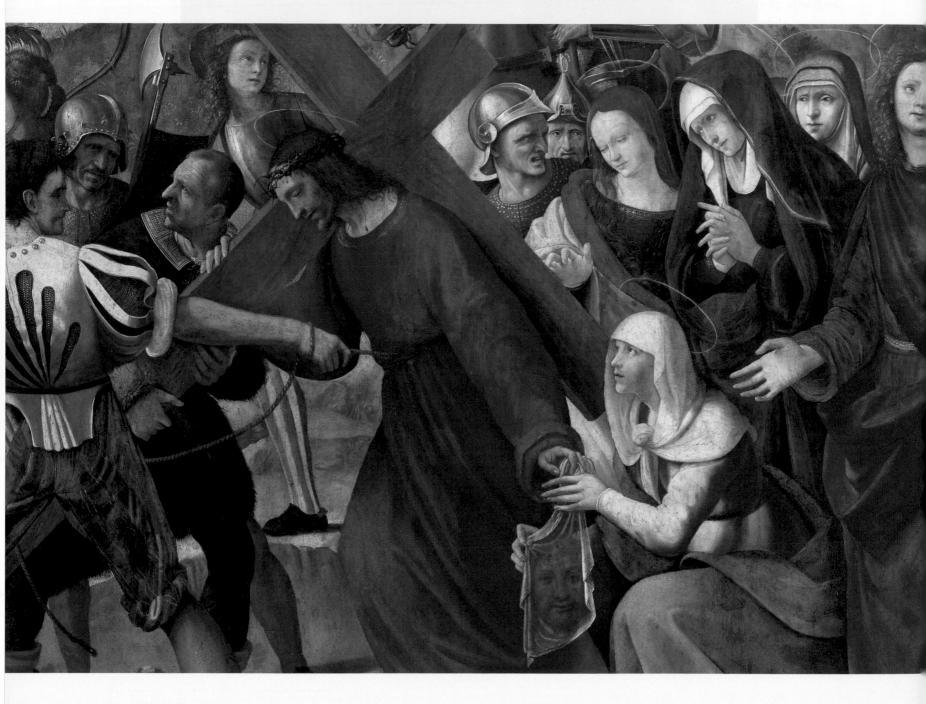

EVERYONE IN MEDIEVAL Europe would have been confident that they knew what Christ looked like. Images of his face were everywhere, many of them claiming to be copies or versions of a miraculous 'true likeness' of Christ housed in St Peter's in Rome. This was the 'Veronica', also known as the *vernicle* or the *sudarium* (meaning a cloth for wiping sweat). According to the most familiar version of the story, this was a cloth offered to Christ by Saint Veronica on the road to Calvary so that he could wipe his face. On receiving it back she discovered Christ's features miraculously imprinted upon it. A play on the word Veronica, which can be read as *vera icon* (meaning 'true image'), meant that the saint's name was also used to describe her cloth.

The Veronica became the most reproduced image in Christendom and perhaps the most famous relic in Rome. The Italian poet Dante (1265–1321), writing after the Holy Year of Jubilee in 1300 when pilgrims had flocked to Rome to see the Veronica (fig. 21), tells:

... Of one

Who haply from Croatia wends to see Our Veronica, and while 'tis shown, Hangs over it with sated gaze And all that he has heard revolving, saith Unto himself in thought: "And did'st thou look E'en thus, O Jesus, my true Lord and God And was this semblance Thine?"¹

Nearly 300 years later Michel de Montaigne (1533–1592), the French man of letters, could claim that, 'No other relic has such veneration paid to it. The people throw themselves down before it upon their faces, most of them with tears in their eyes and with lamentations and tears of compassion'.² This despite the fact that the relic being venerated was probably not the original: the Veronica had apparently been lost during the Sack of Rome by German Lutheran soldiers in 1527, when, according to one contemporary, it 'was passed from hand to hand in all the taverns of Rome'.

Considering the masses of pilgrims who came to see the image and the innumerable copies of it, it is perhaps surprising that we do not know what the Veronica actually looked like. Its original crystal frame preserved in the Vatican gives its measurements as 40 x 37 centimetres, but we can be certain of little else (fig. 22). The earliest accounts of the relic in the eleventh century do not mention an image at all and the 'copies' that proliferated from the thirteenth century differ considerably from each other even if they share a family resemblance. They show a long-haired, bearded man whom we still easily recognise as Jesus. But this version of Christ's face was well established before the

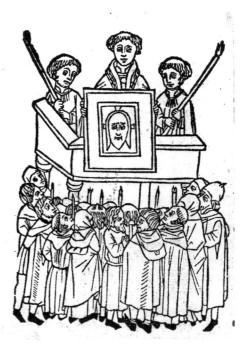

FIG 21 The Veronica displayed to pilgrims in Rome. *Woodcut illustration from the* Mirabilia Urbis Romae (*The Wonders of the City of Rome*), c.1475. *Munich, Bayerische Staatsbibliothek.*

Paradiso, canto xxx1, lines 103-108, trans. Cary.
 Quoted in Thurston 1900, p. 273.

33 The Procession to Calvary, probably about 1505

Ridolfo Ghirlandaio (1483–1561) *Oil on canvas, transferred from wood, 166.4 x 161.3 cm.* London, National Gallery, NG 1143 THIS ALTARPIECE SHOWS the most familiar version of the Veronica story which, despite its subsequent popularity, only became established early in the fourteenth century. Veronica, a pagan woman, described as a virgin, witnessed Christ carrying the cross on the road to Calvary. Taking pity on him she wiped his face with a cloth. As a reward for her compassion Christ's features were miraculously transferred onto the cloth.

The subject of Christ carrying the cross was unusual as the principal scene of an altarpiece in Italy (although not in northern Europe) and this, together with the prominence given to Veronica and her veil, suggests that the painting may have been intended for a chapel dedicated to the Saint. She kneels in the foreground and receives the cloth from Christ's outstretched hand. Ghirlandaio has arranged the gestures in such a way that the miraculous image, while playing its role within the narrative, is also presented frontally; a picture within a picture. The cloth has been painted to appear gauze-like and translucent, an effect that has survived the evident wear of this painting. Also just visible are traces of blood trickling down Christ's forehead. The open eyes and full face on the cloth are in marked contrast to the lowered lids and perfect profile of the figure of Christ carrying the cross. It is surely deliberate that it is the miraculous image that engages most directly with the spectator, allowing for its contemplation divorced from its narrative surroundings. The profile view of the figure of Christ is unusual but might reflect a dependence on another 'True Likeness', the so-called Emerald Vernicle (see cat. no. 40).

There is one other figure looking out of the painting; the man with close-cropped hair on the left who, in a startling anachronism, has a gun slung over his shoulder. His face has the characteristics of a portrait – one of many in the painting if we are to believe the Renaissance biographer, Giorgio Vasari, who described this picture at some length in the 1550 edition of his Lives of the Artists. Vasari claimed that Ghirlandaio included a number of 'very beautiful heads taken from life and executed with lovingness', including portraits of Ridolfo's father - the leading fifteenth-century artist Domenico Ghirlandaio - and a number of friends and studio assistants. Distinguishing portrait heads in narrative paintings is always a tricky business but others that suggest the requisite degree of particularity are the figure in the black hat on the extreme right and the figure of the man taking hold of the cross, presumably intended to be Simon of Cyrene who helped Christ with his burden. In contrast the face of the grimacing helmeted soldier to the right of Christ appears to derive not from life but from a drawing by Leonardo da Vinci. Vasari tells us that the altarpiece was painted for the church of San Gallo in Florence, which was destroyed in 1529, and implies that it was one of Ridolfo's earliest important commissions. AS

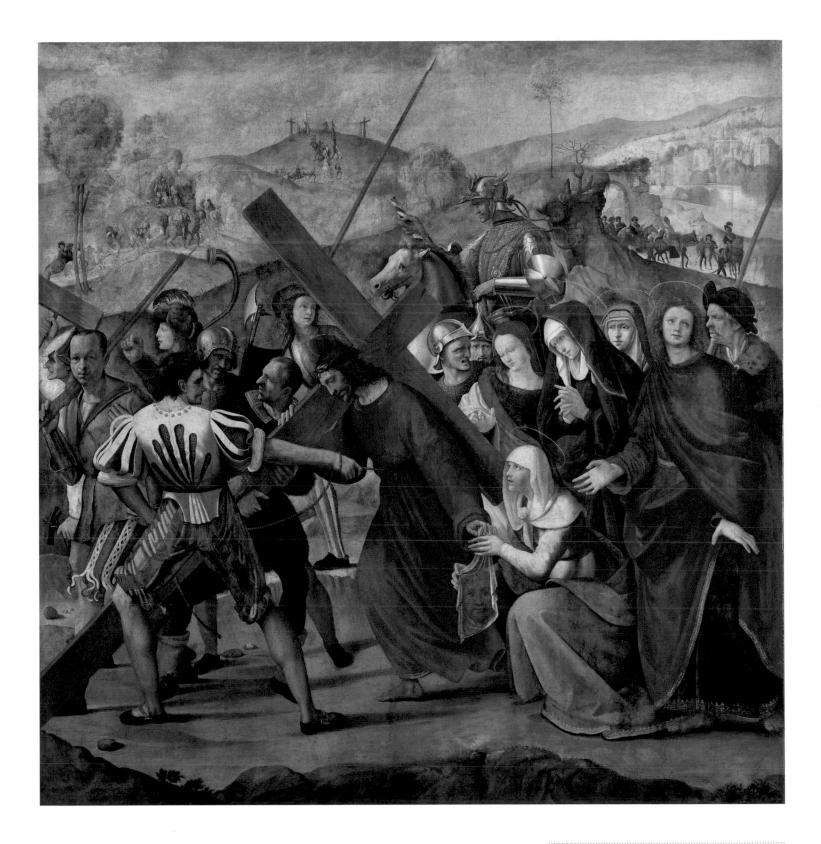

34 Saint Veronica with the Sudarium about 1420

Master of Saint Veronica (active early fifteenth century)

Oil on Walnut, 44.2 x 33.7 cm. Saint Veronica's halo is inscribed sancta veronica; Christ's halo is inscribed ihs. Xps. ihs. x. (a repeated abbreviation for Jesus Christ).

London, National Gallery, NG 687

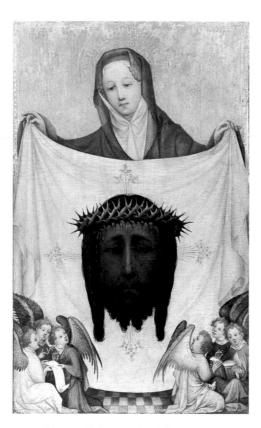

FIG 24 Master of Saint Veronica, Saint Veronica with the Sudarium, c.1415. Tempera with traces of oil and resin on panel, 78.1 x 48.2 cm. Munich, Bayerische Staatsgemaldesammlungen, Alte Pinakothek.

IN THIS SMALL PANEL by an anonymous Cologne artist of the early fifteenth century, Veronica is shown holding the *sudarium* in front of her. She is on a different scale to the miraculous image she presents for veneration and is clearly subsidiary. She appears not in any narrative context but almost as a mark of authenticity. By her presence she both identifies the image and, as the relic's first owner, provides visual 'proof' of its age and origin. She inclines her head and lowers her eyes directing attention towards the disembodied face of Christ. The way she holds up the cloth recalls how the *sudarium* would have been displayed to pilgrims in Rome (fig. 21), reminding those in front of the painting of the reality of the relic and the veneration due to it. Reinforcing the theme of veneration, two angels were punched into the gold background on either side of Veronica, but they are now barely visible.

Once removed from its narrative context the Veronica had several different meanings. It came to stand for Christ's continuing presence – suggested by the physical reality of the relic itself – and, by extension, the continuing presence in the world of Christ's body in the Eucharist. In a fifteenth-century German prayer book a miniature of the Veronica holding the *sudarium* exactly as in this painting accompanies prayers to be said at the elevation of the Host – the moment in the Mass when the consecrated Host is shown to the congregation.¹

The painter of this panel is known as the Master of Saint Veronica but is named not after this painting, but after another one of the same subject now in Munich (fig. 24). The similarities between the two in arrangement and style are clear and extend to the similarly punched borders in the gold background. It is the differences between the images that are most intriguing: in the National Gallery painting the frame cuts the figure of Saint Veronica off just below the knee, making her physically more substantial and bringing her closer to the picture plane than in the Munich version. The conceit of the cloth being thrust out of the painting towards us is enhanced by Veronica's fingers, which project over the edge of the gilded and punched border. What is more, Christ's face with its gilded halo (absent in the Munich version) appears to float free of the cloth. In the Munich painting Christ is dark-faced and wears the crown of thorns, in contrast to his 'perfect' and untroubled features in the National Gallery picture. It is tempting to see this as reflecting the contrast between the two most popular Indulgenced prayers associated with the Veronica: on the one hand, the early fourteenth-century Salve sancta facies (Hail, holy face) which speaks of the 'vision of divine splendour which was imprinted on the white cloth' (cat. no. 37), and on the other, the thirteenth-century Ave facies praeclara (Hail, splendid face) which dwells on a countenance 'darkened by fear and stained with holy blood', which it calls the 'standard of compassion'. AS

1 Hamburger 1998, fig. 7.19, p. 335.

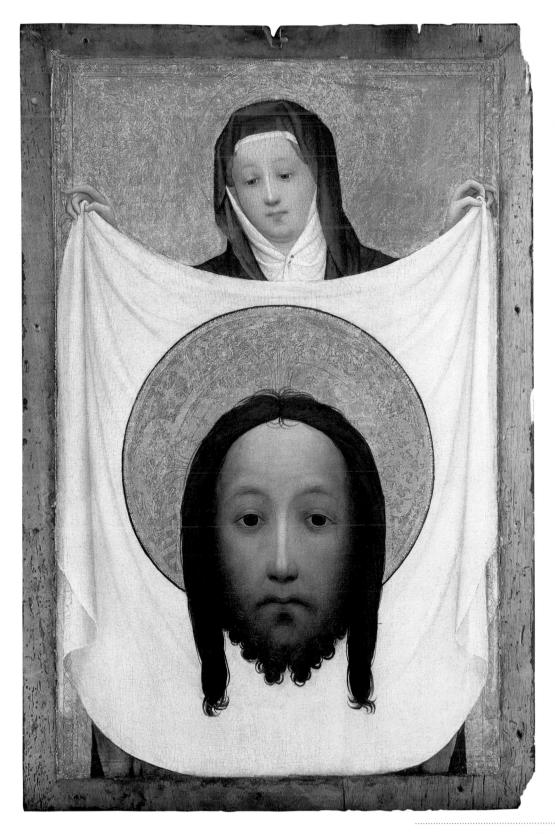

35 Two Angels Holding the Veronica, 1513

Albrecht Dürer (1471–1528) Engraving, 102 x 140 mm. Signed with monogram and dated 1513 London, British Museum, E.4–98

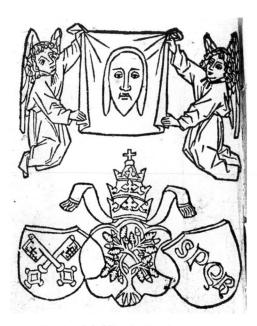

FIG 25 Two Angels holding the Veronica and the Arms of Pope Sixtus IV, *Woodcut illustration from the* Mirabilia Urbis Romae, c.1475. *Munich, Bayerische Staatsbibliothek.* I N THIS ELABORATE ENGRAVING the German Renaissance master, Albrecht Dürer has removed Veronica's veil both from its narrative context and from Veronica herself. He shows it instead displayed by two angels, in a manner similar to its heraldic presentation in an illustration from a fifteenth-century guidebook to the marvels of Rome (fig. 25). Although the Veronica is presented 'out of time', the print clearly encourages an emotional and empathetic response and is intended to act as an aid to the contemplation of Christ's suffering and sacrifice. Christ stares out from under the crown of thorns with a pained expression, as blood trickles down his forehead. More significantly the angels do not merely present the image but respond to it with faces and gestures of extreme grief, directing the viewer's devotional response.

Dürer had already included an image of the Veronica in his 'Small Passion' (cat. no. 56), where it is also divorced from any narrative context and is held between Saints Peter and Paul, the two Saints of Rome where the relic itself was kept. The print shown here was produced the year after Dürer's so-called 'Engraved Passion' of ten scenes, with which it shares its dark background. Although clearly independent of that Passion series, and different in size and format, thematically this print has been seen as its concluding and crowning illustration.

The Veronica image seems to have had a particular significance for Dürer and he made a number of versions of the subject. A drawing by him in green ink of 1515 is in the *Prayer Book of the Emperor Maximilian*, and an engraving of the Veronica held by an angel dates from the following year. In his diary of 1520, recording his travels in the Netherlands, he mentions a number of images of 'Veronica's face' he distributed as gifts, including two impressions of the present engraving and four, presumably small, paintings. There may also have been a more elaborate painting of about 1500 known from a description and drawing dating from some hundred years later.¹

Dürer's most startling response to the Veronica was, however, his own self-portrait of 1500, now in Munich, in which he presented himself full-face with Christ-like beard and hair, in apparent emulation of the Veronica. The implications of this have been the subject of considerable discussion.² Among other things, Dürer may have intended to suggest that like the miraculous Veronica image of Christ, his self-portrait was a true likeness, an entirely faithful record. It has often been noted that even in this engraving of 1513, Christ's features, which stand out from the cloth and the page almost like relief sculpture, bear a resemblance to Dürer's own. *AS*

1 Koerner 1993, p.92.

2 See especially Koerner 1993.

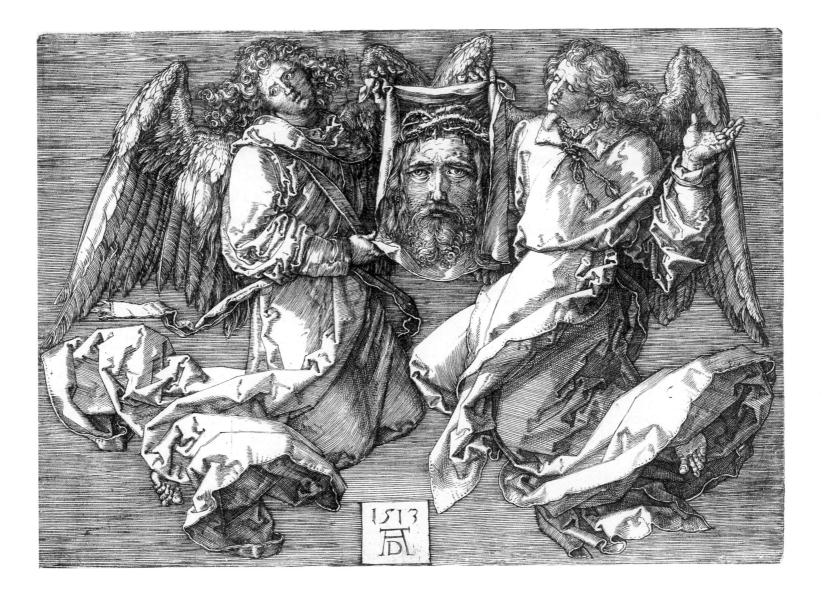

36 The Veil of Saint Veronica, about 1635

Francisco de Zurbarán (1598–1664) *Oil on canvas, 70 x 51 cm.* Stockholm, Nationalmuseum, NM5382 THE SPANISH PAINTER Zurbarán's imaginative recasting of the image of the Veronica survives in a number of versions, some of which are the work of his assistants and collaborators.¹ This painting from Stockholm is perhaps the finest of the surviving examples, but they all share its essential features. It is a masterpiece of illusionistic painting, a *trompe l'oeil* in which the cloth appears to hang, pinned to the surface on which it is actually painted. The cloth is tied at its top corners to hang from two pieces of string, while two pins on its central axis raise its bottom edge and form a gable over Christ's face. Although the degree of Zurbarán's illusionism was new, he was not the first artist to attempt to paint the Veronica image in this way: El Greco set a notable precedent. Indeed the very nature of the *sudarium* as both object (a piece of cloth) and image (the face of Christ) encouraged this kind of depiction.

Zurbarán's originality lies in the way in which he has shown the face on the cloth. He has abandoned the traditional appearance of the Veronica image – full face and colourful and often seeming to hover in front of the cloth itself. Instead, in a remarkable piece of imaginative reconstruction, he has attempted to show what the legend describes – a cloth on which the features of the suffering Christ have been miraculously imprinted. This is no small development, for the familiar Veronica images claimed to be a record of Christ's true likeness as preserved on the *sudarium* in Rome. In abandoning the iconic version of the image, Zurbarán chose to ignore the significance of the *sudarium* as a true likeness and instead to treat it as a physical relic of Christ's Passion and an aid to empathetic meditation. Zurbarán's depiction of Christ's face indeed derives less from earlier images of the Veronica than images of Christ on the road to Calvary – a fact confirmed by the curious three-quarter view which makes no logical sense as the impression that would be left by pressing a cloth to a face. Christ's mouth is open, recalling the moment when he turned to the grieving women on the road to Calvary to say 'Daughters of Jerusalem, weep not for me' (LUKE 23: 28), a scene which is often illustrated.

The intense emotional involvement elicited and encouraged by images such as Zurbarán's in seventeenth-century Spain is suggested by the account of Juan Acuña de Adarve describing a nun's experience in front of a Veronica: 'One day, during Holy Week, having flagellated with iron chains as was her custom, and having prostrated herself before the Veronica, she said: "Oh! Gentle Jesus, I beg you Lord, in the name of your Holy Passion, allow me through the taking of my vows to be your bride, so that once liberated from the things of this world I may devote myself more entirely to You, Saviour of my soul". Having uttered these words, the Veronica was transformed, becoming the beautiful face of Our Lord Jesus Christ, as lifelike as sinful mortal flesh and bones. And such were her words at the sight of our Saviour, such her tears, her lamentations and torment born of so much love, that the Lord himself comforted her, promising to take her as his bride ... Having spoken thus, the Veronica returned to its former shape'.² AS

1 Gállego/Gudiol 1976, nos. 554-563; Stoichita 1991.

2 Quoted in Stoichita 1995, pp. 63ff.

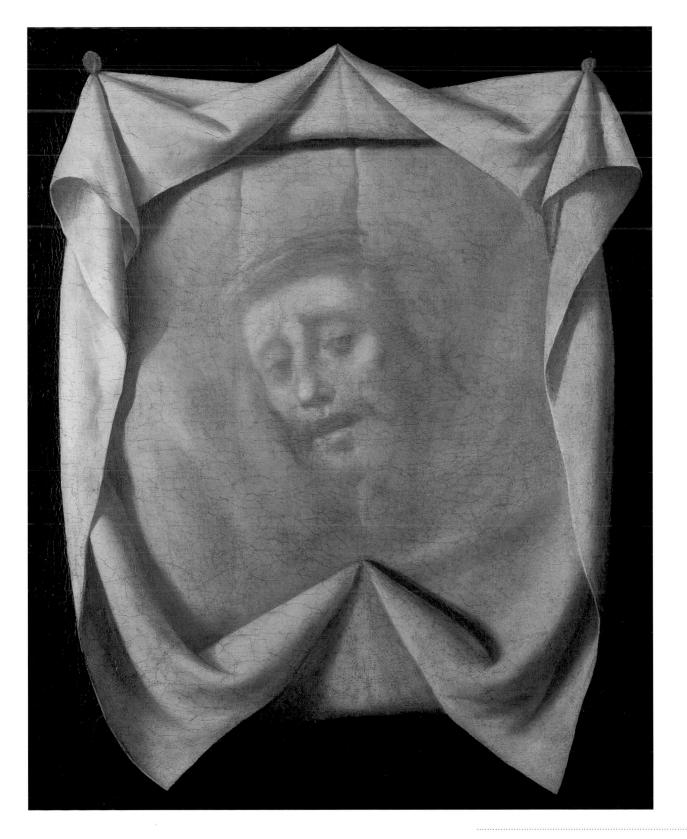

37 Portrait of a Young Man, 1450-60

Petrus Christus (active 1444; died 1475/6) *Oil on oak, 35.5 x 26.3 cm.* London, National Gallery, NG 2593 THIS PORTRAIT BY THE fifteenth-century Netherlandish painter Petrus Christus shows how the image of the Veronica entered people's homes and how it might have been displayed and used by the devout. On the wall behind this unidentified young man is a sheet of parchment tacked onto a wooden board and framed with a strip of red tape. The tape has broken at the bottom right hand corner where the parchment is shown curling away from the board. At the top of the sheet is an illumination of the face of Christ with the Greek letters Alpha and Omega above it. Below, in two columns are the legible, if worn, words of the prayer 'To the holy Veronica' known as the *Salve sancta facies* or 'Hail, holy face'.

Incipit or [ati] o ad s[an]c[t] am V[ero]nica[m.]

Salue sa[n]cta facies Nostri rede[m]ptoris in q[ua] nitet (spec?)ies Di[vi]ni splendoris Imp[re]ssa paniculo Niuei coloris Data q[ue] Veronice Signu[m] ob amoris(.) Salue n[ost]ra gloria In hac vita dura Labili q[ue] fragili Cito transitura Nos p[er]duc ad p[at]riam Ofelikx figura Ad videndu[m] faciem Que est xpi pura(.)

Salue o sudariu[m] Nobile iocale Es n[ost]r[u]m solaciu[m] Et memoriale Non depicta ma[n]ibus Scolpta vel polita Hoc scit su[mmus] Artifex Qui te fecit ita(.) Esto nobis q[uae]sim[us] Tutu[m] adiuuame[n] Dulce refrigeriu[m] Atq[ue] [c]o[n]solamen Vt nobis no[n] noceat Hostile grauamen Se[d] fruamur requie Dicam[us] o[m]nes Ame[n].

Explicit

Beginning of the Prayer to the Holy Veronica. Hail, Holy Face of our Redeemer, in which shines the vision of divine splendour that was imprinted on the white cloth given to Veronica as a token of love. Hail, our glory in this hard life – fraught, fragile and soon to be over – lead us, wonderful image, to our true homeland, that we may see the face of Christ himself. Hail, Sudarium, excellent jewel, be our solace and reminder. No human hand depicted, carved or polished you, as the heavenly Artist knows who made you as you are. Be to us, we beg, a trusty help, a sweet comfort and consolation, that the enemy's aggression may do us no harm but we may enjoy rest. Let us say together Amen. End.

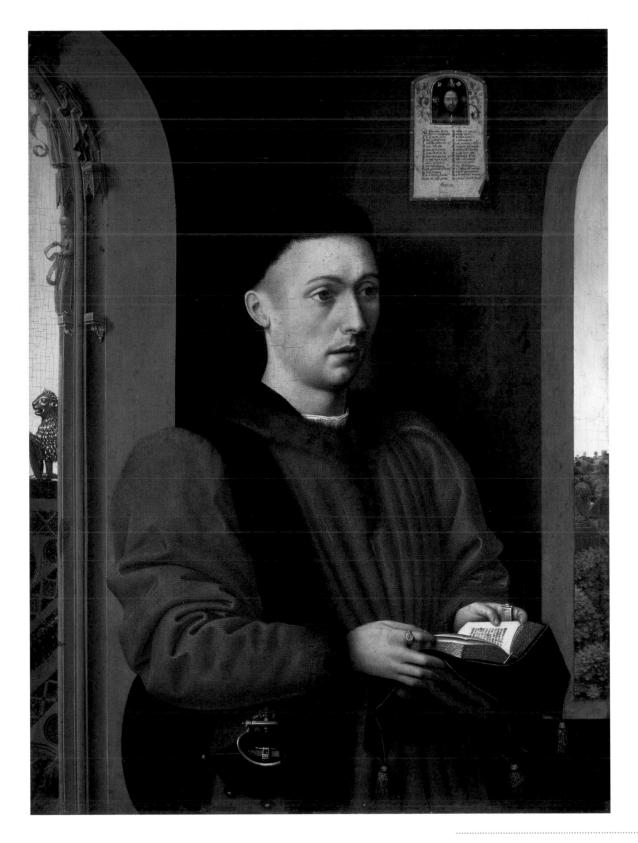

The prayer, which is given in abbreviated form, is the most famous of those associated with the Veronica image. It is usually attributed to an anonymous author writing during the papacy of John XXII (1316–1334), but sometimes to the Pope himself. The prayer was of particular importance as one of those that carried with it an Indulgence – a remission from time spent in Purgatory – for those who recited it in front of a depiction of the Veronica. The emphasis of the prayer is reflected in the type of 'holy face' shown in Christus's painting. Christ is depicted without the crown of thorns and, although the prayer was written after the establishment of the Veronica story within the Passion narrative, it concentrates on the 'divine splendour' of the 'wonderful image', rather than its role as a reminder of Christ's suffering. In Christus's painting the Greek letters Alpha and Omega – the beginning and the end – above the face emphasise Christ's abiding presence just as the prayer anticipates the moment at the Last Judgement when the elect may see 'the face of Christ himself', recalling the famous words of Saint Paul to the Corinthians: 'For now we see through a glass darkly but then face to face' (I CORINTHIANS 13: 12). *AS*

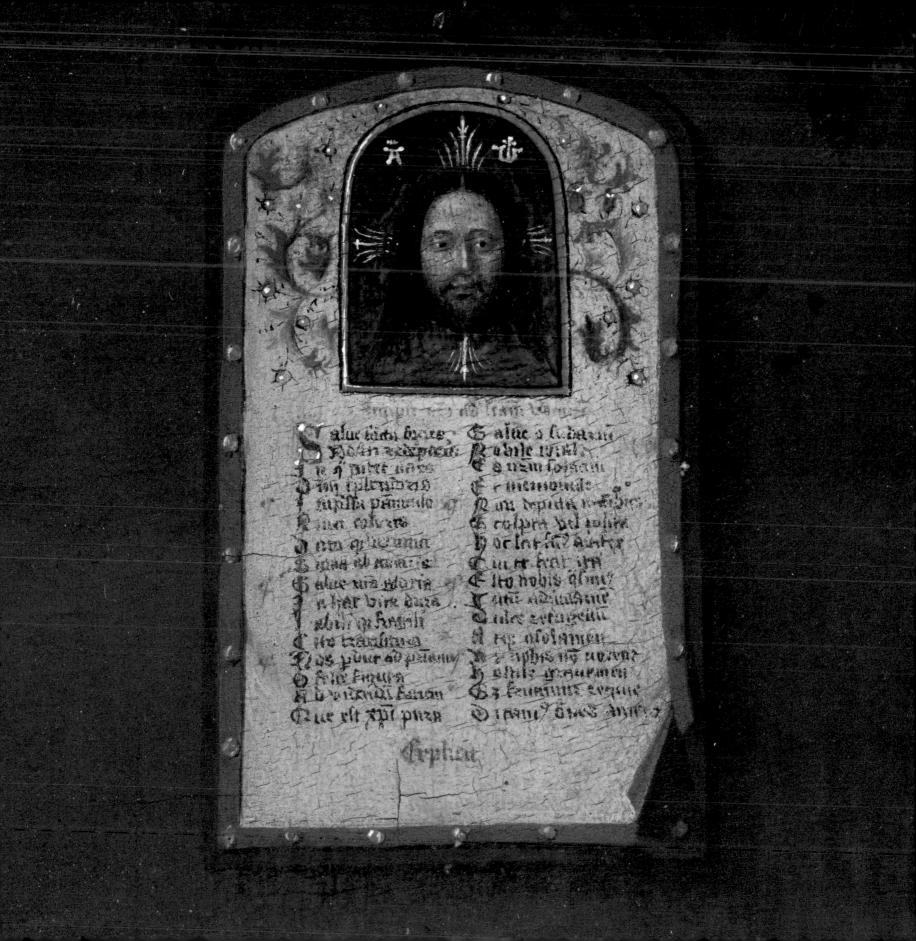

38 The Face of Christ, late fifteenth century

German/Netherlandish

Papier-mûché, painted, 19 x 15 x 5.5 cm. Utrecht, Museum Catharijneconvent, INV. ABM v 279 THIS PAPIER-MÂCHÉ FACE of Christ is not strictly a Veronica, although it clearly derives from Veronica images. It may originally have been shown in front of a cloth, but the only indications as to its original display are a number of small holes on the reverse at the top suggesting it was hung from a thread, as it still is today. The image focuses on Christ's suffering: blood is painted dripping down the brow from the prominent thorns of his crown. It differs from most representations of the Veronica image in showing Christ with closed eyes.

Fragile and damaged, this is a rare survivor among similar Veronica-related objects which were produced cheaply and were widely available in fifteenth-century Europe. Such objects illustrate the extent to which the devotion to the 'Holy Face' permeated all levels of society. Another comparable papier-mâché head is recorded in a private collection in Wiesbaden, Germany.

Encouraged by the Devotions and Indulgences attached to the image, the Veronica was copied, imitated and adapted in a variety of different ways in the fifteenth century. These included prints and pilgrim badges and led to the establishment of specialised groups of artists and merchants – the *pictores Veronicarum* (Veronica painters) and the *mercanti di Verniculi* (Vernicle vendors) – dedicated exclusively to the production and sale of Veronica-related images. *AS*

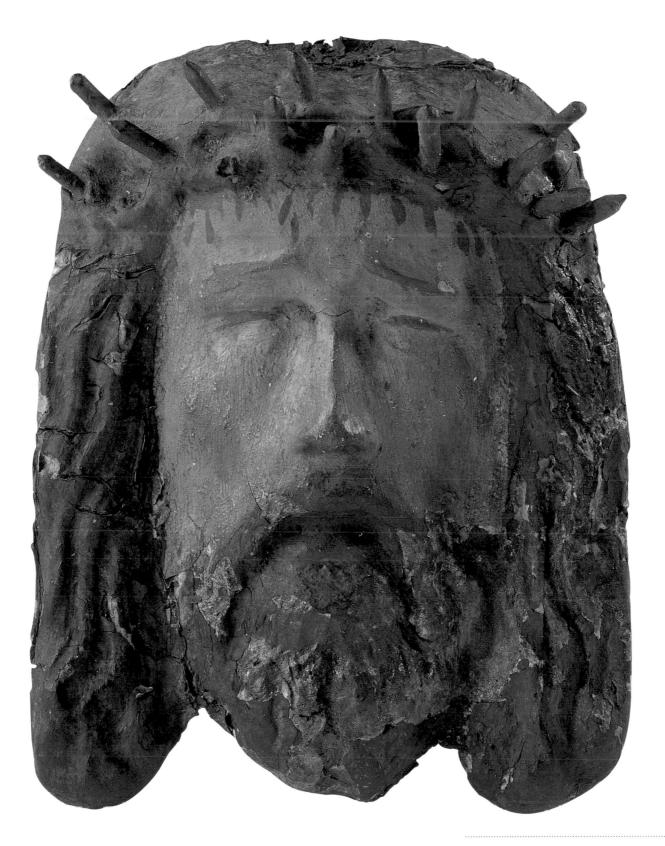

39 The Veil of Saint Veronica, 1649

Claude Mellan (1598–1688)

Engraving, 430 x 306 mm. Signed: MELLAN G. P. ET F. IN ÆDIBUS REG. / 1649 (Mellan, engraved, designed and made it in the royal palace. 1649) On the hem of the veil: Formatur Unicus Una / Non Alter

London, The Strang Print Room, University College, INV. 1557 The FACT THAT THE Veronica was a miraculous image, an exact replica of Christ's face not made by any artist's hand, made it an object of particular interest for artists themselves. It is this aspect of the Veronica that must have suggested it as the subject for this near miraculous print. Astonishingly, the image is conjured from one single line which starts at the tip of Christ's nose and then, varying in thickness, spirals outward to the edge of the page. How the French painter and engraver, Claude Mellan, made the print was described by his earliest biographer, Claude Augustin Mariette: having first placed the point of his burin (the engraver's cutting tool) at the centre of the copper plate he engraved a single slightly undulating spiralling line – although because the plate is rectangular rather than circular, the line is in fact broken at the corners. He then drew the design onto the plate itself and, using this as his guide, strengthened and widened the line as necessary to produce the finished image, including the inscriptions at the bottom.

Shown as if written on the hem of the veil itself are the words '*Formatur Unicus Una*' (the unique one made by one), and below them, and the veil, the further inscription '*Non Alter*' (no other). Both short epigraphs were devised by Michel de Marolles, Abbé de Villeloin (1600–1681), a voracious collector of prints, who, in 1667, sold his collection of 123,000 works to King Louis XIV for over 50,000 *livres*. Marolles had his portrait made by Mellan a year earlier in 1648 and later in his memoirs he laboured the point that his inscriptions were intended to refer as much to Mellan's artistry as to the print's subject: '*Formaturque* [*sic*] *unicus una* alludes to the beauty of the only son of the Eternal Father, born of a Virgin, and to the single spiralling line … Non alter, because there is no one else who looks like [Christ] and because the engraver of this image had produced such a masterpiece, that anyone else would have great difficulty equalling his achievement'.¹ The challenge implied by the words *Non alter* were possibly the spur for at least five copies from the seventeenth and eighteenth centuries, which all omit this phrase. The original copper-plate for Mellan's print survives in the Brussels Royal Collection.

Mellan's print unequivocally demonstrates his printmaking skills but it also testifies, like Zurbarán's painting (cat. no. 36), to the continued popularity of the Veronica image in the seventeenth century. It is interesting that he made the print the year before the Holy Year, or Jubilee, of 1650 in whose celebrations in Rome the display of the *sudarium* had always played a central role. In a number of the medals cast by Innocent x in 1649 to celebrate the impending Holy Year, the *sudarium* is shown hanging in the Holy Door of St Peter's basilica, which was ceremonially opened at the beginning of a Holy Year. *AS*

1 Quoted in Paris 1988, p. 121.

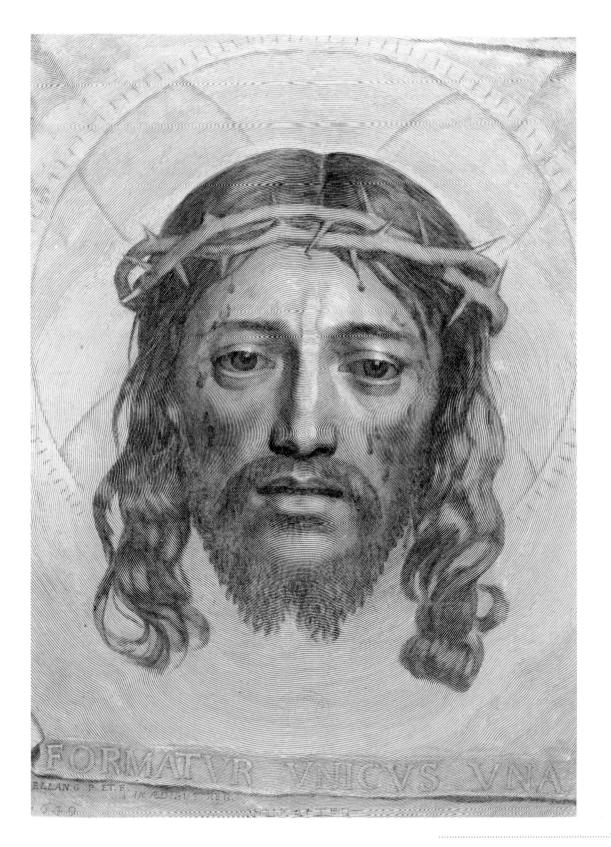

40 Diptych with the Head of Christ and the Lentulus Letter, late fifteenth or early sixteenth century

Southern Netherlandish *Oil on wood, 38.5 x 27.3 cm.* Utrecht, Museum Catharijneconvent, INV. BMR s 2

- 1 Temporibus octauiani Cesaris cum ex uniuersis mundi partibus. hii qui pro senatu populoq(ue) romano preerant proui(n)ciis, scriberent senatoribus qui rome erant. novitates que occurrebant per mu(n)di climata. publius lentulus in Iudea preses senatui populoq(ue) romano. Ep(isto)lam hanc misit cuius (?) verba hec sunt videlicet Apparuit temporibus n(ost)ris et ad huc est homo magne virtutis. Cui nomen est Cristus Jhesus. qui dicitur a gentibus propheta veritatis. quem eius discipuli vocant filiu(m) dei. suscitans mortuos. et sanans languores. homo quidem statura procerus. et spectabilis. vultum habens venerabilem. quem intuentes possunt diligere et formidare. Capillos habens [coloris] nucis auellane (?) p(re)mature. et planos fere usq(ue) ad aures. Ab aurib(us) vero crispos aliqua(n)tulum. ceruliores. et fulgentiores ad humeris uentilantes. discrimen habens in medio capitis. iuxta morem nasarenoru(m). frontem planam. et serenissima(m). In facie sine ruga et macula aliqua. qua(m) rubor moderatus venuscat. Nasi et oris multa prors(us) (com)prehensio. Barbam ip(si)us copiosam et capill(is) concolorem. non longa(m). sed in m(e)dio (?) bifurcata(m). aspectu(m) simplice(m) et maturu(m). ocul(is) glaucis et claris existe(n)tib(us). In repatio(n)e terribilis. et ammonitione placid(us) et amabil(is). ylaris servata gravitate. qui nu(m)q(uam) vis(us) e(st) ride(re). flere aute(m) sit. in statura corporis p(ro)pagat(us) et rect(us). man(us) h(abe)ns et brachia visui delectabilia. In colloquio quibus (?) rarus. et modestus. Speciosus forma p(re) filiis homi (num). Hec ep(isto)la in annalibus romanorum comperta est.
- 2 On the Lentulus Letter, see Dobschütz 1899, pp. 308–330.

THE LEFT-HAND PANEL OF this Netherlandish diptych contains the text of the letter said to have been sent by Publius Lentulus, Governor of Judaea, to Octavius Caesar. It apparently relates an eye-witness description of the appearance of Jesus Christ:

In the time of Octavius Caesar, when those men who governed the provinces on behalf of the senate and people of Rome, wrote from every part of the world to the senators in Rome with news of events happening throughout the world, Publius Lentulus, the governor in Judaea for the Roman senate and people, sent this letter, the words of which now follow:

There appeared in these times and there still is a man of great virtue, called Jesus Christ, who by the people is called a prophet; but his disciples call him the Son of God. He raises the dead and cures all manner of diseases; he is somewhat tall in stature and has a comely and reverend countenance, such as the beholders both fear and love. His hair is the colour of an unripe hazelnut, and is smooth almost down to his ears, but from thence downward, is somewhat curled, darker and shinier, waving about his shoulders; with a parting in the middle of his head in the manner of the Nazarenes. His forehead is very plain and smooth. His face without either wrinkle or spot, beautiful with a comely red; his nose and mouth so formed that nothing can be reprehended. His beard is full, of the same colour of his hair, not long, and forked in form; simple and mature in aspect; his eyes, blue-grey, clear and quick. In reproving he is severe; in counselling calm and gentle. Lightheartedness is restrained by gravity; he is never seen by anyone to laugh, but often seen by many to weep; in proportion to his body, he is well shaped and straight, and both arms and hands are very delectable. In speaking he is very temperate, modest and wise. A man, for singular beauty, far exceeding all the sons of men. This letter was found in the records of the Romans.¹

The so-called Lentulus Letter is the most famous of the literary descriptions of Christ's appearance.² It claims to have been written by an eye-witness, Publius Lentulus, the governor or pro-consul of Judaea, supposedly (although not in fact) Pilate's predecessor. The description first appears, but not under the name of Lentulus, in fourteenth-century manuscripts and the account probably dates from that or the previous century. The description therefore follows the traditional way of depicting Christ and was presumably written while looking at such an image. This makes assessing its impact on artists' representations difficult to judge. Indeed with the exception of the details relating to the colour and style of Christ's hair and eyes, the letter gives few specifics that would be of any use to someone actually constructing a portrait.

The popularity of the letter in the fifteenth century and beyond reflects a growing interest in the historical Jesus. In 1500 Pope Alexander VI sent a lavishly illuminated text of the letter to Frederick the Wise, Elector of Saxony, and there was a proliferation of

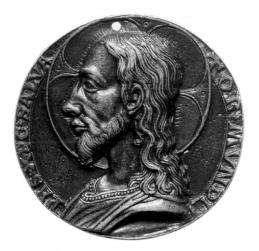

FIG 26 Portrait Medal of Christ, *Italian*, c.1490s. *Bronze*, *diameter 86 mm. Private collection*.

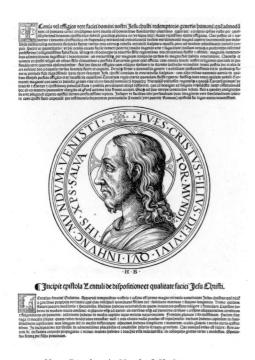

FIG 27 Hans Burgkmair, Head of Christ and the Lentulus Letter, c.1515. Engraving, diameter of the medallion 111 mm. Munich, Staatliche Graphische Sammlung.

- 3 On the Emerald Vernicle, see King 1870, pp.
 181-90; Hill 1920; Shearman 1972, pp. 50-51;
 Tudor-Craig 1998, pp. 8-10.
- 4 Royal Collection, on loan to the Victoria and Albert Museum.

manuscript and printed versions of the letter in northern Europe around this time, when this diptych was also painted. The popularity of the letter coincided with scholars' attempts to renew the faith by returning to other original sources, such as the Hebrew and Greek Bibles and the writings of the early Church Fathers.

In this diptych the text of the letter is paired with a portrait of Christ that also had claims to historical authenticity. It derives from a then celebrated 'true likeness' that had only recently become known in the West. This was the profile of Christ carved onto an emerald which had come from the Treasury of Constantinople.³ It had been among the gifts, which also included the head of the lance that had pierced Christ's side, given to Pope Innocent VIII in or around 1492 by the Sultan Bajazet II, in return for the Pope keeping the Sultan's brother, Djem, imprisoned in the Vatican. The gem, which also bore a portrait of Saint Paul, no longer survives, but its impact when it arrived in Rome was immediate. It was reproduced in a number of bronze medals dating from the end of the fifteenth-century (fig. 26). These in turn influenced artists' representations of Christ, most famously Raphael's in the tapestry cartoon of the Miraculous Draught of Fishes,4 but also possibly Ghirlandaio's in his Procession to Calvary (cat. no. 33). The image of Christ in profile remained popular throughout the sixteenth century and beyond, and is found for example on the reverse of portrait medallions of Pope Pius IV (1555-59) and Sixtus v (1585-90), as well as on a medal celebrating the canonisation of Ignatius Loyola in 1622.

The combination of letter and image is not unique to the diptych. It is found in two prints by the German engraver Hans Burgkmair, one of about 1511 and another of about 1515 (fig. 27), although in both the text differs slightly from the present example – indeed in the earlier of the two prints, the letter, which is given in both Latin and German, is attributed to Pilate rather than Lentulus. The popularity of both image and letter at the beginning of the sixteenth century make their combination unsurprising, but did create problems for the artist. The Lentulus description, with its forked beard and centre parting is clearly better suited to a full-face representation. Here the insistent parting (absent from the medallion images) shows the artist responding to the description in the letter. This makes it even more surprising that Christ's eyes, described as blue-grey in the letter, are clearly brown in the painting. *AS*

96 The True Likeness

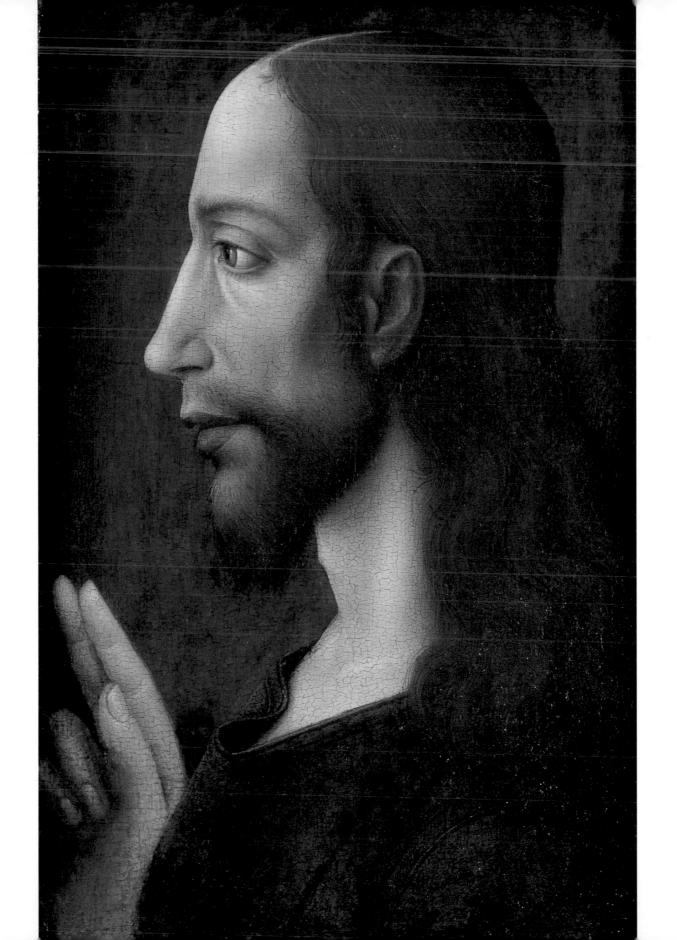

41 Icon of the Mandylion of Edessa, eighteenth century

Perhaps made in Italy

Egg tempera with resin glazes on wood, 40 x 32 cm.

In the cross of Christ's Halo: $0 \otimes N$ (I am) Beneath Christ's Face: TON AFION MAN Δ H Λ IO (sic) (The Holy Mandylion) For translations of the inscriptions beside each scene, see illustration captions. Hampton Court, The Royal Collection Trust, INV. HC 1567 403934

In its earliest version, found in Eusebius's Church History (c.325), Abgar receives a letter but no image from Christ. An image – a portrait from the life rather than a miraculous one – is first mentioned in the document known as the Doctrine of Addai, which probably dates from about AD 400. But it is in the sixth century, in the aftermath of the image's miraculous intervention in the war against the Persians, that the portrait of Christ is first described as 'divinely wrought ... which the hands of men did not form'. Evagrius (c.536–600) Church History, 4. 27.

2 Wilson 1978, p. 238.

- 3 Ibid., p. 239.
- 4 Ibid., p. 242.
- 5 Ibid., p. 244.

F ROM THE SIXTH TO THE EARLY thirteenth century the most famous miraculous image of Christ 'not made by human hands' was not Veronica's *sudarium* but the Mandylion of Edessa, which from AD 944 until 1203 was housed in the Imperial Treasury of Constantinople. This eighteenth-century icon from the Royal Collection not only reproduces the Mandylion image itself, but it illustrates episodes from the Mandylion legend.

All ten scenes around its border are accompanied by a Greek inscription, and have as their source the Story of the Image of Edessa written shortly after the image was transferred to Constantinople from Edessa (modern Urfa in Turkey, near the Syrian border) in 944, although elements of the legend can be traced back as far as the fourth century.¹ The legend, as recounted in the tenth century, tells of Abgar, King of Edessa during the time of Christ, who was afflicted with arthritis and leprosy. On hearing of Christ's reputation as a healer, he sent him a letter inviting him to come to Edessa. Abgar sent the letter with his servant Ananias and told him 'that if he was not able to persuade Jesus to return to him by means of the letter, he was to bring back to him a portrait accurately drawn of Jesus's appearance'.² On arrival in Judaea, Ananias tried to draw Jesus, but Jesus called him over and gave him a letter declining Abgar's invitation but promising that the King would be cured. 'The saviour then washed his face in water, wiped off the moisture that was left on the towel that was given to him, and in some divine and inexpressible manner had his own likeness impressed on it'.3 Ananias returned with both image and letter to Abgar who was cured and converted. To demonstrate his devotion to the portrait, Abgar then destroyed 'a statue of one of the notable Greek Gods' that had stood at the main gate of the city replacing it with the miraculous image'.⁴ This part of the legend is depicted in the first six scenes around the icon.

The following three scenes relate to the re-discovery of the image in the sixth century. According to the legend, Abgar's descendants returned to paganism, and the sacred image on the city gate was hidden behind a tile and bricked in. It remained hidden and forgotten until the city was besieged by the Persians who tunnelled under the city walls. In a vision Eulalius, Bishop of Edessa, was told where the image was concealed. He found it intact with a lamp still burning in front of it and 'on the piece of tile which had been placed in front of the lamp to protect it he found that there had been engraved another likeness of the image'.⁵ The Bishop then took the still-burning lamp and dripped oil from it into the Persians' tunnel, killing them all and saving the city.

The final scene on the icon – at the bottom right hand corner – relates to a miracle during the journey of the miraculous image from Edessa to Constantinople in 944. By this time Edessa was under the control of the Muslim Empire and the Christian Emperor in Constantinople secured the Mandylion in return for the release of 200 Muslim prisoners and 12,000 pieces of silver.

Although the subject of this painting is easily recounted, it is far less certain when, where, or why it was produced. It has been attributed to the seventeenth-century Cretan

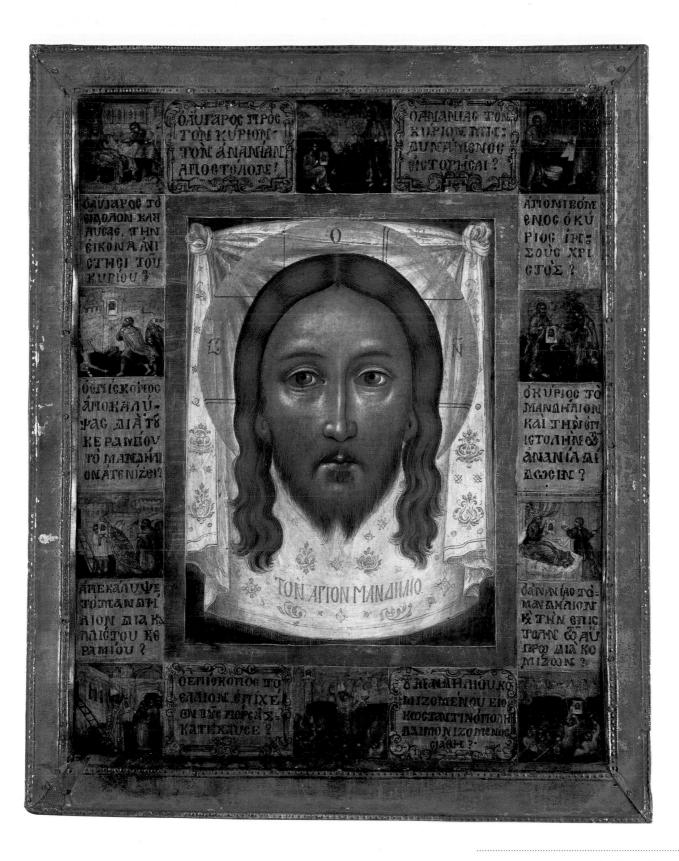

FIG 28 In Eastern Orthodox countries the Mandylion image was used as a military banner as late as the twentieth century, as documented in this photograph of Bulgarian soldiers in the First World War. (London, The Imperial War Museum)

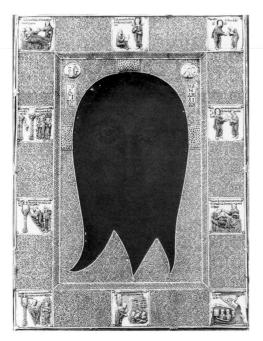

FIG 29 The Holy Face (The Mandylion), canvas fixed to panel with silver casing. c. 40 x 29 cm. S. Bartolomeo degli Armeni, Genoa.

painter, Emmanuel Tzanes, who worked in Venice,⁶ but this is no longer accepted and the icon probably dates from the following century.⁷ It seems to be a free copy of the Mandylion image that is preserved at the Barnabite Monastery attached to the Church of S. Bartolomeo degli Armeni in Genoa (fig. 29). The Byzantine Emperor John v presented this strikingly archaic image to Leonardo Montaldo, the Captain of the Genoese colony on the Bosphorus, who in turn left it to the Monastery in 1384.8 The Genoese picture is one of three Mandylion images that were claimed as original during the Middle Ages. Another, in the Sainte-Chapelle in Paris, was lost during the French Revolution, while the third, identical in size and very similar in appearance to the Genoa image, is now preserved at the Vatican, having belonged to the nuns of the order of Saint Clare in the Convent of S. Silvestro in Capite until 1870. Unlike the Vatican version, and indeed unlike other versions and copies of the Mandylion icon, the Genoese example has ten small scenes running around the silver gilt frame of the panel. These are identical in subject and arrangement to those on the Royal Collection icon and the inscriptions differ only very slightly.⁹ This makes it highly likely that this icon was copied from the one in Genoa, or from a copy of that one. The icon was therefore probably painted in Italy, although the use of egg tempera as a medium, which was still employed by Byzantine icon-painters at this date, suggests a Greek artist. There is, however, a curious error in the Greek inscription beneath the face of Christ, which reads: TON ATION MANAHAIO rather than the correct TO AFION MANAHAION (The Holy Mandylion). AS

SCENE 1 Abgar sends Ananias to Jesus.

Scene 2 Ananias is unable to draw

SCENE 3 Jesus wipes his face.

SCENE 7 Having revealed the Mandylion behind the tile the Bishop looks upon it.

SCENE 4 Jesus gives the Mandylion and the letter to Ananias.

SCENE 8 *He reveals the Mandylion on the most beautiful tile.*

SCENE 5 Ananias takes the Mandylion and letter to Abgar.

SCENE 9 The bishop burns the

Persians by pouring the oil.

SCENE 6 After Abgar has put down the idol he sets up the icon of Jesus.

SCENE 10 As the Mandylion is carried to Constantinople a possessed

Scenes depicting the legend of the Mandylion. The captions are translations of the Greek inscriptions.

- 6 Cust/Dobschütz 1904.
- 7 Drandakis 1974.
- 8 Dufour Bozzo 1974 and in Kessler 1998.
- 9 Other narrative cycles relating to the Mandylion image found in manuscripts make a different selection of scenes. For example, Paris, B.N., Cod. gr. 1528, folios 181v and 182r; Moscow Historical Museum, Cod. 382, folio 192v; New York, Pierpont Morgan Library, Cod. 499. All these are discussed in Weitzmann 1971, pp. 231–46.

42 The Ostentation of the Holy Shroud of Turin, 1689–90

Pietro Antonio Boglietto, active late seventeenth century *Engraving on silk, 28 x 20 cm.* Sherborne Castle, Dorset, Mr John Wingfield Digby

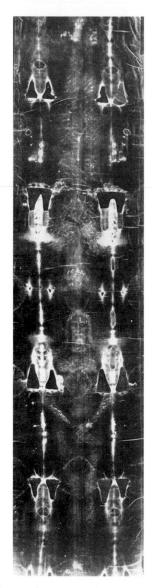

FIG 30 Photographic negative of the Turin Shroud, photographed by Giuseppe Enrie in 1931.

THE PRINT RECORDS ONE OF THE periodic Ostentations, or public displays, of the Turin Shroud. Five bishops hold up the fourteen-foot cloth for veneration. The inscription below states that it is 'The True Portrait of the Most Holy Sudarium', the name sometimes used to describe the cloth in which Christ was laid in the tomb.

The Shroud was the most treasured relic of the House of Savoy, rulers of Piedmont in northern Italy and subsequently of a united Italy, who gained possession of it in the 1450s. The print is dedicated to three daughters of Duke Victor Amadeus II of Savoy (ruled 1675–1730) and Anne of Orléans, whose arms are shown to the left and right, respectively. The Duke and Duchess flank the bishop in the centre of the composition. The print is datable to the brief period between the birth of Maria Ludovica, the Duke's youngest daughter, in September 1688, and the death of his second daughter, Maria Anna, in August 1690. It is replete with Savoy emblems: the canopy is decorated with the cross of Saints Maurice and Lazarus and with the Savoy knot, while the flying flags are the Savoy standard of white cross on a red ground. The Shroud itself is presented as the most distinguished of the emblems associated with the Savoy family.

The image on the Turin Shroud (figs. 23 and 30) shows a man who has suffered all the torments described in the Gospels: the scourging; the crowning with thorns; the nailing to the cross and the lancing of the side.¹ Many believe that this is the cloth in which Christ himself was buried and that the image it bears is a miraculous imprint of his dead body. Some marks are visible to the naked eye, but the first photographs of the Shroud taken at the end of the nineteenth century proved revelatory: they showed a vast amount of additional detail and provided the haunting image of the suffering face which has today become the most reproduced likeness of Christ. In addition to being an object of veneration, the Shroud is now a scientific phenomenon. All manner of specialists, from professors of anatomy to experts on pigment and pollen, from nuclear scientists to computer specialists using the latest digital imaging technology, have sought to understand how the impressions were made. Various theories have been proposed, including the transference of a particular combination of chemicals from the body to the cloth; some kind of scorching process; and the effects of a thermo-nuclear flash at the moment of Resurrection. Although recent Carbon-14 tests have apparently indicated that the Shroud is medieval and not from the first century - results which have themselves been challenged – the Shroud refuses to yield many of its secrets.

The early history of the Shroud is unknown, although some considered it identical to the Mandylion of Edessa (cat. no. 41) which disappeared from Constantinople in 1204. The Shroud first appears in Lirey in France in the 1350s, when the first Ostentations are recorded. Pilgrims flocked to see it, but local bishops expressed misgivings from the start and tried to ban the displays. After various vicissitudes, including several changes of ownership, removal to different places in France and northern Italy, and damage by fire (the repair patches are apparent both in the photographs and in the print), the Shroud was brought to Turin in 1578. In 1694 it was placed in a special shrine in the spectacular

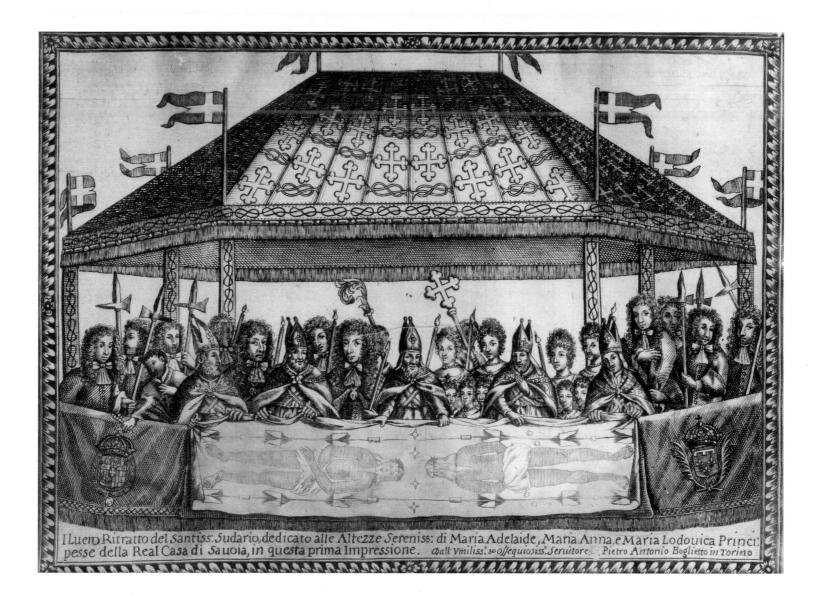

Royal Chapel of the Cathedral of Turin designed by the architect Guarino Guarini.² In 1670, the Congregation of Indulgences granted an Indulgence 'not for venerating the cloth as the true Shroud of Christ, but rather for meditating on the Passion, especially his death and burial'.³ Ecclesiastical authorities up to the present day have remained non-committal about the authenticity of the Shroud. *GF*

- 1 On the history and interpretation of the Turin Shroud, see Wilson 1978, and Moretto 1999.
- 2 The Chapel was severely damaged by fire in 1998, although the Shroud itself was rescued unharmed from the flames.
- 3 Quoted in Wilson 1978, p. 227.

4 PASSION AND COMPASSION

MAGERY BASED ON THE Passion of Christ became increasingly common from the thirteenth century. The ground was prepared by the immensely influential writings of the Cistercian monk Saint Bernard of Clairvaux (1090–1153) and by the religious renewal brought about by the Franciscans. Both Saint Bernard and Saint Francis of Assisi (1182–1226) placed a special emphasis on the humanity of Christ and encouraged an 'affective' spirituality which concentrated on the Passion. Human compassion, the natural sense of sympathy and pity for the suffering of others, could be harnessed to inspire and deepen faith in Christ and to strengthen devotion to him. The image of Christ on the cross was no longer solely the sign of God's love and his sacrifice for humanity; it became the focus for humanity's own compassion for the suffering Saviour.

This change in religious sensibility can be clearly seen by comparing the imagery of the fifth-century ivory reliefs in the British Museum, and the thirteenth-century Umbrian diptych in the National Gallery (cat. nos. 43 and 44). In the former, the Passion is conceived principally as the prelude to the Resurrection. The events shown are interpreted in the light of the final triumph and confirm Christ's divine status. No sign of vulnerability or human weakness is apparent in any of the scenes and even on the cross Christ is victorious. This is in marked contrast to the imagery of the diptych which shows Christ both as the tender infant of the Virgin and the 'Man of Sorrows', the signs of whose mental and physical anguish are clearly imprinted on his face and on his dead body. Confronted with such desolation even the angels have shielded their eyes. On the one hand the image denounces the viewer as the perpetrator of crimes against divinity, on the other, Christ's pathetic state appeals directly to our sense of pity and compassion. The mix of emotions which well up in the devout upon looking at such an image, a blend of guilt and gratitude, sorrow and sympathy, is a very powerful combination. The two works - the early ivory casket panels and the medieval diptych for private devotion - encompass the two extremes of the human manifestation of Christ's kenosis, his descent from victorious God-Man to abandoned wretch.

In his widely known *Life of Christ*, dating from the mid-fourteenth century, the Carthusian monk, Ludolph of Saxony (died 1378), expressed the attraction – without seeking to explain it – that the more human Christ held:

I know not for sure ... how it is that you are sweeter in the heart of one who loves you in the form of flesh than as the word ... It is sweeter to view you as dying before the Jews on the tree, than as holding sway over the angels in Heaven, to see you as a man bearing every aspect of human nature to the end, than as God manifesting divine nature, to see you as the dying Redeemer than as the invisible Creator.¹

1 Quoted from Duffy 1992, p. 237.

51 The Deposition, about 1325

Ugolino di Nerio (active 1317; died 1339/49?) *Tempera on panel, 34.5 x 53 cm.* London, National Gallery, NG 3375 The FRANCISCAN FRIARS OF Santa Croce in Florence who got a close-up view of this panel of the main altarpiece of their church as they celebrated Mass, would have been able to inspect minutely the faces and gestures of each figure in turn and would perhaps have tried to empathise with the diverse emotions depicted, so as to feel closer to Christ and to the anguished Virgin. Events from the Passion narrative, like the Deposition, which are described only cursorily in the Gospels, were rounded out with imaginative details by medieval writers and artists for the benefit of the devout. Thus, Ugolino di Nerio in this work makes much of the tenderness with which Joseph of Arimathea lowers Christ's body from the cross and Nicodemus removes the nail from Christ's feet, and even more of the deep grief experienced by the other mourners. Mary Magdalene pours tears over Christ's hand, John weeps profusely as he holds Christ's body, and the grief-stricken Virgin embraces Christ and presses her face tight against his, emphasising the intimate bond between mother and son, between the Virgin's 'compassion' and Christ's 'Passion'.

Indeed, one of the most striking features of the composition is the way Christ's dead body seems to actually embrace his mother as he comes down from the cross, a motif that reflects the metaphor that the crucified Christ embraces the believer. Saint Bernard of Clairvaux described a vision in which the crucified Christ had lifted his arms from the cross beam and drawn him into his embrace.¹ In the *Meditations on the Life of Christ*, particularly relevant in the Franciscan context of Santa Croce, there is a detailed passage on the Deposition of Christ, in which the gesture of embracing is emphasised. The Virgin is described as embracing Christ's hand against her face. And having described how Joseph of Arimathea removed the metal nails from Christ's body, the author tells of how he gently helped to support Christ's body, and comments: 'Happy indeed is this Joseph, who deserves thus to embrace the body of the Lord!'²

This panel formed part of the lower horizontal section, or predella, of the altarpiece, which depicted the Easter story in seven scenes, from the Last Supper to the Resurrection. The Crucifixion itself does not appear in the predella but was placed in a prominent position above the main central image of the Virgin and Child. Ugolino probably derived ideas for his Passion sequence from his teacher, Duccio, who had painted scenes from Christ's Passion on the back of the double-sided *Maestà* altarpiece of Siena Cathedral (1308–11). While Ugolino's work shows the same interest in Byzantine painting and in combining a linear approach with ornamental and decorative elements, it is nonetheless distinguishable from Duccio's on account of the heightened, even harrowing emotion that his figures show. *SA-Q*

 Vita prima; the passage is quoted in Belting 1990, p. 241, note 21. The famous twelfth-century hymn of lamentation, the *Planctus ante nescia*, which was often sung in Passion plays, has the line: 'Rush to the embrace! While he hangs on the tree of the cross, he offers himself with outstretched arms to the loving for a mutual embrace' (ibid. p. 75); for a full discussion of the subject of the Deposition in the context of liturgy and theatre ibid. pp. 143–66.
 Meditations, pp. 341–2.

126 PASSION AND COMPASSION

52 Lamentation over the Dead Christ, 1455-1460

Donatello (1386/87-1466) Bronze relief, 33.5 x 41.5 cm. London, Victoria and Albert Museum, INV. 8552-1863 **D**^{ONATELLO EMPLOYS ALL HIS POWERS as a sculptor to convey the varied and deeply felt emotions experienced by Christ's mother and followers at his death. The scene is not described in the Gospels, which record simply that Christ's body was removed from the cross, prepared for burial, and laid in a new tomb. Yet by the mid-fifteenth century, the Virgin's lament over the dead Christ had become an established subject both for artists and writers of devotional literature. It gave the Virgin greater prominence in the Passion story and provided in her the ideal model of compassion for Christ. In this scene the Virgin also became the 'Addolorata', the epitome of every grieving mother.}

The lamentation of the Virgin became an important part of church liturgy and private devotion. The Virgin's grief was articulated in the form of hymns by Byzantine writers such as Ephraim of Syria (*c*.306–373). By the early thirteenth century these had been incorporated into both the Eastern and Western Church's liturgy for Good Friday. Commonly, the Virgin invokes the hearer to take pity on her by evoking Christ's childhood, accentuating the contrast between the past and present, birth and death, and happiness and sorrow. In the early fifteenth century Saint Bernardino of Siena (1380–1444) imagined that the Virgin, while holding the dead Christ 'believed that the days of Bethlehem had returned; ... that he was sleeping, and she cradled him to her breast. She imagined the winding sheet in which he was wrapped to be his swaddling clothes'.¹

Western artists were quick to convert such texts into images. Using the popular icontype of Christ being laid in a tomb (the '*Threnos*') as their basis, they raised the emotional pitch by showing the Virgin actually cradling her son, and including mourners whose reaction to the corpse was histrionic. Donatello took up the challenge of exploring the emotions of the lament in all its possible ramifications, and gathered inspiration from a wide variety of sources to do so. His figures of the women who cry, gesticulate, cover their faces or tear wildly at their dishevelled hair, for instance, recall those from Roman and Etruscan tombs, in particular the sarcophagi which show women lamenting the death of the ancient hunter Meleager. By contrast, the figure of Saint John, who turns his back to Christ as though suffering from intense exhaustion, is based on early Florentine paintings such as Giotto's *Lamentation* in the Arena Chapel, Padua. In the midst of general hysteria, Donatello shows the Virgin, who is slumped on the ground to nurse her dead son, as though she has retreated into a private world of extreme grief.

By modelling with great vigour and spontaneity the wax from which this relief was cast – and by leaving it unfinished so that original tool-gouges are still visible in the bronze – Donatello is able to effectively suggest movement and drama and, more importantly, something of his personal empathy with the suffering depicted. To his contemporaries, used to a sweeter style of religious art, his raw and uncompromising depictions of religious subjects may have been an affront to their sensibilities, if not their beliefs. Yet it is precisely because Donatello's art has such emotional power that it can speak so directly to the modern viewer. *SA-Q*

1 Quoted in Mâle 1986, 111, pp. 119-20.

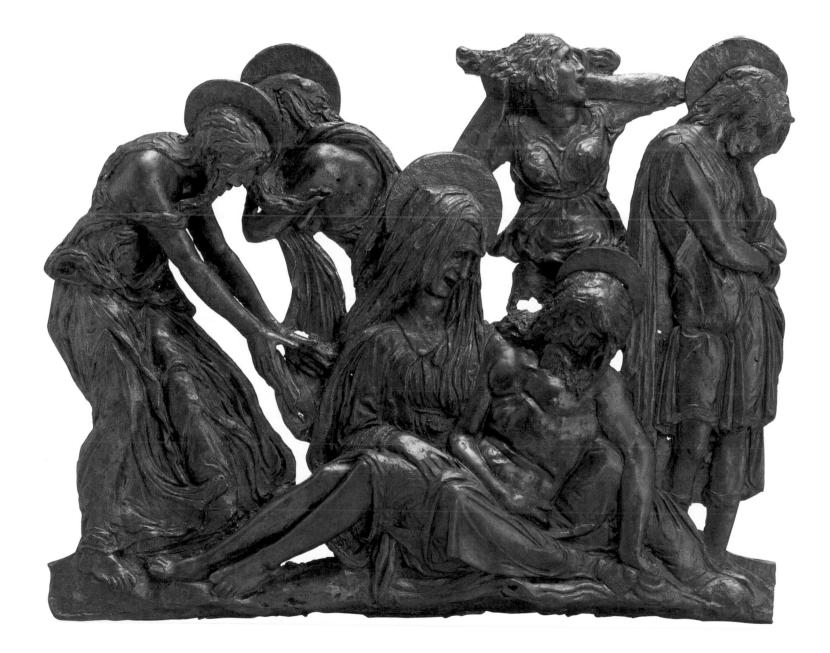

53 The Entombment, probably 1450s

Dirk Bouts (1400?–1474) Glue tempera on linen, painted surface approximately 87.5 x 73.6 cm. London, National Gallery, NG 664 I (cat. no. 52), where extreme emotions are expressed through violent gestures, the Haarlem painter Dirk Bouts has chosen a more restrained type of pathos. The solemn figures surrounding the dead body of Christ mostly keep their emotions in check. The interpretation of the subject is contemplative, inviting compassionate reflection rather than seeking to inspire strong empathetic feelings in the viewer.

After Christ's death, Joseph of Arimathea went secretly to Pontius Pilate to request Jesus's body for burial. Once he had obtained Pilate's authorisation, he and Nicodemus, a Pharisee who was a secret disciple of Jesus, took the body and 'wrapped it in a clean linen cloth, and laid it in his own [Joseph's] new tomb, which he had hewn out in the rock' (MATTHEW 27: 59-60). Saint John, in his Gospel, adds that Nicodemus had brought a 'mixture of myrrh and aloes, about an hundred pound weight' (JOHN 19: 39) to anoint Christ's body, as was customary in the Jewish burial rites.

Christ's body, wrapped in a white shroud, is being gently lowered into a stone tomb which extends across almost the entire width of the painting. It is handled with extraordinary care and respect: only the Virgin touches Christ directly, all the other figures hold him through the shroud. Various medieval mystical texts describe the Virgin's physical attachment to her son as he was being buried. In the *Meditations* she is made to say: 'Willingly would I be buried with you, to be with you wherever you are. But if I cannot bury my body, I would be buried in mind. I shall bury my soul in the tomb with your body'.¹ Details such as the blood trickling from Christ's wounds and his crossed legs, shown in the position they were in when he was nailed to the cross, emphasise the fact of Christ's physical death. The Virgin is supported by Saint John and flanked by Mary Cleophas and Mary Salome. The bearded man at the left is presumably Nicodemus; Joseph of Arimathea supports Christ's feet. In the foreground is Mary Magdalene.

To intensify the atmosphere, Bouts has positioned the figures tightly around the tomb. Each of them seems to meditate on the event. Their expressions are subtly different, as though the artist's intention were to convey a variety of griefs and senses of loss. Of the women on the far side of the tomb, one wipes tears from her eyes and the other covers her mouth; the eyes of all three are downcast. The men, on the other hand, and the Magdalen, look directly at Christ's body. The beautiful landscape, the 'garden' Saint John describes as the site of Christ's burial, offers a serene setting for the sad event.

Bouts's *Entombment* is painted using the delicate medium of glue tempera on fine linen. Very few pictures of this kind survive from the fifteenth century. In the nineteenth century it was in an Italian collection, together with three companion pieces, also on linen, showing the *Annunciation*, the *Adoration of the Kings* and the *Resurrection* (now respectively in the J. Paul Getty Museum, Los Angeles, a private collection, and the Norton Simon Museum, Pasadena). They may have formed part of an altarpiece with a Crucifixion at the centre, possibly the painting now in the Musées des Beaux-Arts, Brussels, also by Bouts, which is identical in style and technique. *XB*

1 Meditations 1961, p. 344.

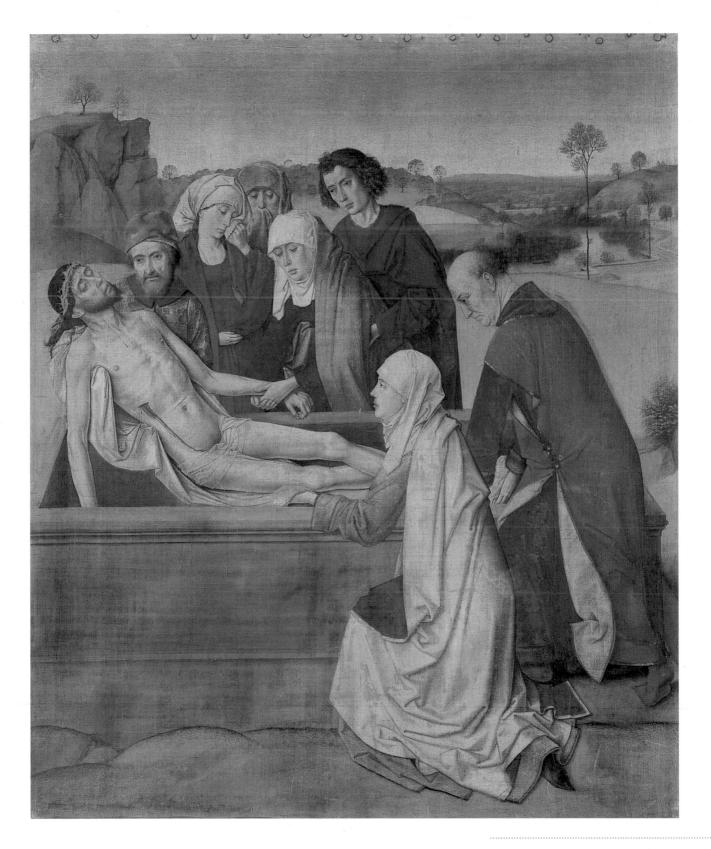

5 Praying the Passion

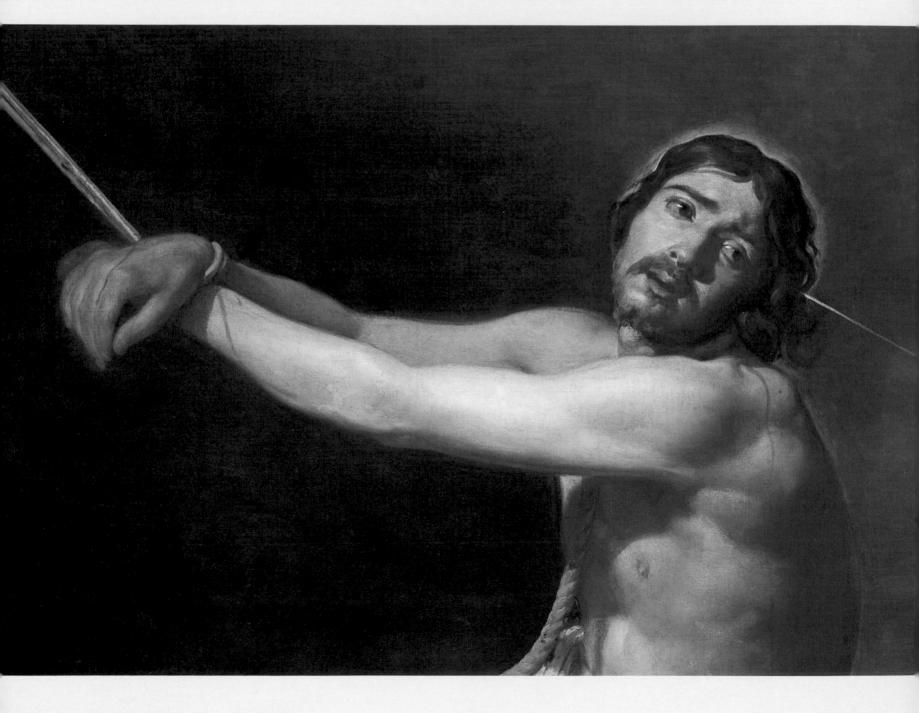

PASSION IMAGE, whether an altarpiece in a church or a picture or print in the home, could serve as the focus for prayer. A depiction of the suffering Christ served as a reminder of the sacrifice he had made for the sake of humanity, and the feelings of gratitude, pity or pious remorse it inspired in the devout were intended to deepen their love of God. Most Christian traditions have placed great importance on the role that the image – narrative, icon or symbol – plays in the process of meditation and contemplation, since looking upon a representation of Christ is meant ultimately to lead to the imitation of Christ.

In the late nineteenth century Velázquez's painting of *Christ after the Flagellation contemplated by the Christian Soul* (cat. no. 54) was known as 'The Institution of Prayer', a title with a peculiarly Victorian ring to it, but one that nevertheless effectively explains the action of the picture. A child, the personification of a soul, is being instructed by an angel to focus its prayerful attention on the suffering Christ. The child-soul joins its hands together and looks towards Christ with both pity and longing and is rewarded with Christ's gaze, directly at his heart. The painting might be said to offer a clear exposition of the dynamic of prayer: the soul contemplates the suffering Christ with devotional fervour, and Christ in turn invests it with his sanctifying grace. But the painting is also designed to assist us, the viewer, to contemplate the Saviour in his Passion, and the angel's gestures are obviously directed at us too.

Perhaps the Passion image in front of which most prayers were said in the Middle Ages was the '*Imago Pietatis*', or 'Image of Pity' (see cat. nos. 44, 59–60). It shows Christ taken down from the cross, sitting or standing in the tomb, his arms crossed in front of him and his head inclined to one side. He is placed frontally for our contemplation and the wounds in his hands and side are prominently displayed. Sometimes his eyes are open but more often they are shut, implying that he is dead. The image was apparently based on a vision which the sixth-century Pope Gregory the Great experienced while celebrating Mass, so its status was almost that of a 'true likeness'. It also eloquently identified the body of Christ with the Eucharist, but the most significant reason for its popularity was that it was an Indulgenced image (see p. 76). The inscription beneath an English print dating from about 1500 (cat. no. 60), states that those who 'before this Image of Pity devoutly say five Pater Nosters, five Ave Marias and a Credo ... are granted 32,755 years of pardon'.

But there were other ways that images of the Passion could be used in prayer. It is interesting to note that the narrative pace of the Gospels slows down markedly at the Passion, and they give a careful and detailed account of the events leading up to Christ's Crucifixion and burial. There is an assorted cast of characters – Judas, Pilate, the High Priest, Peter, the Soldiers, Simon of Cyrene, the Virgin Mary and Holy Women, the two thieves and Joseph of Arimathea – and the settings are varied; we move from the Garden

FIG 33 Anton Wierix, Rosario Doloroso, 1590s. Engraving, 143 x 92mm. London, British Museum. The print is the second in a series of three engravings showing the Joyful, Sorrowful and Glorious Mysteries of the rosary. Here the five Sorrowful Mysteries are shown on rose blooms joined by rosary beads and attached to a thorn bush. They are the Agony in the Garden, the Scourging, the Crowning with Thorns, the Carrying of the Cross and the Crucifixion. At the centre is the Pietà. of Gethsemane at night, to the High Priest's House, then to the *Praetorium* in the morning and through the streets of Jerusalem to Calvary, outside the city walls. The subject matter is ideally suited to serial representation and consequently to the sequential mode of meditation. The practice of meditating on the events of the Passion one after the other was rooted both in the liturgical calendar – with its succession of related feasts – and also in the tradition of pilgrimage to the Holy Places.

When Christians visited the Holy Land they would follow Christ's itinerary from Maundy Thursday to Holy Saturday, visiting the Holy sites, walking the *Via Crucis* (Way of the Cross) and praying at the Church of the Holy Sepulchre, built on the place where Christ was buried. Those who could not make the journey could nonetheless share the pilgrimage experience and live through Christ's final hours empathetically in the Stations of the Cross, a medieval devotion which comprises fourteen images representing the different events of the Passion, from the sentencing of Christ to his burial, before which prayers and petitions are made. Likewise, the rosary (cat. no. 55) offered the opportunity to live through Christ's Passion in the Five Sorrowful Mysteries often represented in prayer books and prints, during which sequences of prayers were recited while meditating upon the episodes from the Agony in the Garden to the Crucifixion (fig. 33). The eye could thus be led by the pictorial representation of the Mysteries while the mind focused on the prayers of the rosary.

Artists also devised their own series of Passion images for sequential meditation. Albrecht Dürer (1471–1528) made three different printed Passion series, one of which, the 'Small Passion',

comprises as many as thirty-seven scenes (cat. no. 56). It was issued in book form with devotional poems in Latin attached so that users could both look upon the images and pray the words. The small Passion polyptych illustrated here, dating from the midsixteenth century (cat. no. 57), has four doors which open in sequence so that the whole Passion story is told in ten exquisitely painted scenes. The very act of opening and closing these doors becomes part of the process of prayer, enabling the devout viewer to delve ever deeper and with increasing sympathy into the suffering and humiliation of Christ. The two central scenes, both of which are reached at the end of the revelatory sequence of door-opening, are ostentation images in which Christ is presented to the viewer, first as the Man of Sorrows in the *Ecce Homo* scene, and then in the *Pietà* as the dead Saviour borne in the arms of his weeping mother.

For the purposes of private devotion, Passion imagery did not need to form explicit narrative. It often took on a very abstract character. Artists created a range of hieroglyphs or symbols which brought to mind the different parts of the Passion. These function in a different way from the visualised metaphors of the Good Shepherd and the lamb, or the chi-rho monogram and the Sacred trigram (pp. 9-11); they are mnemonics, visual clues that serve to remind the viewer of the torments that Christ underwent. When the Instruments of the Passion – the spear, the cross, the reed and sponge, and the crown of thorns - are abstracted from the narrative context they become aides-memoires acting as cues for mediation. No longer the tools of ignominy or dishonour, the Instruments of the Passion become the Arma Christi (Arms of Christ), the emblems of Salvation. Medieval artists outdid each other in expanding the repertory of hieroglyphs: Veronica's sudarium is one, the thirty pieces of silver another, and so too is the cock that made Peter realise that he had betrayed the Lord.

These abstracted emblems were readily comprehensible to the non-literate and the very lack of explicit narrative context could foster the practice of affective forms of devotion. Some of the objects of the *Arma Christi* had survived as relics – the *sudarium* and Longinus' spear for example – and these inspired their own prayers, like the *Salve sancta facies* (Hail, Holy Face, see cat. no. 37). The emblematic character of the Instruments meant that they could be arranged to make up the coat of arms of Christ and became a sort of heraldic blazon of Redemption (fig. 34).

The five wounds of Christ also formed part of this divine heraldry (cat. no. 62). The devotion to the wounds in the hands, feet and side was very widespread in late medieval Europe and gave rise to some fascinating imagery. The wounds became neat lozenges, floating away from Christ's body to rearrange themselves into abstract patterns in paintings, church furniture and jewellery (cat. no. 63). The cult of the wounds, like the devotion to the Image of Pity, was connected with universal concerns about judgement and eternal life. When a special Mass of the Wounds was instituted in the fourteenth century, it was often said for the dead. The wound in the side was always accorded special prominence because it was considered the door to Christ's heart (cat. nos. 64 and 65). After the Reformation the cults of the *Arma Christi* and the Wounds of Christ largely receded, together with the imagery associated with them. The devotion to the wound in the side, however, was transformed into the devotion to the Sacred Heart of Jesus, which also gave rise to a new, if less visually interesting, iconography. *GF*

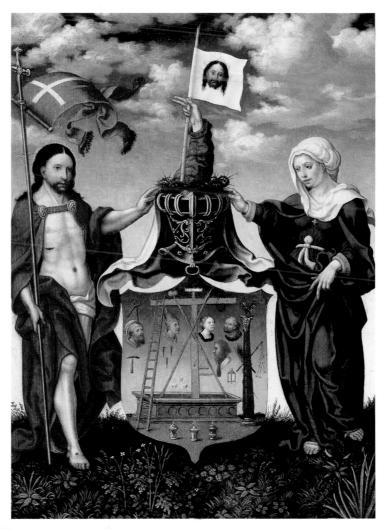

FIG 34 Circle of Bernard van Orley, Christ the Redeemer and the Virgin with the Arma Christi, c.1520s. Oil on canvas, 53 x 38 cm. Madrid, private collection.

54 Christ after the Flagellation contemplated by the Christian Soul, late 1620s or early 1630s

Diego Velázquez 1599–1660 *Oil on canvas, 165 x 206 cm.* London, National Gallery, NG 1148 THE ROPE THAT BINDS Christ to the column on the left of the composition is pulled taut by the weight of his body. The grim instruments of torture, the bloodstained whip and the birch, are neatly arranged on the floor in front of him, close to the viewer. Bits of birch have broken off and lie scattered around, indicating the ferocity of the Flagellation. But this is not a straightforward narrative picture. Christ's tormentors are not present; instead, to the right, is an angel who looks down tenderly at a kneeling child, the personification of a soul. The angel gestures with his right hand, directing the meditations of both the child-soul in the picture and the viewer of the picture towards contemplation of the suffering Christ.

Although the Gospels do not dwell on Christ's scourging, the episode proved a fertile one for the writers of commentaries and meditative texts, as well as for artists. Velázquez's particular treatment was not unprecedented and it appears to be modelled on a painting which the Sevillian priest-painter Juan de Roelas (1558–1625) made in 1616 for King Philip III of Spain.¹ That work originally bore an inscription: 'O Soul, have pity on me, for you have reduced me to this state',² a phrase which provides the key for interpreting Velázquez's painting.

Velázquez's rendering of the anatomy of Christ, with its fine modelling and elegant contours, suggests that he was seeking to show the contrast between the beauty of Christ and the ugliness of the punishment to which he was subjected. The sight of his broken body is meant to induce our compassion, but also sorrow for the sins which have visited this humiliation upon him. Christ's plaintive look seems to echo the Good Friday 'Reproaches', a hymn used in the Roman Good Friday liturgy, which articulates Christ's disbelief at the ingratitude of his people: 'My people, how have I offended you? Answer me. I bore you up with manna in the desert, but you struck me down and scourged me'.

When the picture was first exhibited at the National Gallery in 1883, various titles were proposed for a British audience quite unfamiliar with such imagery. The most pertinent of these was 'The Institution of Prayer' (see p. 133). At one stage the child was thought to be the medieval mystic, Saint Bridget of Sweden, and so the picture was called 'A Vision of Saint Bridget'. It was no doubt the combination of realism and pathos in the work that led at least one visitor to the National Gallery in 1884 to be profoundly moved before it, though for entirely the wrong reasons: Lord Napier remarked in a letter to the donor of the picture, John Savile Lumley, that 'an old woman of the better lower class' had felt deep emotion at the thought that it showed a child being taken to visit his suffering father in prison.³

Nothing is known of the circumstances in which Velázquez produced this picture. It is likely to have been painted for the private contemplation of a powerful and devout individual at the Spanish court where Velázquez worked, someone like the King's Dominican Confessor, Fray Antonio de Sotomayor, who appears in the early 1630s to have commissioned another of Velázquez's rare religious paintings, *The Temptation of Saint Thomas Aquinas.*⁴ *GF and XB*.

1 Madrid, Convento de la Encarnación.

2 'Alma duelete de mi, que tu me pusiste así', Valdivieso/Serrera 1985, p. 158.

- 3 Glendinning 1989, p. 126.
- 4 Orihuela, Museo Diocesano.

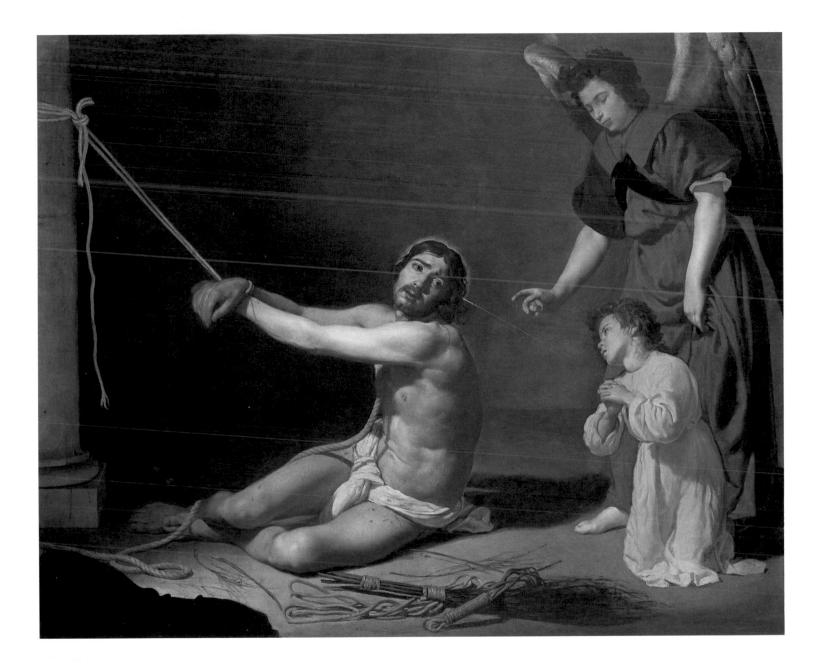

55 Prayer-nut with the Man of Sorrows, about 1500

Southern Netherlandislı Boxwood, diameter: 44 mm. London, Victoria and Albert Museum, INV. 265–1874

FIG 35 Sculptor from the Lower Rhine, Saint Mary Magdalene, c.1530. Oak, height 82 cm. Utrecht, Catharijneconvent. The Saint is dressed in contemporary early sixteenthcentury costume with a rosary hanging from her belt to which is attached a prayer-nut.

P BAYER-NUTS, or large single rosary beads, were commonly used for private devotion by members of the wealthy classes in the Netherlands prior to the Reformation. They were normally attached to a string of rosary beads, as may be seen in the sculpture from the Lower Rhine showing Saint Mary Magdalene (fig. 35). As well as being beautiful and precious objects, they could function as a focus for prayer and meditation, and in some cases they would have been scented with fragrant pastes or oils in order to heighten the sensory aspects of the religious experience.

Prayer-nuts were invariably made of boxwood, which is particularly suitable for intricate small-scale carving.¹ They were usually decorated on the outside with complex Gothic patterns and the two halves of the orb, joined by a hinge, opened like a prayer book to reveal scenes from the New Testament or from the lives of the saints. Through contemplation of the object the worshipper was drawn into a sort of religious microcosm, in which the minute scale and precision of the carving helped to concentrate the mind. The upper half of this prayer-nut (reproduced here larger than life-size) shows Saint John the Evangelist holding the Gospel; he might conceivably have been the patron saint of the original owner. The lower part shows Christ as the Man of Sorrows seated and tied to the column, before being led to his Crucifixion. The user would thus have had an image of the suffering Christ before his or her eyes while reciting the rosary.

The rosary, one of the most popular forms of sequential prayer, offered a definite structure for meditation and prayer.² In Europe the use of the rosary became wide-spread from the twelfth century and coincided with the rise of the mendicant orders, the Franciscans and the Dominicans, who had a special devotion to the Virgin Mary. The Dominicans became the principal promoters of the rosary, claiming that the Virgin had appeared in a vision to their founder, Saint Dominic (1170–1221), and presented him with a chaplet of beads that he was to call 'Our Lady's Crown of Roses', hence 'rosary'.

Until the sixteenth century, the number and arrangement of rosary beads, forming either a string or a circle, varied according to local practice. Groups of beads for the Hail Mary prayers were interspersed with beads for the Our Father. During the course of the previous century the sequences of 'Ave Marias' and 'Paternosters' had become firmly associated with particular events in the life of Christ and the Virgin, enabling the devout to meditate upon the history of the redemption effected by Christ, from the Annunciation to the Ascension of Christ and the Crowning of the Virgin as Queen of Heaven. The fifteen subjects of meditation, corresponding to the fifteen 'decades' of the Rosary (sets of ten Hail Marys, an Our Father, and a Gloria), were divided into three groups of five 'Mysteries': the Joyful Mysteries, which comprise the Annunciation, the Visitation, the Nativity, the Presentation in the Temple and the Finding of Jesus in the Temple; the Sorrowful Mysteries, based on the Passion, which comprise the Agony in the Garden, the Scourging, the Crowning with Thorns, the Carrying of the Cross and the Crucifixion (see fig. 33); and the Glorious Mysteries, comprising the Resurrection, the Ascension, the Descent of the Holy Spirit, the Assumption and the Coronation of the Virgin. Each of these groups of Mysteries corresponds with one chaplet, or round, of the rosary, and each chaplet come to be associated with a different day of the week. *XB*

1 For prayer-nuts and carved pomanders, see Leeds 1999.

2 On rosary beads in general see: Wilkins 1969; Marks 1977; Baker 1992; Winston-Allen 1997; Roberta 1998.

56 Eight scenes from the 'Small Passion', 1509–11

Albrecht Dürer (1471-1528)

Woodcuts, each c.126 x 97 mm, comprising: The Flagellation, Christ Crowned with Thorns, 'Ecce Homo', Pilate Washing his Hands, The Bearing of the Cross, Saint Veronica with the Sudarium and Saints Peter and Paul, The Nailing to the Cross, The Crucifixion.

Each print is signed with Dürer's monogram, the Bearing of the Cross is dated 1509; Saint Veronica with the Sudarium and Saints Peter and Paul is dated 1510. London, British Museum, respectively, E.2 238, 239, 240, 241 and 1895-1-22-526, 527, 528, 529

1 An early Netherlandish printed Passion of 1457 (British Museum, M, A.7; S.127 ff.) has all but one of the scenes that Dürer depicted, from the *Last Supper* onwards and includes two additional ones. The closest precedent to the 'Small Passion' in both number, choice and treatment of scenes was a Passion series made by Dürer's pupil Hans Schäufelein, published in 1507 to accompany Ulrich Pinder's *Speculum Passionis* (The Mirror of the Passion). Some scholars have been so disturbed to find the characteristically imitative Schäufelein apparently inspiring his master, that they have suggested Dürer must have acted as adviser on the series. See Winkler 1941 pp. 197–208; Washington 1971, p.184. The division of the passion into a sequence of narrative scenes, each inviting individual contemplation, was not an innovation brought about by printing, but when series of prints started to be made from the 1440s onwards the Passion was certainly their most common subject. Early printed Passions survive throughout Europe and were produced by most early masters of the medium including Dürer's German predecessors, the so-called Master E.S. (active c.1450-1467) and Martin Schongauer (c.1450-1491). Dürer himself produced three series of Passion prints of which the so-called 'Small Passion' with its thirty-seven prints was by far the most extensive – indeed it was the longest series of woodcuts ever issued by Dürer. The 'Large Passion', published in 1511 and named from the size of each print rather than their number, consisted of twelve full-page woodcuts; the 'Engraved Passion', started in 1507 and completed in 1512, had fifteen separate scenes. The variety in the number of scenes reflects the fact that there was no standard way of dividing the Passion narrative and although the 'Small Passion' was unusually extensive it was not uniquely so.¹

Not all the scenes of Dürer's 'Small Passion' were dedicated to the Passion itself and the work as a whole encompasses the Fall and Redemption of humanity. A frontispiece is followed by scenes of the Fall (Adam and Eve eating the apple), The Expulsion from Paradise, the Annunciation and the Nativity. Twenty-four Passion scenes are then followed by the Resurrection, four scenes of Christ's post-Resurrection appearances, and then the Ascension, Pentecost and the Last Judgement.

The 'Small Passion' was issued by Dürer as a book rather than as separate prints. It was published in 1511, the prints having been made over the previous two years (two

THE FLAGELLATION

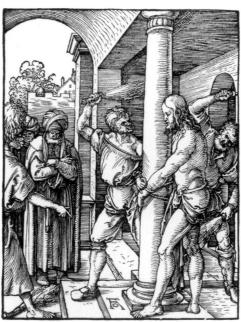

CHRIST CROWNED WITH THORNS

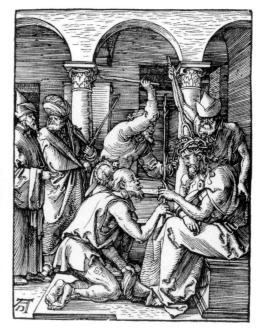

prints are dated 1509 and two 1510). In the same year Dürer published both the 'Large Passion' and his large-scale series of the Life of the Virgin (although he started work on these in the late 14900 and had issued some scenes as single sheets). All three works were accompanied by Latin verses written by the Augustinian monk 'Benedictus Chelidonius' a Latinised version of the German name *Schwalbe*, meaning swallow. The poems accompanying the 'Small Passion' were apparently written in about two months, after the prints themselves had been completed, but they would always have been an integral part of the work as conceived by Dürer, even if many later editions and copies of the series did not include them. The original woodblocks continued to be used after Dürer's death and all but two of them survive, preserved in the British Museum.²

The title page makes clear the importance of the relationship between images and verses and the title gives Chelidonius almost as great a prominence as Dürer.³ Beneath it is an image of Christ as the Man of Sorrows on the Cold Stone (cat. no. 47) accompanied by a short verse addressed to the reader, exploiting the idea of the perpetual Passion, which is that Christ's suffering is perpetuated by humanity's ongoing sins:

O cause of much great sorrow to me who is just,

O bloody cause of the cross and of my death,

O man, is it not enough that I have suffered these things for you once?

O cease crucifying me for new sins.

The twenty-line verses that accompany each subsequent print do not describe Dürer's scenes, but they do frequently call on us to behold or look upon Christ's misery. They

'Ессе Номо'

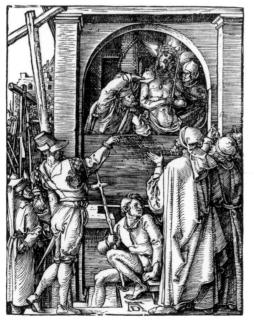

PILATE WASHING HIS HANDS

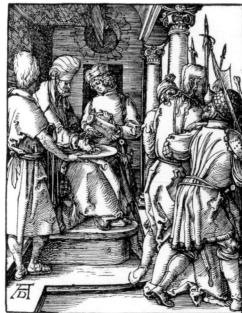

- 2 For later issues and versions see *The Illustrated Bartsch*, 10 (Commentary), pp. 256–319. There are also some rare impressions, including those exhibited here, made before the addition of the text.
- 3 'The Passion of Christ illustrated by Albrecht Dürer of Augsberg with verses of various kinds of brother Benedictus Chelidonius Musophili' (Musophili may be translated as 'Lover of the Muses').

share Dürer's concentration on Christ's human suffering, and emphasise, as do the prints, his patient endurance. They also continue to implicate the reader as a cause of Christ's agony, as for example in the verses that accompany the *Christ crowned with Thorns*:

It is not enough to have flayed Christ with whips And vilely persecuted him with all manner of insults Behold him more dreadfully tormented ... He takes in his right hand a broken reed With briars and brambles the divine head, true object of veneration, Is choked and gouged. Stabbed. Battered. Then he is hailed as the King of the Jews on bended knee, With mocking laughter he is invested as the ruler of all things. Spat upon. Kicked. Pummelled with blows. Torn From his high throne and dragged by the hair. Look you wretched man, you cause of so much pain. The holy body is opened all over with wounds. Christ, you have been made man so as to make us gods, and You have been chained so as to release us from our chains. God Tortured with floggings and thorns under an unjust judge, You teach us to bear our sorrows with calm resignation ...

The Bearing of the Cross

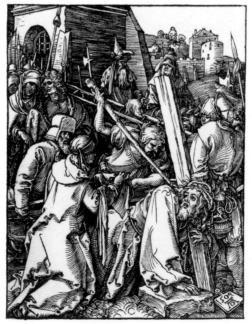

Saint Veronica with the Sudarium and Saints Peter and Paul

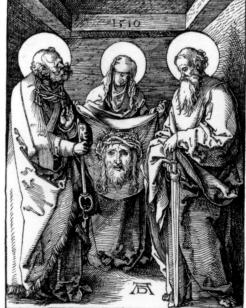

The scale of the 'Small Passion' would have made it an eminently portable devotional aid, but it is less easy to say who might have had it in their pocket. In contrast to the intricate and iconographically subtle 'Engraved Passion', the 'Small Passion' is characteristically described as Durer's 'most popular Passion',4 in which the scenes were rendered 'in a direct, easily understandable manner for a wide audience'.⁵ But the Latin verses were clearly aimed at an educated elite. They are constructed in a variety of meters and forms, in emulation of Horace's 'Odes', and aim at classical erudition, using terms such as 'Elysium' and 'Styx' for Heaven and Hell, and 'Ceres' and 'Bacchus' for bread and wine. The cost of the work would also have limited its audience. Our knowledge of the price and dissemination of Dürer's prints is almost entirely based on his own diary covering his trip to the Netherlands in 1520-21. This records him either selling or giving away thirty copies of the 'Small Passion' including sixteen copies to a dealer Sebald Fischer in Amsterdam for six stuiver each - the same price he asked for the shorter but larger format 'Apocalypse', 'Large Passion' and 'Life of the Virgin', but half as much as he charged for the 'Engraved Passion'. Although the diary shows that Dürer charged more when he could get it, including at one point ten times as much, six stuiver a copy is probably the best guide to the value Dürer set on the work. According to the diary, it was equivalent to the price of a pair of shoes, three times the cost of an evening meal or a visit to the barber and twice as much as he paid for an elk's foot. AS

The Nailing to the Cross

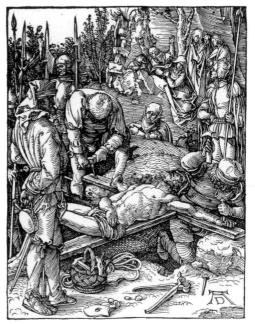

THE CRUCIFIXION

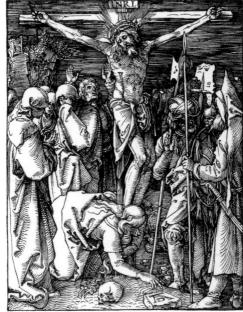

4 Wölfflin 1971, p.175. 5 Strauss 1980, p. 445.

57 Portable Passion Polyptych, midsixteenth century

Netherlandish

Oil on oak panels. The brass casing, hinges and nails are modern.

Overall dimensions (including brass casing), 27.8 x 20.9 x 5 cm; individual panels 24.6 x 19.2 cm. (outer doors); 24.2 x 20.2 cm. (inner doors).

The arms of the Spanish families of Ribera (left) and Enríquez (right) appear on both the front and back.

London, The Wernher Collection

 If the picture dates from the middle decades of the sixteenth century, the most likely candidates for the patron who commissioned it are Fadrique Enríquez de Ribera, first Marqués de Tarifa, who died in 1539, or his nephew and successor Per Afán Enríquez de Ribera, who died in 1571.

- 2 For a discussion of folding polyptychs designed to be portable, see *Art of Devotion*, pp. 137–56.
- 3 A late example of the use of the term is found in a Spanish inventory of 1662, which describes an object that sounds as though it was similar in type to this one: 'A painting of Our Lady on panel with four doors with various paintings which is called a portable oratory which is about three quarters [of a *vara*] high [about 61.5 cm.]', Inventory of the goods of Pedro Pacheco, Doctor, who died in Madrid, see Getty Provenance Index, E-428, item 0083.

THIS REMARKABLE POLYPTYCH shows ten scenes from the Passion, beginning with the arrest of Christ and ending with the Virgin's Lamentation over his dead body (the *Pietà*). The object survives in a complete state, which makes it possible to understand how it was intended to function. It bears the arms of the Enríquez de Ribera family of Seville, who held the title of the Marquisate of Tarifa.¹ Designed to be portable, it closes very neatly and could have been placed in a box or wrapped in a cloth when taken on a journey.² In Spain it would have been called an *oratorio portatil*, or portable oratory, a description which implies that it was intended to be used for prayer.³

The very act of opening and shutting the various panels of the polyptych enabled the viewer to follow the narrative of Christ's Passion. The individual scenes would have provided a focus for prayer and meditation on the Passion, perhaps in conjunction with set texts, rather like the *Via Crucis*, or Stations of the Cross, a devotion which comprises fourteen images from the Passion before which prayers and passages of the Gospels are recited, usually in Holy Week.

The devotional journey begins with all the panels shut and only the first scene of the *Arrest of Christ* (1) visible on the front. As this panel is opened (there was probably a thread of some sort attached to the door to help it open; the brass fittings currently attached to the outer edges of the panels appear to be modern), it reveals the reverse, which has the next scene in the sequence, *Christ before the High Priest* (2). The opening of this panel exposes the third scene, now in the central area, showing the *Flagellation* (3). As that panel is opened, its reverse shows the *Crowning with Thorns* (4). At this point the central iconic image of the *Ecce Homo* becomes visible (5). The panels are then closed and the altarpiece turned around. A similar process of opening the panels on the other

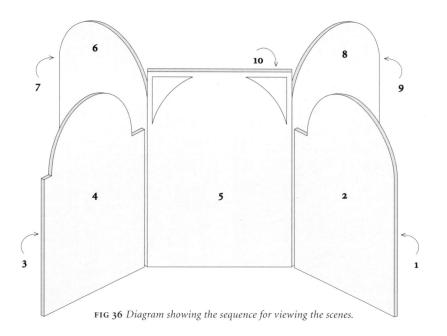

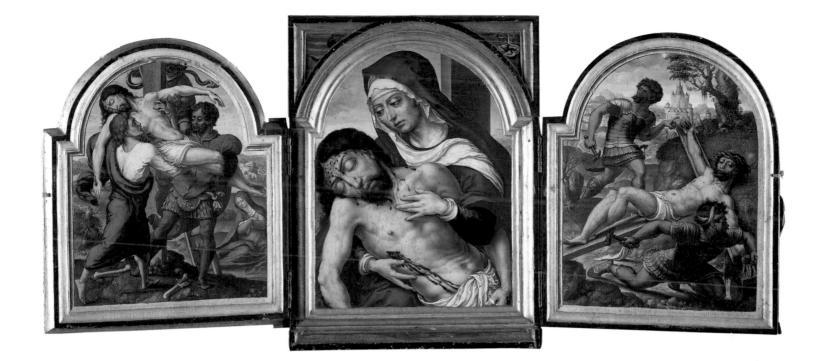

side leads the viewer from the *Way to Calvary with Simon of Cyrene* (6) through the *Nailing to the Cross* (7), the *Crucifixion* (8), and the *Descent from the Cross* (9), to the last scene, the *Pietà* (10), in which the Virgin holds the body of the dead Christ. Both the front and back sequences end with Ostentation images, in which the suffering or dead Christ is put before the viewer for silent contemplation.

Figure 37 shows the panels on the back of the polyptych open, and it may be seen that only two out of the three scenes which are visible appear in narrative order. Because of the way in which the sequence of scenes has been arranged on the panels, we may be sure that the polyptych was intended to be viewed as a succession of consecutive stages rather than as an open and static object, and this makes it more akin to an illustrated book than to an altarpiece. It is unlikely that the polyptych was ever meant to be shown fully open on both sides.

Each panel is painted with great attention to the details of costume, armour, gesture, expression and landscape. The artist has not yet been identified but would appear to be a Netherlandish painter, or one who trained in the Netherlands, who was very familiar with Italian art.⁴ The *Flagellation* (3), for example, recalls Michelangelo's famous composition of the subject.⁵ The first scene introduces us to some of the artist's peculiar mannerisms: the arm holding a sword on the left of the composition is that of the Apostle Peter, who struck at the High Priest's servant's ear. The painter's tendency to show disembodied limbs at the edges of a composition is designed to suggest that the action extends beyond its borders, and perhaps to draw the viewer on to the next episode in the

FIG 37 Back view showing the Descent from the Cross (9), the Pietà (10), and the Nailing to the Cross (7).

- 4 Several other paintings which appear to come from the same workshop are known: a *Crucifixion* and a *Descent from the Cross* are reproduced in Friedländer, 1972, nos. 16 and 17, and attributed to Gossaert; three others appeared at Christie's, London, attributed to the circle of Gossaert: *The Betrayal of Christ*, 16 April 1999, lot 93, and *Christ before the High Priest* and *The Nailing to the Cross*, on 17 December 1999, lot 122. They are less refined in execution than the Wernher Polyptych shown here. It is possible that those five panels went together, with others that are lost, to form a similar polyptych.
- 5 This composition is best known from Sebastiano del Piombo's painting in S. Pietro in Montorio, Rome.

1 Front right wing (outer): The Arrest of Christ

2 FRONT RIGHT WING (INNER): Christ before the High Priest

3 FRONT LEFT WING (OUTER): Flagellation at the Column

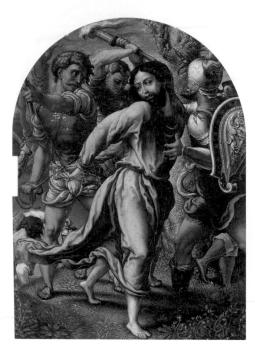

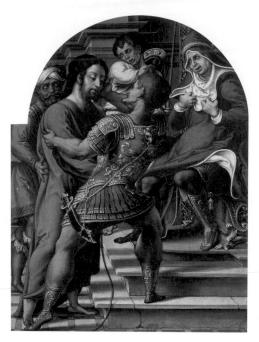

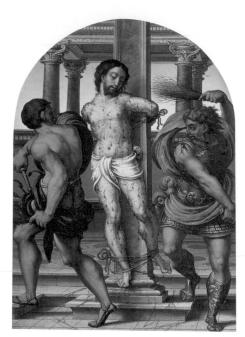

6 Back right wing (outer): The way to Calvary with Simon of Cyrene

7 Back right wing (inner): Nailing to the Cross

8 Back left wing (outer): The Crucifixion

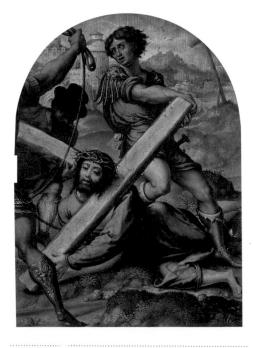

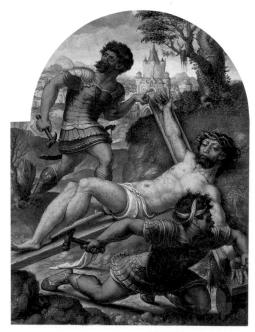

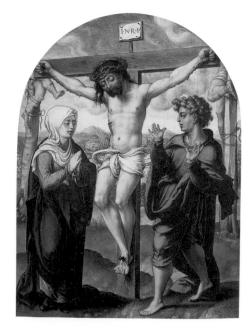

4 Front left wing (inner): Crowning with Thorns 5 FRONT CENTRE PANEL: Ecce Homo

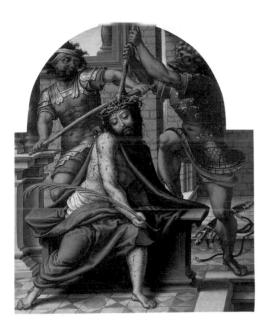

9 Back left wing (inner): Descent from the Cross

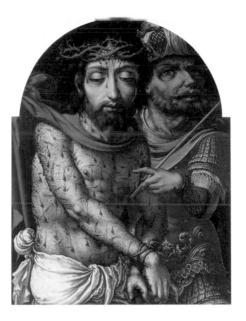

10 Back centre panel: *Pietà*

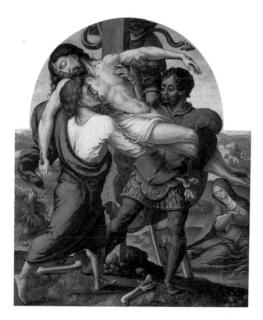

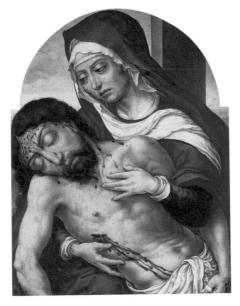

The scenes are shown here in narrative order.

narrative. Several panels, such as the *Flagellation* and the *Crowning with Thorns* (3 and 4), have an elaborate architectural setting, but what is particularly striking is the emphasis on the blood of Christ, which runs down his pale skin in large scarlet beads. The blood is very apparent, too, in the *Ecce Homo* scene (5), where it seems as if Pontius Pilate is actually raising Jesus's cloak in order to draw attention to his numerous flagellation wounds. This is clearly intentional and may have been designed to satisfy the (to modern eyes) morbid spirituality of the Spanish patron of the polyptych, but it is in tune with the contemporary obsession with the minutiae of the Passion.

In earlier times various authors had attempted to work out the number of Christ's wounds, and even the number of drops of blood he shed. The fourteenth-century English mystic and poet, Richard Rolle, devised some very ingenious conceits in his *Meditations on the Passion* which compared Christ's scourged body to a starry heaven, a net with many holes, a dovecot and a honeycomb: 'More yet, Sweet Jesu, thy body is like a book written all with red ink; so is thy body all written with red wounds.'⁶

The artist has not always been attentive to continuity between the scenes: the cross that Christ carries in the *Way to Calvary* (6) is not the same as the one on which he is shown crucified (8), and Saint John wears different garments and has a different hair style in scenes 8 and 9. *GF*

6 Gray 1963, pp. 84-5.

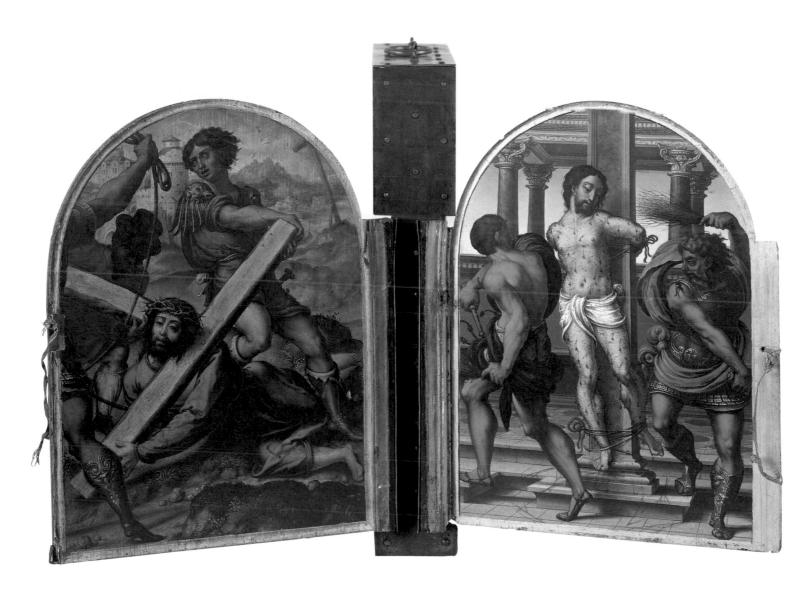

FIG 38 *Side view showing the* Way to Calvary with Simon of Cyrene (*back right wing, outer, 6*) *and the* Flagellation at the Column (*front left wing, outer, 3*).

58 Mass of Saint Gregory, 1490s(?)

Israhel van Meckenem (about 1440–1503) Engraving, made from two plates, 419 x 293 mm. Signed: IV.M.; inscribed on the altar frontal: I jhesus maria M London, British Museum, 1845–8–9–348

FIG 39 The Imago Pietatis Icon *from Santa Croce in Gerusalemme, Rome. Twelfth or thirteenth century. Mosaic, 19 x 13 cm.*

This Engraving commemorates a vision which Pope Gregory the Great (c.540-604) is said to have experienced as he celebrated Mass one day in Rome, in the church of Santa Croce in Gerusalemme. He is shown kneeling in front of the altar between two acolytes; on the left a cardinal holds his papal tiara and on the right another cardinal holds his cross. Above the altar and in front of the open triptych altarpiece showing scenes of the Passion and Resurrection, Christ appears as the Man of Sorrows, standing or seated in his tomb. The cross above him is surrounded by the Instruments of the Passion (cat. no. 59).

In addition to this engraving, Israhel van Meckenem made two others showing only the Man of Sorrows image, which bear a Latin inscription declaring that they were copies of 'the first Image of Pity (*ymaginis pietatis*), which is preserved in the Church of Santa Croce' and which Pope Gregory 'ordered to be painted according to a vision that he had had'. In fact the image which is preserved in the church, a Carthusian foundation, is not a painting but a Byzantine mosaic (fig. 39), which was either transferred from Constantinople to Rome in the twelfth or thirteenth century, or was made by Western craftsman in this period after an Eastern model. An Indulgence of 20,000 years was available to those who said certain prayers after confession in front of the mosaic icon. The Indulgence was extended by Pope Urban IV (1328–59) to apply equally to copies, and over time the number of years of pardon from Purgatory was greatly increased, so that by the second half of the fifteenth century, 45,000 years were pledged. As a result, the Image of Pity became one of the most popular of all devotional images throughout medieval and early Renaissance Europe.

The story of Saint Gregory's vision also invested the Image of Pity with the status of an 'authentic' portrait of Christ, and it was skilfully disseminated as such by the Carthusians through the Charterhouses of Europe. In the narrative context of the vision, the Image of Pity also pointed to the underlying relationship between the Body of Christ and the Eucharist. The chalice stands on the altar but the bread of the Eucharist, which represents Christ's broken body, is not shown and has been substituted by the figure of Christ himself. In the clearest possible way the image demonstrates that, so far as the Roman Catholic Church was concerned, the sacrificial elements of the Mass become, at the moment of consecration, the Body and Blood of Christ, and that those who partake of the elements receive Christ directly. Naturally ecclesiastical authorities were keen to promote an image which spoke so eloquently on the doctrine of the 'Real Presence' in the Eucharist.

Israhel van Meckenem was a goldsmith and a prolific printmaker; about 620 engravings by him are known. He probably came from Meckenheim near Bonn, and may have been the pupil of the anonymous artist known as Master E.S.. After 1475 he was based mainly in Bocholt, a town in Westphalia on the border between Germany and the eastern Netherlands. *SA-Q*

PRAYING THE PASSION 151

59 The Man of Sorrows as the Image of Pity, second half of the fourteenth century

Venetian(?)

Tempera and gold on poplar panel, arched top, 53.1 x 30.2 cm. London, National Gallery, NG 3893

60 The Image of Pity, about 1500

English

Woodcut pasted into a manuscript prayer book, 225 x 140 mm. Inscribed To them that before this ymage of pyte deuoutly say fyue Pater noster fyue Aueys & a Credo pytously beholdyng these armes of xps [Christ's] passyon ar graunted XXXII M. VII. C. & LV. yeres of pardon (The inscription has been crossed out but is in the most part readable). Oxford, The Bodleian Library, University of Oxford, Ms Rawl.D 403, fol. 2V

FIG 40 Giovanni Bellini, Dead Christ supported by Angels, c.1465–70. Tempera and oil on wood, 94.6 x 71.8 cm. London, National Gallery, NG 3912.

THE IMAGO PIETATIS, or Image of Pity, had a variety of manifestations. Christ is usually shown alone, as in these examples, but he is sometimes upheld by two angels (fig. 40) or by the Virgin Mary and Saint John the Evangelist. He is occasionally shown full length and sometimes reveals his side wound (cat. no. 68), or raises one hand in the act of judgement (cat. no. 75). The two images discussed here differ from one another in that the painting shows him with his eyes closed, and therefore dead in the tomb, whereas the print shows him alive. While the former would have been found in a wealthy household, the rather crude woodcut of the Image of Pity would have been affordable to all. Prints like this one were hawked at pilgrimage shrines and fairs, or sold by itinerant pedlars travelling around the countryside, and so were very widely disseminated. Once purchased they could be attached to the chimney-mantel for all the members of a family to see, or pasted into Books of Hours or private prayer books, as is the case here.¹

Both objects served the purposes of private devotion. Typical of the sort of prayer that was said before them is this one from a Franciscan prayer book compiled in Genoa in about 1300: 'O how intensely Thou embraced me, good Jesu, when the blood went forth from Thy heart, the water from Thy side, and the soul from Thy body. Most sweet youth, what hast Thou done that Thou shouldst suffer so? Surely, I, too, am the cause of Thy sorrow'.² The prayer most frequently associated with the Image of Pity in fifteenth-century England was the *Adoro te, Domine Jesu Christus in cruce pendentem* (I adore you, Lord Jesus Christ, hanging upon the cross), which comprises seven appeals to Christ in his Passion to be merciful and to defend the soul against sin and hell. Although the prayer was not written specifically to accompany the image, it had been adapted from an earlier prayer to concentrate on Christ's meritorious suffering, rather than on his triumph, and so accorded better with the iconography of the Image of Pity.³

The print bears an inscription which states that an Indulgence of 32, 755 years was offered to those who said five Our Fathers, five Hail Marys and recited the Creed while looking at the image. Although the words have been roughly cancelled out with a pen they remain readable. This probably happened at the hands of a Protestant for whom the Roman Catholic notions of Purgatory and Indulgences were repellent. Indeed, it was the abuse and sale of Indulgences in Germany at the beginning of the sixteenth century that led Martin Luther to post his ninety-five propositions on the door of the castle church at Wittenberg, which launched the Reformation.

This emphasis on the number five (five Our Fathers, five Hail Marys, etc.) was quite common in the rubrics accompanying Indulgenced images of the Man of Sorrows, and was clearly associated with the five wounds of Christ. The Image of Pity was frequently shown with the Instruments of the Passion, the objects used to humiliate and to kill Christ. The purpose of these displays was to enable the viewer to visualise and then meditate more comprehensively and in greater detail on Christ's sufferings. The items vary in number but usually include objects symbolic not only of the Crucifixion (ladder and nails) but the whole Passion, from the Betrayal (Judas's face and the thirty pieces

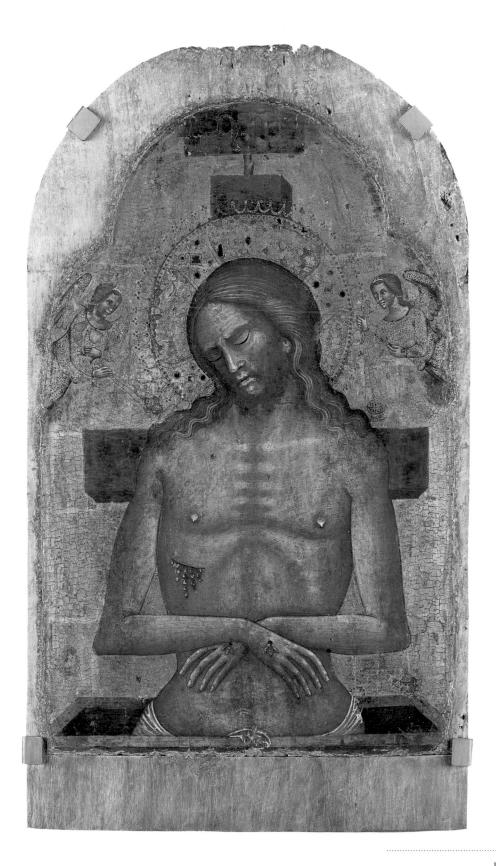

of silver) and Peter's Denial (the cockerel), through to the Trial and the Way to Calvary (Pilate's jug and basin, the column, the heads of mocking soldiers and the hand that struck Christ, and Saint Veronica's veil) and finally the Deposition and Entombment (the jars of spices and ointments brought to the grave by the three Marys). In this particular print, the Sacrifice of Christ is alluded to both by the pelican, a bird that was traditionally believed to wound her own breast in order to feed her young with her blood, and by the Eucharistic elements. *SA-Q*

A	В	С	D	E
v)·B·	I	F
U				G
T		<u> </u>		н
s	T AN			I
R	Oge of y	n that ly for oy to devone : Epuic Vine	e clycopyna Ip cap cync po a a Sac	J
Q	of pptoully of pps pally	tripldyng on ar gen	the armes	к
р	о	N	м	L

FIG 41 The Instruments of the Passsion surrounding the Image of Pity, beginning upper left:

- A The mocking soldier
- в Peter's cockerel
- c Veronica's cloth
- D The High Priest
- E Pontius Pilate
- F The Pelican in its piety
- G Christ's seamless garment
- н The hammer and pincers
- 1 The clubs and swords used in the arrest of Christ
- J The thirty pieces of silver paid to Judas
- κ The three dice with which the soldiers played for Christ's cloak
- L The nails
- м The chalice and host
- N The jar of vinegar
- o The jars of spices and ointments
- P The hand pulling Christ's hair
- Q The ladder of the Crucifixion
- R The birches used for the flogging
- s The column, rope and scourges
- т Pilate's basin
- U The lantern used in the arrest of Christ
- v The hand that slapped Christ in the face in front of the High Priest

To the left of Christ: The spear that pierced his side To the right: The stick with a sponge dipped in vinegar

- 1 This print (cat. no. 59) was inserted with two other woodcuts showing a *Pietà* and the Last Judgement, into a manuscript which was written in about 1500 in the Briggittine Convent of Syon, near Isleworth, Middlesex, a religious house founded by Henry v in 1415.
- 2 Quoted in Art of Devotion, p. 110.
- 3 Duffy 1992, pp. 239-41.

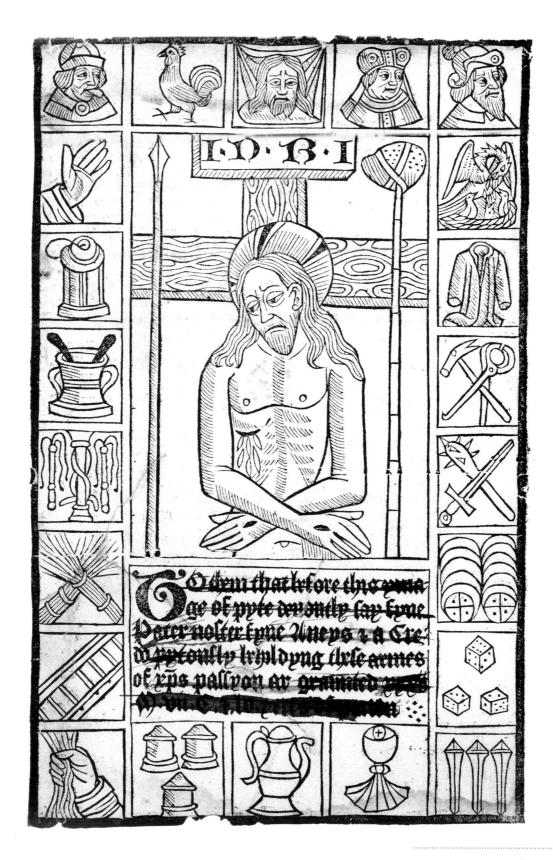

61 Devotional Booklet, about 1330-40

German, Lower Rhine or Westphalia Elephant ivory with painted and gilded leaves. Height: 10.5 cm; Width: 5.9 cm. (each leaf)

London, Victoria and Albert Museum, 1NV. 11–1872 THIS LUXURY BOOKLET, with its carved and painted ivory covers and painted ivory leaves, would have acted as a private devotional aid to meditation on the Passion. The book was almost certainly custom-made, in or around Cologne, for the monk (perhaps an abbot) who appears kneeling on both the front and back covers. The front shows him with Saint Lawrence and a bishop saint who presumably had particular significance for the kneeling monk or his religious house. On the back he appears with the scene of the Coronation of the Virgin.

Neither cover relates directly to the Passion, but this is the subject of the scenes inside. The division of the Passion so that each of Christ's sufferings stands alone as a focus of devotion was encouraged by the early fourteenth-century Franciscan *Meditations*, written shortly before this booklet was made and of particular influence in Germany at this time, where they were adapted by Ludolf of Saxony (died 1378) in his own *Life of Christ*. In both the *Meditations* and the ivory booklet the reader is encouraged to enter into each individual episode of the Passion: 'now we shall see each event individually, with great industry'. The emphasis of both is on the sufferings inflicted 'not just by one but by many' on a passive and accepting Christ. This idea is given clear visual expression in the first four scenes of the booklet in which Christ's pose remains almost identical as his tormentors change around him.

BACK COVER

FRONT COVER

THE LAST SUPPER

THE BETRAYAL

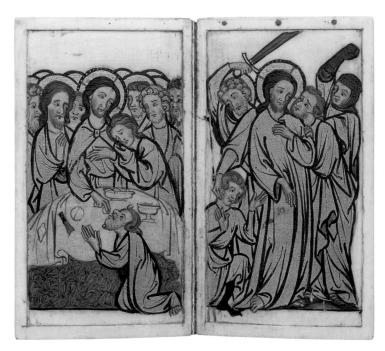

CHRIST BEFORE PILATE

CHRIST BEFORE HEROD

THE FLAGELLATION

PILATE WASHING HIS HANDS

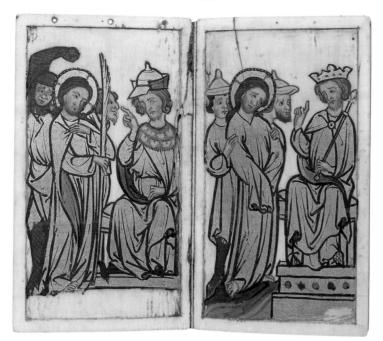

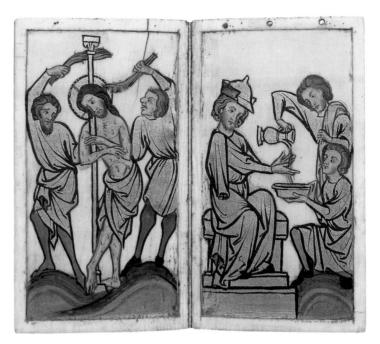

Christ Carrying the Cross

THE CRUCIFIXION

The Resurrection

The 'Veronica'

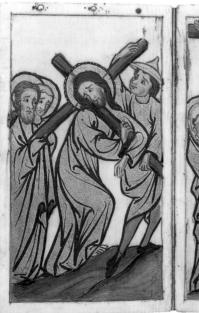

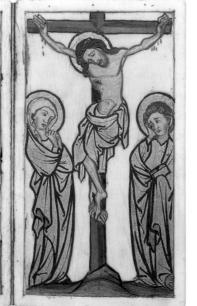

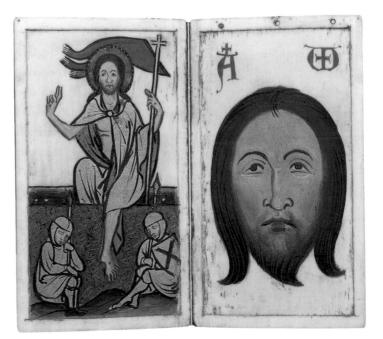

62 Angel holding a Shield with the Wounds of Christ, 1475–85

Netherlandish *Oak, 42 x 22.5 x 10 ст.* Utrecht, Museum Catharijneconvent, INV. ВМН bh 562

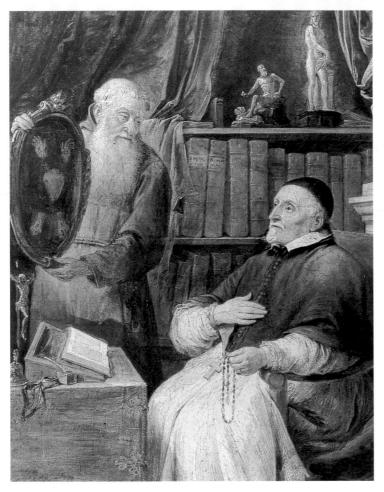

FIG 42 David Teniers, Antonius Triest, Bishop of Ghent, at his Devotions, 1652. Detail. Oil on canvas, 44 x 36 cm. St Petersburg, State Hermitage Museum

- 1 See Gray 1963 and Duffy 1992, pp. 234-48.
- 2 A medieval English example of a bench-end decorated with the Blazon of the Wounds is in the parish church of North Cadbury, Somerset. See Anderson 1955, pl. 12.

 \mathbf{D}_{gave} rise to some very interesting, although to modern eyes perhaps rather morbid, imagery. The cult of the Wounds arose from the paradox of Christ's death as a life-giving event – his Passion was terrible but glorious – and his wounds, like the Instruments of the Passion, were frequently described as 'sweet' or 'lovely' in the hymns and religious poems of the time. The Five Wounds of Christ, in his hands, feet, and side, were perceived as the 'doors' or 'wells' of salvation, the signs by which mankind had been redeemed from sin and death, and they were consequently invoked at times of distress

> and on the deathbed. When a special Mass of the Five Wounds was established in the fourteenth century, it was commonly specified for funerals.¹

> The representation of the Wounds of Christ, disembodied and abstracted from any narrative context, as in this wooden carving, could serve as the focus of devotion and prayer. Henry v1 of England (1422–61) was said to have ordered his chaplain to place before him at table a picture representing the Wounds so that he could gaze upon it as he ate, and a painting by Teniers shows an image of the wounds being held up by a Franciscan friar for the devotions of Antonius Triest, the Bishop of Ghent (fig. 42). The wounds on this relief are arranged on a shield held by an angel, and they acquire a heraldic character, like certain representations of the Instruments of the Passion (fig. 34). The type of image is consequently known as the 'Blazon of the Wounds', or sometimes the 'Passion Shield'. The Blazon of the Wounds was adopted as a badge of the Catholics in the Pilgrimage of Grace, the name of the rising against Henry VIII in 1536–37.

> Numerous examples of this imagery survive in fifteenth-century woodcuts, in stained-glass windows, engraved tombstones, roof-bosses and bench-ends.² This oak relief, which seems originally to have been coloured (traces of black and blue-green paint have been found), may well have been intended as a fitting in a church interior. *GF*

160 PRAYING THE PASSION

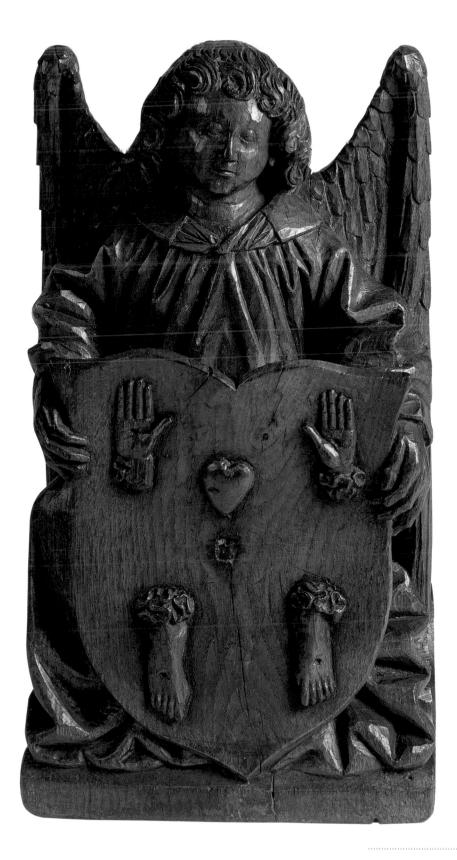

64 Prayer Roll, late fifteenth century

English

Parchment, c.341 x 10.2/11.8 cm. (made up of four attached membranes, 90 x 11.8 cm., 70 x 11.8 cm., 87.5 x 10.3 cm., 93.8 x 10.2 cm.). The initials are in gold or blue. Inscribed at the top of the second membrane: W[ill]yam thomas I pray yow pray for me your lovyng master Prynce Henry.

Private collection

FIG 44 A woman at her devotions using a prayer roll. Detail from a miniature of the Coronation of the Virgin *in the* 'Rothschild Prayerbook' of about 1510 (fol. 134v).

1 The prayer roll was probably made for the bishop who is shown kneeling before the Trinity in the first miniature on the first membrane. His arms are present but have not yet been identitified. At some point before 1509 Prince Henry Tudor, later Henry VIII, added the inscription at the top of the second membrane. The William Thomas mentioned in the inscription has not been certainly identified.

2 Uzielli 1899, Bühler 1964.

THIS IS ONE OF THE FINEST surviving English prayer rolls and has never before been exhibited.¹ It contains thirteen miniatures which are juxtaposed with devotional texts, prayers in Latin and English, and cues for individual Psalms. The exhibited section of the roll, which consists of the second section of parchment, shows the Image of Pity (cat. nos. 58–60), the Crucifixion with Angels, the Wound in the Side, and the Nails with the Wounds of Christ and the Crown of Thorns. The images which precede these show the Trinity and the Crucifixion and among those that follow are the Virgin and Child, and a variety of individual saints including Michael, George, and the lesser-known Pantaleon and Armagil.

The user would have scrolled down the roll reciting the texts and prayers while focusing his or her attention on the images. The principal advantage of the prayer roll over a traditionally bound prayer book was that it was more portable; it could be rolled quite tightly and tucked neatly into a pocket. The texts indicate that the roll was intended to be carried around, as it offered protection against accidents and dying without the sacraments. Some prayer rolls were used as 'birth girdles', worn round the belly by mothers during labour as a sort of medical charm. This may account for why so few survive.

The rubric to the right of the image of the Crucified Christ in this roll explains that the miniature is based on the measurement of the length of the Body of Christ: 'This cros. xv. tymes moten [measured] is the length of our Lord IHU [Jesus] Criste and that day that ye bere it upon you ther shal no evyl spirite have power of you on lande ne on watter ne with thonder ne litenyng be hurt ... and if a woman be in travell off childe lay this on her body and she shall be delyverd with oute pane the childe Cristendyn.' The 'Measure of the Cross' was a charm with a long history and a Europe-wide diffusion.² It functioned in a manner similar to a Relic of the True Cross since it brought the bearer into a privileged contact with the Crucified Christ, if only through a relationship of scale. According to the measurement Christ would have been about 195 centimetres tall.

Related to the 'Measure of the Cross' was the 'Measure of the Nails', which also appears in this prayer roll. The three nails are supposedly life-size representations of those which held Christ on the cross and in the miniature they pass through his disembodied hands and feet. The crown of thorns is woven through the nails and in the middle is Christ's heart, pierced through the wound in the side, which itself appears in the vignette above, borne aloft by angels in a cloud of glory. The text adjacent to the nails shows why devotion to the wounds and the nails was so popular: 'Pope Innocent hath granted to every man and woman that berith upon them ye length of these nailes seying daily v Pater nosters v Ave Marias and i Credo shall have vij giftes. The first is that he shal not dye no soden deth. The second is he shal not be slayne with no sword ne smyte. The iija is he shal not be poysoned. The iiij his enemys shal not overcome hym. The v is he shall have sufficient goodes to his lyves ende. The vj is he shal not dye withowte all the sacramentes of holy church. The vij is he shall be defended from evell'. *GF*

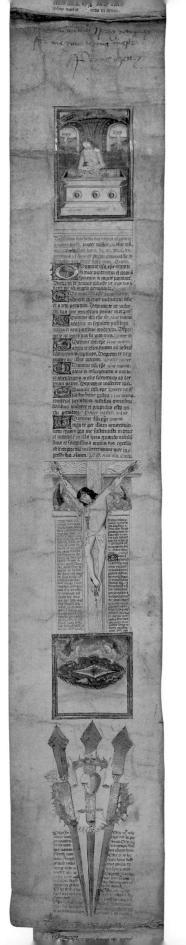

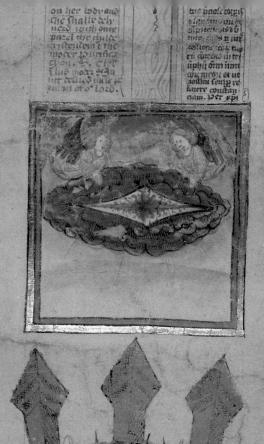

Dopeda nacent hati erenution encry man mo isoman stirrity opon these Plangth of the le males leying active of locator mer. M stire actor and the actor applies is eaco. Appliinducion, affees internation of the first is is internation of the actor as the actor ac

into

130121

Chir uf, isin Chir uf, isin Chir uf, isin Chiron Chirom Chiron Han Chiron Han Chiron Han Chiron Han Chiron Han Chiron Han Chiron Johnson Chiron Johnson Chiron Johnson Chiron Han Chiron

K. R. C. I.

65 Prayer sheet with the Wounds and the Nail, late seventeenth century

Issued by J. P. Steudner in Augsburg, Germany. Engluving, 40 x 31 cm. Nuremberg, Germanischer Nationalmuseum, INV. 24492/1199 THIS BIZARRE PRINT is an illustrated prayer sheet showing, at the top, an abstracted rendition of the wound on Christ's shoulder which resulted from his carrying the cross; in the centre, one of the nails of the Crucifixion, and underneath, the wound in the side. The print was published in Augsburg in southern Germany at the end of the seventeenth century and testifies to the enduring nature, in Roman Catholic regions, of the medieval devotions to the Wounds of Christ.

It should be said, however, that depictions of the wound on Christ's shoulder are rare and seem not to have inspired a very significant devotional tradition. The prayer directly beneath it opens as follows: 'O dearest Lord Jesus, you gentle Lamb of God, I, a poor and sinful person, greet and honour the most sacred wound which you received on your shoulder as you carried the heavy cross'. It ends with an appeal to Christ that he should forgive the devotee's sins and that he should let him follow in the 'way of the cross and in your bloodstained footprints to eternal happiness'. This recalls the imagery of the fourteenth-century German devotional booklet (cat. no. 61).

The prayer to the wound in the side addresses Christ as 'Gracious Pelican' (see cat. no. 60) and then turns to the wound: 'O most healing wound of the heart of Jesus Christ, in your divine goodness I adore you and greet you. Blessed is the love which split you open and blessed is the blood and water flowing from your side to wash our sins away'. The prayer entreats Christ to show his 'honeysweet wound' to God the Father on Judgement Day so that he may forgive 'all the sins which I, with my sinful heart, have often committed'. This is precisely the subject of the painting by Petrus Christus of *Christ as Saviour and Judge* (cat. no. 75).

To the modern viewer the similarity of the cartouche images to male and female genitalia suggests disturbing pornographic comparisons, but the seventeenth-century viewer may not have found the similarities so unsettling. The highly sensual, at times almost obsessively erotic, concern with the Wounds of Christ demonstrated in the poetry, devotions and visual imagery of the Middle Ages, indicates that the sensual mode was felt to be a legitimate and effective means of entering into a relationship with the Christ of the Passion narratives. Even the libido could be redirected from its base concerns towards a proper and virtuous devotion to holy things. *GF*

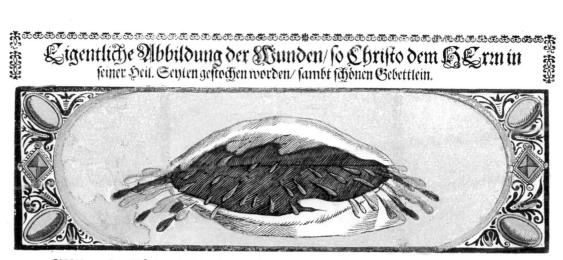

Abbildung der Råglen/ fo Shrifto dur ff feine Seilige Sand vnd Fußgefflagen worden.

Alertitebfter DEt: JEju Chriftei du fanftemutiges tamblein BOttes / 3ch armer fündiger Menich / gruffe vnd ehre die allerheitigfte Bunden / bie du auff beiner Achfel empfangen / als du bein ichweres Greug trugeft : Beicher wegen du / jugleich wegen der berg außftehmber Bebeine / fondertich groffen Schmergen vnd Pein über alle andere an deinem gebenedepten beib gelitten. 3ch bette bich an / D ichmerghaffter JEju / Dir fage ich bob / Ehr und Preifs 2

Ż aus innigen Derten / und dande dir für die allerheiligfte / tieffefte und peinlichte Bunden beiner D. Achfel / und bitte demutiglich / du wolleft dich megen der grof-fen Schmersen / und Dein/ fo buin difer tieffen Bunden erlitten / und wegen def fchweren Laft def Ereuses / ben du auff beiner 2Bunden gebuldete / über mich armen Gunder erbarmen / mir alle meine lafitche und tobeliche Gunden suvergenfen / und michin deinem Ereustweg und blutigen Juffapffen / sur etwigen Gee 1200 A ligteit begleitten / Zmen. Bebett zu der Septen . 2Bunden.

\$ Ô The second Bunden haft wollen empfangen / baf bu am Lag def ftrengen Berichts / biefelbige theure Bunden beinem Dimilifden Datter seigen wolleft / für alle Gunben/ The second secon welche ich mit meinem fündigen Dergen offemal begangen hab / Zmen. Augfpurg/ ben Johann Philipp Steudner/ Brieffmabler / Dauf und Laden ben der Degg.

The second

6 The Saving Body

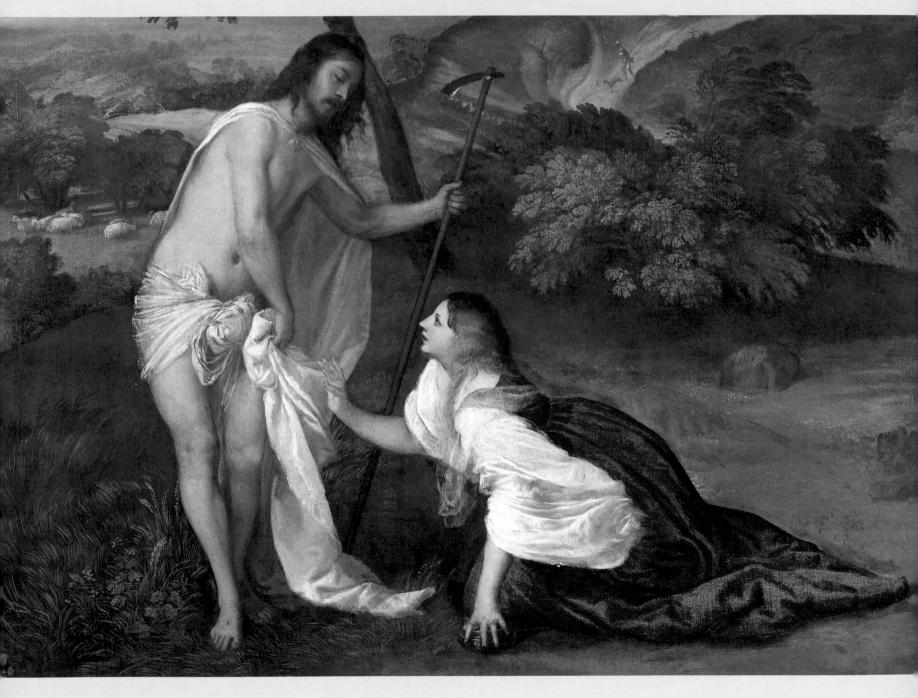

ESTERN ART IS UNIQUE in its preoccupation with the naked body, in particular the naked male body. In the language of art, of course, the naked body is not usually a naked body, but a nude – 'an art form invented by the Greeks in the fifth century BC'.¹ Despite Christianity's ambivalent view of the body, this pagan invention profoundly affected Christian imagery.

Although the Gospels refer to Jesus's nakedness only once, when he is stripped of his garments to be crucified, fifth- and sixth-century Christian artists represented him as a classical nude in scenes of his Baptism in the River Jordan. They did so partly because he was then immersed in water, where he would have been expected to take off his clothes, but mainly because it was at the Baptism that his dual nature as man and God was revealed. The nudity once associated with Graeco-Roman statues of pagan gods, expressing ideal harmony and beauty, was still, at that date, the clearest visual sign of divinity.

Ancient Greek philosophers introduced the distinction between body and soul, but pagan Greeks and Romans generally believed that body and soul developed in tandem: 'a healthy mind in a healthy body'. Christians, on the other hand, came to perceive body and soul as virtual opposites; Christian ascetics mortified their bodies for the welfare of their souls. The nude was reduced to the naked: a body humiliated, shorn of dignity, vulnerable to mockery, injury and pain. By the seventh century, it no longer seemed decorous to show the Son of God naked even on the cross, where he often appears clothed in a tunic or knee-length skirt; in Baptism scenes his body is concealed under a solid, bell-shaped mass of water.

Yet Christianity teaches that Christ was, as we ourselves shall be, resurrected in the body, and the notion of Christ's body is central to Christian belief and practice. From the thirteenth century, as greater stress was put on an affective relationship with Christ (see cat. no. 23), artists once again divested him of his garments – in order, now, to evoke pity for his abject, human nakedness (cat. no. 44). By the fifteenth century, as Italian artists rediscovered the expressive formulae of Graeco-Roman art, the naked and the nude were fused. Complex doctrines could be now communicated simply by picturing the saving body of the risen Christ – a beautiful body beyond the reach of Mary Magdalene's earthly love (cat. no. 66), but also the body proffered to doubting Thomas as tangible proof of Christ's victory over death (cat. no. 67).

The significance of Christ's body in the life of the Church was first enunciated in the Gospels, most clearly by Saint John, and in the Letters of Saint Paul. Christ speaks of himself as:

... the living bread, which came down from heaven: if any man eat of this bread, he shall live for ever: and the bread that I will give is my flesh, which I will give for the life of the world. (JOHN 6: 51)

1 K. Clark, *The Nude: A Study of Ideal Art*, London, 1956, p. 3.

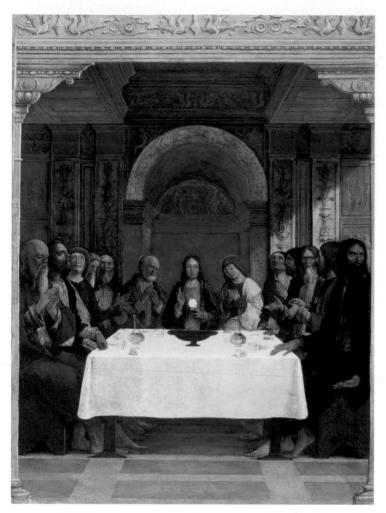

FIG 45 Ercole de'Roberti, The Institution of the Eucharist, probably 1490s. Egg on wood, 29.8 x 21 cm. London, National Gallery, NG 1127.

Christ's body is the Eucharist administered at the altar table. But it is also more. Through Holy Communion, Christians are made one with Christ and with each other; Christ's body becomes the Church of Christ:

He that eateth my flosh, and drinketh my blood, dwelleth in me, and I in him. (JOHN 6: 56) For we being many are one bread, and one body: for we are all partakers of that one bread. (I CORINTHIANS 10: 17)

If to the faithful the Eucharistic body is essentially the means of fellowship and salvation, to the historian the sacrament of the Eucharist, as administered by the Church, can also appear as a political instrument: it was above all through this sacrament that the Roman Church claimed authority over Christendom. The doctrine of transubstantiation, defined by the Lateran Council in 1215, holds that Christ is truly present in the bread and wine consecrated by an ordained priest. The belief in transubstantiation is thus by definition also an assertion of the clergy's exalted role. When threatened by schism or the loss of privilege, the Roman Church has usually responded by celebrating the Eucharistic mystery with renewed fervour and pomp.

This first became apparent in 1264, when, to combat heretical doubt, Pope Urban IV declared that the Feast of Corpus Christi – the Body of Christ – until then a local festival in honour of the Real Presence, should be celebrated throughout the whole

Church. Corpus Christi became one of the Church's principal feasts, marked by splendid pageants and processions during which time the consecrated Host was displayed and in which secular institutions and even princes and sovereigns were encouraged to take part. The rejection of the doctrine of transubstantiation by Protestant reformers naturally led to the suppression of the festival in reformed churches, in mainly Protestant or anticlerical countries, and to its ever greater prominence in Roman Catholic ones, where to this day it continues to involve entire communities.

Since seeing and adoring the Host, whether in procession or in church, is itself thought of as a form of communion, elaborate containers were created for its display. Not surprisingly, their decoration, like that of Roman Catholic altars and liturgical vessels in general, is designed to reinforce belief in Christ's Real Presence in the Eucharist (cat. no. 72).

Some episodes in the Gospels are especially suited to the purpose. The Last Supper, at which the Eucharist was instituted (fig. 45), and the Crucifixion. In Raphael's altarpiece (fig. 46), angels collect Christ's blood in chalices and Christ's body is elevated on the

cross, just as the Eucharist is lifted by the priest above the altar. In seenes of the Deposition from the Cross, Christ's body can appear to be being lowered onto the altar (cat. no. 69). However, a purely symbolic Eucharistic imagery was also invented. Bellini's Blood of the Redeemer, which may once have decorated the door of a tabernacle where the consecrated Host was kept, does not illustrate a particular moment either in Christ's life or after his death (cat. 110. 71). I imeless, like the nude sculptures of classical Greece whose relaxed pose he adopts, Christ appears as the sacrifice that supersedes the idolatrous pagan sacrifices of the bas-reliefs in the background. His blood flows perpetually from the wound nearest his heart into the chalice, and he compassionately bares his body to our gaze as the living bread which came down from heaven. Palma Giovane (cat. no. 70) makes a similar point in his drawing. If this design was, as seems probable, embroidered on the back of a priestly vestment worn while celebrating Mass, it would have been most clearly visible when the priest - according to sixteenth-century liturgical practice - raised the chalice above the altar with his back to the congregation.

While these images are demonstrably related to liturgical use, the intended function of other works shown here is less obvious; their symbolism perhaps even more complex. The anonymous Florentine artist's grasp of the classical idiom of the nude enables him to contrast the beauty of Christ's body with the pathos and horror of its injury (cat. no. 68). No more is needed either to arouse compassion or to evoke meditation.

Northern European artists, perhaps less confident in their ability to communicate feelings and ideas through Christ's body alone, tended to rely more on the context in which it appeared. The wine press, because it is a recurrent biblical metaphor as well as a Eucharistic symbol, represents Christ as the fulfilment of Old Testament prophecies (cat. nos. 73 and 74). By using the conventions of both royal portraiture and scenes of the Last Judgment, +NR-I

Petrus Christus's exceptionally rich image shows Christ as at once the object of Sacrifice, and as our Saviour, Advocate, Judge and King (cat. no. 75).

All these works, however, whatever their origins and intended functions, depend on the extraordinary conjunction of Christian theology and the Western artistic tradition – for the body is central to both. Christ's saving body, the visible symbol of his abiding presence in the world, could never have spoken so eloquently to believers had the pagan Greeks not invented the nude, the human body sublimated into art. *EL*

FIG 46 Raphael, The Crucified Christ with the Virgin Mary, Saints and Angels (Mond Crucifixion), c.1503. Oil on poplar, 280.7 x 165.1 cm. London, National Gallery, NG 3943.

66 Noli me Tangere, about 1515

Titian (active about 1506–1576) Oil on canvas, 109 x 91 cm. London, National Gallery, NG 270 **T**^{HE LATIN TITLE OF Titian's painting, *Noli me Tangere* (Touch me Not), are the words spoken by Christ to Mary Magdalene at his first apparition the morning after his resurrection. According to the Gospel of Saint John, the Magdalen had come to Christ's tomb, but finding it empty and thinking that his body had been taken away, she began to weep in distress (JOHN 20: 11-18). At that moment a man appeared before her and, mistaking him for a gardener, she implored him to tell her where she might find Christ's body. When the man spoke her name, she recognised Jesus and attempted in vain to touch him. It is this very moment that Titian has depicted.}

The artist shows Christ holding a gardener's hoe, enabling us to understand the Magdalen's initial reaction. X-rays of the picture demonstrate that Titian had originally painted Christ wearing a gardener's hat, perhaps to disguise him further, but he subsequently painted it out. We, however, quickly recognise him as the Christ who died on the cross, for his feet bear the marks from the nails. We recognise him, too, as the risen Christ, because the white garment that covers his nakedness symbolically alludes to his resurrection. Mary enthusiastically leans forward on the jar of ointment she has brought to anoint him in order that she might touch him. But Christ draws back saying, 'Touch me not; for I am not yet ascended to my Father'. Instead, he tells her to 'go to my brethren, and say unto them, I ascend unto my Father, and your Father; and to my God, and your God' (JOHN 20: 17).

This passage from the Gospel of Saint John has both fascinated and puzzled people through the ages. Christ reserves his first appearance after his resurrection for Mary Magdalene, the woman who had been a sinner (LUKE 7: 47), yet the boldness of the Latin phrase *Noli me Tangere* hints at reproach. Other translations render Christ's words as 'Do not desire to touch me', or 'Do not cling to me', suggesting that the love Mary Magdalene had for Christ, which had transformed her, must now itself be transformed. The time of Christ's bodily presence on earth is passing and she will learn to love him spiritually, as God rather than as a man. Titian captures the subtlety and profoundness of the exchange between them in the poses and gestures, in Christ's graceful pulling away and in the reaching out and yearning of the Magdalen.

Nothing is known of the circumstances in which Titian painted this picture. Nevertheless, his sensitive interpretation of the Gospel story and his evocative treatment of the north Italian landscape in which the figures are set, suggest that the original patron would have enjoyed the picture for its aesthetic merits as well as its religious sentiment. *XB*

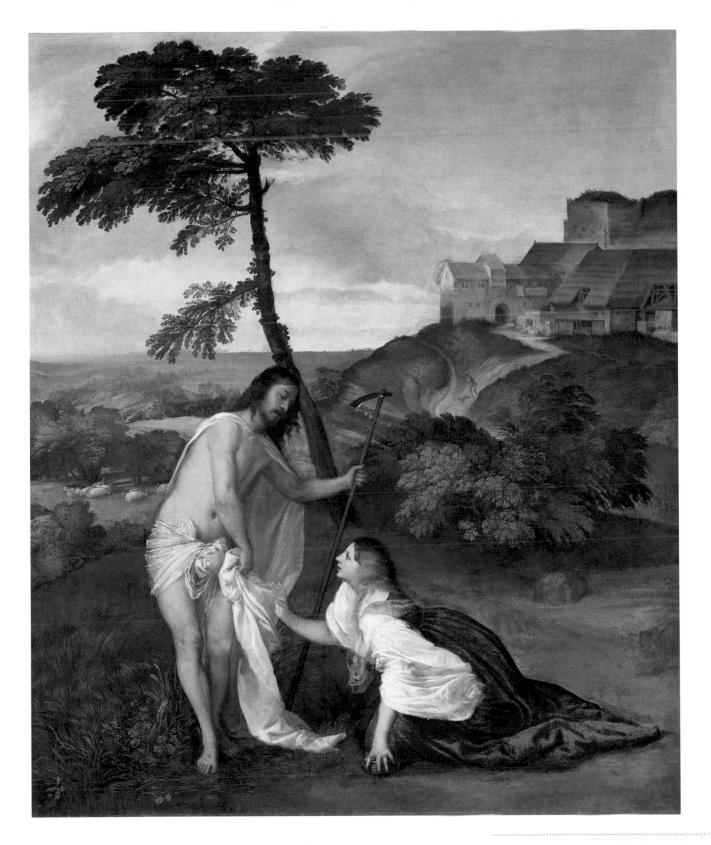

68 Christ showing the Wound in his Side, about 1420-25

Italian (Florentine)

Terracotta, with traces of polychromy, height 105 cm.

London, Victoria and Albert Museum, INV.

FIG 47 Bicci di Lorenzo Pope Martin v visits the Church of S. Egidio (detail), c.1420–25. Fresco. Florence, S. Maria Nuova. A sculpture of Christ displaying the wound in his side, similar to the one shown here, can be seen in the lunette above the door on the left.

I NTHIS IMPRESSIVE, almost life-size sculpture, Christ draws the viewer's attention to the wound in his side, which he holds open with his hands. Although he does not look out at us, he invites us to look and perhaps to touch. The gesture recalls Christ's invitation to Thomas to touch and to believe (cat. no. 67), but the sculpture should not really be thought of primarily in narrative terms. Rather, it is a richly allusive image which speaks of the ongoing relationship between Christ and humanity: the wound is a symbol of Christ's continual and gracious action in the world and of his promise to act as humanity's advocate before the Throne of Judgement on the Last Day (cat. no. 75).

Elaborate devotions grew up based on the Wounds of Christ. The veneration of the side wound seems to have its origin in the fact that it was the wound nearest Christ's heart and could therefore be taken as a pledge of his perpetual heartfelt love for humanity. The side wound was often evoked as a refuge for sinners, for instance in prayers such as the *Salve plaga lateris nostri Redemptoris* (Hail the wound in the side of our Redeemer). Traces of this devotion may be detected in the words of *Rock of Ages*, a hymn still popular today, which includes the lines: 'Rock of Ages cleft for me/ Let me hide myself in Thee'. Apart from sheltering sinners, the side wound was seen to cleanse and feed them. A whole genre of images emerged which presented the blood from the side wound flowing into a pool in which people bathe, while other images portrayed Christ's blood flowing into a chalice; occasionally Eucharist wafers are seen falling from the wound.

The wound in the side was also referred to as a door, recalling Christ's description of himself: 'I am the door: by me if any man enter in, he shall be saved, and shall go in and out, and pasture' (JOHN 10: 9). The metaphor of Christ as the door to the Father or the way to Eternal Life is especially appropriate in the case of the present sculpture since it is very likely that it was placed above a doorway. The design of the figure seems to demand viewing from below, and a very similar sculpture can be seen in a fresco by the fifteenth-century painter, Bicci di Lorenzo, over a doorway leading to the *Chiostro delle Ossa*, or 'Cloister of Bones', next to the entrance to the church of S. Egidio in the hospital of Santa Maria Nuova, Florence. In a hospital, such an image of Christ would have been intended to offer comfort and consolation to the sick and dying, and to their visitors.

The present work has been tentatively identified as the sculpture which is visible in the fresco by Bicci di Lorenzo (fig. 47) and it has been attributed to the sculptor Dello Delli, who is known to have produced some sculptures for S. Egidio. However, the identification, and consequently the attribution, seem very unlikely.

It is just possible that this sculpture may have served as a Passion reliquary; at any rate, when it was acquired by the Victoria and Albert Museum a circular cavity in the chest area was discovered, containing sand and a thorn, presumably a relic from Christ's crown of thorns. *SA-Q*

The Saving Body 177

1

69 The Deposition, about 1500–1505

Master of the Saint Bartholomew Altarpiece (active about 1470 to about 1510) *Oil on oak, 74.9 x 47.3 cm Inscribed at the top of the cross in Hebrew and Greek:* Jesus of Nazareth King of the Jews.

London, National Gallery, NG 6470

The STIFFENED BODY OF the dead Christ dominates the composition of this picture, his outstretched arms mirroring the form of the cross on which he has just died. With reverence and tenderness, Nicodemus and an assistant lower the body into the arms of Joseph of Arimathea (MATTHEW 27: 37). In the left foreground, Saint John the Evangelist supports the swooning Virgin and behind them one of the holy women joins her hands in prayer. Mary Magdalene, whose vase of ointment is on the ground, mourns the death of Christ, while another woman holds the crown of thorns. The skull identifics the site of the Crucifixion as Golgotha, the 'place of the skull' (JOHN 19: 17).

The anonymous painter, whose name derives from the Saint Bartholomew Altarpiece, made for a church in the German city of Cologne, has broadly followed the description of the episode given in the Gospels, seeking only to make it more immediate by showing the figures in modern dress. With skill and inventiveness, however, he draws attention simultaneously to the veracity of the story and to its significance in worship. The lower part of the picture shows the figures set in a real landscape, with plants and rocks naturalistically rendered; further up the picture, however, the natural setting gives way to a gilded box-like arrangement with tracery which actually comes in front of the horizontal beam of the cross, as though the scene were set in a shrine, in the manner of a fifteenth-century painted wooden altarpiece. It is not clear whether this painting was an independent work or part of a larger ensemble, but it would seem likely that it was intended to stand above an altar, for it is there that its meaning would be most clear.

At his death Christ becomes, as it were, the 'Body of Christ', a phrase obviously replete with Eucharistic resonance. The theological parallels between the Crucifixion and the Eucharist are mirrored in the vocabulary that is employed to describe them: Christ speaks of his body in the Eucharist as 'given for you' (LUKE 22: 20); both the Crucifixion and the Sacrament are therefore a sacrifice, and both are redeeming and propitiatory (able to satisfy the just demands of God). The painting subtly alludes to the parallels between the Deposition from the Cross and the Sacrament, in line with certain mystical interpretations of the Middle Ages. In his mid fourteenth-century *Life of Christ*, the Carthusian monk, Ludolph of Saxony, compared the honour of taking Christ down from the cross with that of receiving communion: 'It is far greater', he wrote, 'to receive the Body of Christ from the sacrificial place of the altar than it is to take him down from the sacrificial place of the cross. For those who did the latter received him in their arms and hands, while the former receive him in their mouths and hearts'.¹

If the panel was indeed above an altar, the visual conjunction of the Sacrament and Christ's represented body would have become especially apparent to the congregation when the priest raised the Host in front of the painting during the Rite of Consecration. It was just such a conjunction that was described by the Italian visionary, Angela of Foligno (c.1248-1309), a member of the Franciscan order, who related that on one occasion, 'At the display of the Host during Mass,' she saw a vision of the crucified Christ, looking as if 'he had just been removed from the cross'.² XB and GF

Quoted in Belting 1981, p. 70.
 Ibid., p. 71.

70 Christ in a Chalice sustained by Angels, about 1620

Jacopo Negretti, called Palma Giovane (1544–1628)

Pen and brown ink over traces of pounced black chalk, 269 x 193 mm. The sheet is laid down and is cropped on all four sides; the corners are also cut.

Inscribed Palma

Edinburgh, National Galleries of Scotland, INV. D3099 THE DRAWING SHOWS THE dead Christ in a chalice supported by angels. Blood pours from the wound in his side into the chalice, establishing a complete identification between the blood shed by Christ during his Passion and death; and that of the blood of the Eucharistic Sacrament. In some representations of the Mass of Saint Gregory, for example, the figure of Christ is shown with blood spurting from all his wounds directly into the chalice, thus emphasising this same identification. Likewise, Giovanni Bellini's *Blood of the Redeemer* shows an angel collecting the blood from his side wound in a chalice (cat. no. 71). These images conform to the Roman Catholic belief that the bread and wine consecrated by the priest on the altar become the Body and Blood of Christ. While they retain the appearance and character of bread and wine their nature has been transformed into the living presence of Christ.

The drawing was made by the Venetian painter Jacopo Negretti, known as Palma Giovane, and is a design either for a tabernacle door or, more likely, for embroidery on a church vestment. There is a similar representation of Christ standing in the chalice with attendant angels on the embroidered orphrey cross on the back of a chasuble (the liturgical over-garment worn by a Catholic priest at Mass) in the collection of the Duomo of Motta, near Venice, dating from about 1500.¹ Palma Giovane may have made the design for one of the many Venetian lay confraternities, or *scuole*, devoted to the Sacrament. In his sixteenth-century guide to Venice, Francesco Sansovino states that in most churches in the city there were Sacrament confraternities and that their principal concern was the maintenance of the altar of the tabernacle (the place where the consecrated Host was reserved), and the provision of the vestments, vessels and candles that were required.² The frontispiece of the written constitution of the *Scuola del Santissimo Corpo di Cristo* (Confraternity of the Most Holy Body of Christ) in the parish church of S. Agnese in Venice, has a miniature showing a similar subject as the Palma drawing, with the difference that the angels carry the instruments of the Passion.

The black dots seen on this drawing indicate that the basic design was transferred from another sheet of paper by means of dusting black chalk powder through perforated contours. The pen lines diverge from the dusted chalk, indicating that the artist was modifying his earlier design. Another drawing by Palma Giovane showing Christ standing in a chalice supported by Angels, which is very similar in design, is in the Museo Correr in Venice.³ *GF*

- 1 See *Ornamenta Ecclesiae* 1988, p. 82. The orphrey cross is the decorative cross-shaped band on the back of a chasuble.
- 2 Sansovino 1603, p. 198v; see also Black 1989, pp. 95-98.
- 3 INV. 1242, pen and ink, 268 x 191 mm. See Tietze/Tietze-Conrat 1944, no. 1179, p. 222. Another drawing, a variant of this composition, probably the work of one of his collaborators, was with the Paris dealer, Paul Prouté, in 1971.

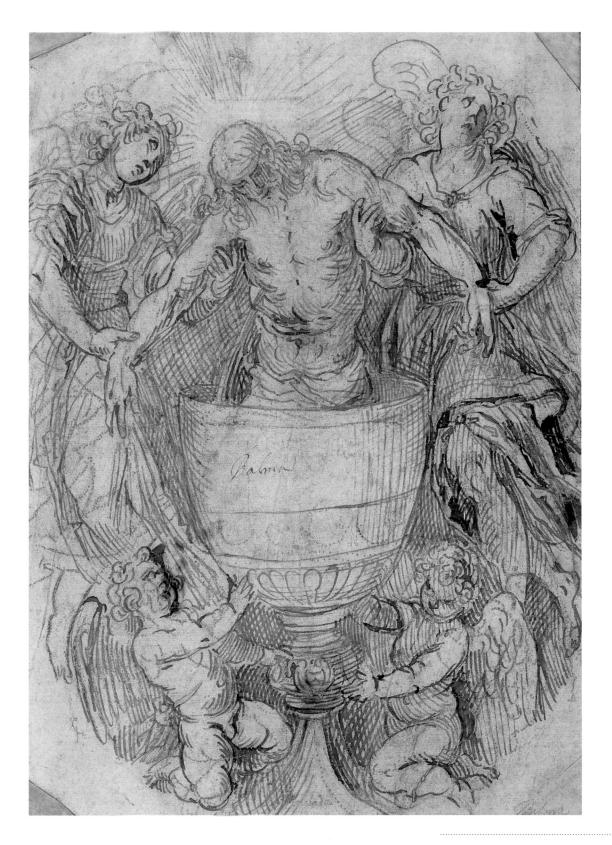

71 The Blood of the Redeemer, 1460-65

Giovanni Bellini (active about 1459; died 1516) *Egg on poplar, 47 x 34.3 cm.*

London, National Gallery, NG 1233

- 1 The lettering on the altar is just visible: 'DI[VI]S MANIB[VS] / AVRELIVS [...]T(?)I'. The inscription is incomplete and possibly inaccurate, but it presumably indicates that the altar is dedicated to the 'Gods of the departed Aurelius', perhaps the Emperor Marcus Aurelius (121–180 AD).
- 2 See HEBREWS chapters 9 and 10.
- 3 Robertson 1968, p. 33, and Braham 1978, p. 12.
- 4 Several Florentine and Roman examples are listed in Middeldorf 1962. On the iconography of the 'Christ of the Passion', the name given to this type of image in Italy, see Horster 1962 and Eisler 1969.

Christ, A GRACIOUS AND ELEGANT FIGURE, holds the cross which bears the crown of thorns and the superscription – now partly worn – with the letters I.N.R.I., which stand for 'Jesus of Nazareth, King of the Jews'. The cross, crown and superscription are the 'Arma Christi', emblems of Christ's triumph over suffering and death, and attributes of the Redeemer. His wounds are prominent and from his side blood pours into a chalice held by a kneeling angel. With his left hand Christ assists the flow and direction of the blood. The puffy clouds which cluster around his knees were originally formed of the heads of cherubim and seraphim in blue, red and gold. The features of one of them, together with its halo, are just visible between the chalice and the angel's head, but at some stage in the painting's history these clouds and cherubim were scraped away.

To the left and right are classical reliefs, painted in gold on a porphyry background, inset in a white marble parapet which divides the foreground area from the landscape beyond. The relief on the left shows a sacrifice scene, with a satyr playing the pipes and two other figures, one of them a pagan priest, holding a ewer in his left hand and possibly with his other hand pouring a libation of wine into the flames which rise from the altar.¹ That this action is obscured by Christ's wounded hand is almost certainly significant, since Christ's sacrifice, effected with his blood, was understood to have superseded all earlier forms of sacrifice, whether the idolatrous offerings of pagans or the Old Testament animal sacrifices.² The relief on the right shows two standing figures in front of a candelabrum, or perhaps an incense burner, before a seated figure who may be the god Hermes. The juxtaposition of Christ with these classical reliefs conveys the meaning that with his Passion and Resurrection he had eclipsed the pagan cults of antiquity and instituted a new order.

This sense of passage from the old to the new is echoed in the landscape. The barren and desolate countryside to the right, with ruined arch and column base, gives way on the left to an ordered cityscape surmounted by a church tower. A priest and an acolyte tread the winding path that leads from the former to the latter, while the dawn light radiates from the left, illuminating the underside of the long thin clouds that stretch across the sky.

The blood of Christ was the currency with which the ransom of fallen humanity had been paid and it was also the pledge of his ongoing relationship with the Church in the Eucharist. Bellini's painting is clearly a Eucharistic image and it has been suggested that the painting may have been designed as the door to a tabernacle, the place in which the consecrated host was reserved.³ Several fifteenth- and sixteenth-century Italian tabernacles are decorated with very similar images of the standing Christ shedding his blood into a chalice and holding the cross.⁴ However, it should be stated that the painting shows no physical signs of having been a tabernacle door and its dimensions are larger than one would expect had it been made for this purpose. The alternative is that it was painted as a work of private devotion for a patron of considerable aesthetic sophistication. *GF*

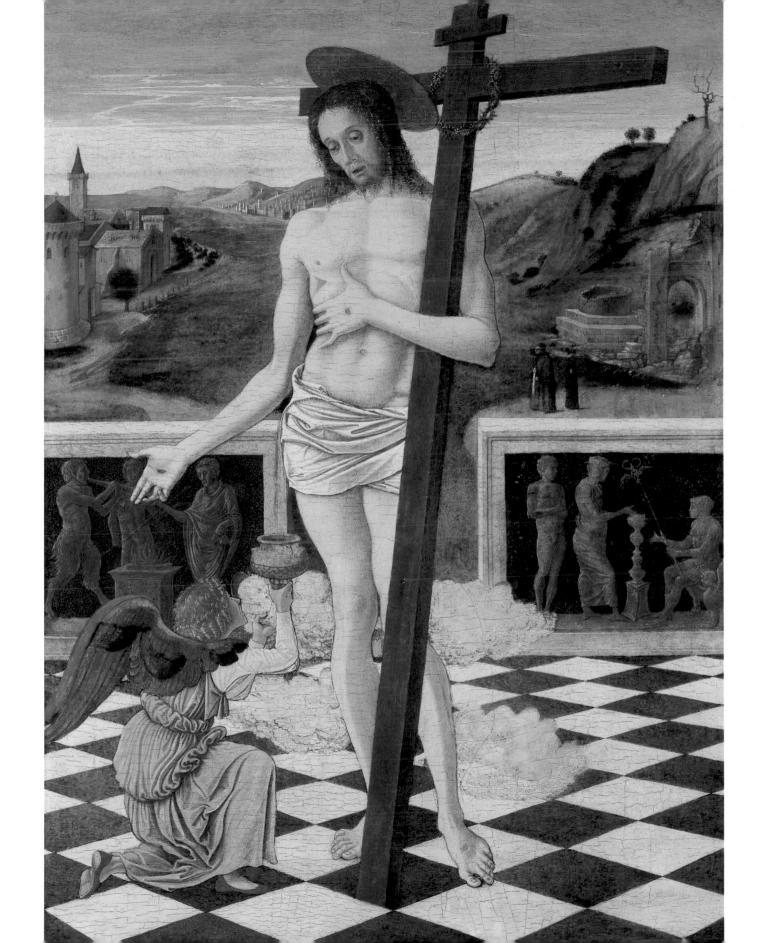

7 The Abiding Presence

Store the state of the state.

HRIST'S APPEARANCES to his followers after the Resurrection were, in pictorial terms at least, never particularly problematic. Artists could, by definition, show what had been seen – the physical body, crucified, dead and risen. But those apparitions, to Mary Magdalene, Thomas and the disciples at Emmaus, were only the first part of the larger promise, given at the end of St Matthew's Gospel: 'Lo, I am with you alway, even unto the end of the world.' (MATTHEW 28: 20) – the quickening reassurance that we will not be abandoned, that the events of this world are somehow under divine guidance. It is perhaps the need for such reassurance in the face of the atrocities of war and genocide that made images of Christ's abiding presence among the most popular and the most controversial in twentieth-century Britain. Yet how is this bewildering mixture of physical absence and spiritual presence to be made visible?

The latest of three versions, Holman Hunt's *Light of the World* (cat. no. 16), already markedly old-fashioned when it was finished around 1904, belongs in every sense to another, earlier age. No picture, it is probably safe to say, has ever enjoyed such rhapsodic praise in the English-speaking world and it is not hard to see why it appealed so strongly to the public of the day. This is a very British Christ, a very Victorian Christ. Three centuries before, John Donne, whose tomb in St Paul's Cathedral is only a few dozen yards from the picture, longed for the violent assaults of a Christ who would come to claim him by force: 'Batter my heart, three-person'd God; for you As yet but knock.' Holman Hunt's Christ, on the other hand, merely knocks courteously, asking to be admitted, with no hint of any desire to intrude, unlikely and perhaps unwilling, to trespass into private territory. This is no terrifying judge coming to pursue us, no shepherd rescuing us in spite of ourselves, but a gentle Jesus in every sense – well-bred, restrained and mild.

Holman Hunt's Christ walks in an overgrown landscape symbolising selfish greed, worldliness and sloth. These are not social injustices, but the private jungle of each particular soul. Fourteen years later, around 1918, Jacob Epstein's larger than life bronze Christ (fig. 49) addressed a world where private concerns had been overwhelmed by one great concern – war.

Epstein chose not to show Christ in the traditional 'true likeness' (see chapter three) long familiar to European eyes, which Hunt had adopted for his picture. Instead, he made a cast of the suffering face of a sick friend which for him possessed and revealed the inherent qualities of Jesus – 'Its pitying accusing eyes and the lofty and broad brow denoting great intellectual strength'¹. Churchmen were horrified by this unfamiliar, unidealised face 'with his Bolshevik appearance': 'Since Cimabue's day till our own Holman Hunt's, sculptors and artists have followed the traditional idea about the

1 Epstein 1942, pp. 104.

77 Christ of Saint John of the Cross, 1951

Salvador Dalí (1904–1989) Oil on canvas, 204.8 x 115.9 cm. Signed: GALA. S. DALÍ Glasgow Museums, The St Mungo Museum of Religious Life and Art

FIG 51 Saint John of the Cross, Christ on the Cross, 1572–77. Pen and ink on paper, 57 x 47 mm. Avila, Carmelite Convent of the Encarnación.

- 1 *Daily Express*, 5 December 1951. Quoted in Etherington-Smith 1992, p. 385.
- 2 Quoted in the *Scottish Art Review*, vol. v1, no. 4, 1958, p. 15.
- 3 From a letter printed in the *Scottish Art Review*, vol IV, no. 1, 1952, p. 5.
- 4 Ibid.
- 5 Louis le Nain, *Farmers in front of their House*, 1642. Oil on canvas, San Francisco, Palace of the Legion of Honor.
- 6 Velázquez, study for *The Surrender of Breda*, c.1635. Charcoal on paper, Madrid, Biblioteca Nacional.

D^{ALÍ'S CHRIST OF SAINT JOHN OF THE CROSS is perhaps the most celebrated and reproduced religious painting made in the twentieth century and it has always provoked strong reactions. Its purchase by the Glasgow Art Gallery in 1952 met with considerable criticism from the art press for its price (£8,200 was considered exorbitant), and its quality. It was described variously as 'skilled sensationalist trickery' and 'calculated melodrama', while in the *Express*, Osbert Lancaster credited it with 'about as much religious feeling as "Through the night of doubt and sorrow" played on a Wurlitzer in the interval of a leg show'.¹ But despite this chorus of condemnation, the people of Glasgow flocked to see the picture. Fifty thousand people saw it in the first two months, and reports spoke admiringly, if condescendingly, both of the social mix of the crowds, 'shop girls and students', and their reactions: 'Men entering the room where the picture is hung instinctively take off their hats. Crowds of chattering, high-spirited school children are hushed into awed silence when they see it.'²}

The work is a startling re-interpretation of one of the most familiar icons of Christian art and its power rests, in part, on the paradoxes it presents to the viewer. The monumental figure of the crucified Christ hovers above the world yet we look down on him. In the detail of Christ's body and his closeness to the picture surface (he appears to project beyond it), Christ is immediately and physically present and yet he is distant, above the clouds, his face hidden.

The painting's title comes from Dalí's principal source of inspiration – a drawing preserved in Avila, Spain, attributed to the Spanish Carmelite friar and mystic, Saint John of the Cross (1542-1591, fig. 51). According to Dalí: 'The drawing so impressed me the first time I saw it that later in California, in a dream, I saw the Christ in the same position, but in the landscape of Port Lligat, and I heard voices which told me, "Dalí you must paint this Christ"'.³ Like the drawing, Dalí's painting shows the cross suspended in mid air and Christ's head tilted so that his face is hidden from the viewer; Dalí apparently used a specially posed photograph of the acrobatic Hollywood stand-in Russ Saunders tied to a panel, as his model. But if Saint John's vision was Dalí's starting point, he developed his image in a dramatically different way. For Saint John, the crucified Christ was primarily a focus for compassion, a tortured and murdered man, but Dalí aimed instead at an image of perfection and transcendence: 'My aesthetic ambition ... was completely the opposite of all the Christs painted by most of the modern painters, who have all interpreted him in the expressionistic and contortionistic sense, thus obtaining emotion through ugliness. My principal preoccupation was that my Christ would be beautiful as the God that he is.'4

Dalí showed his Crucifixion hovering above Port Lligat in eastern Spain where he lived and worked and which often appears in his paintings, including the slightly earlier *Madonna of Port Lligat* (1949). The figure by the boat comes from a work by the French seventeenth-century painter Louis Le Nain,⁵ his face altered to resemble a local fisherman, while the silhouette on the extreme left is borrowed from a drawing by Velázquez.⁶

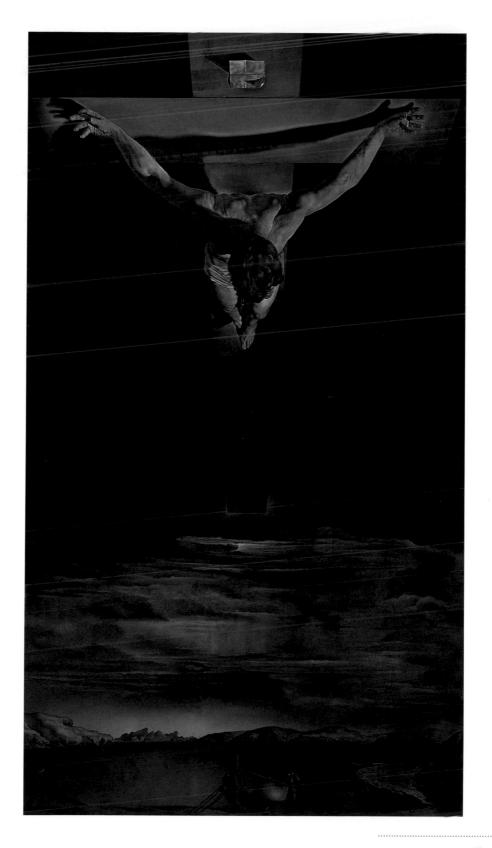

The painting was one of a number with religious and mystical themes Dalí painted from 1949 onwards, during his period of 'religious, nuclear and hallucinogenic mysticism' in which he published his *Manifesto Mystique* (April 1951). He later described himself, with typical opacity, as being in a 'rigorous, architectonic, Pythagorean and exhausting mystical reverie', triggered in part by the explosion of the atomic bomb at Hiroshima on 6 August 1945. One of Dalí's various accounts of the painting's gestation describes its design – in which the figure of Christ can be inscribed in an inverted triangle with his round head near the bottom corner – as being linked to a 'cosmic dream' in which a triangle containing a circle stood for the nucleus of the atom.⁷

A parallel preoccupation was what Dalí described as the 'mechanistic materialism' of modern painting, in contrast to the transcendent ideals of perfection established during the Renaissance which he hoped to reclaim. Or, as he put it in his colourful and mischie-vous retrospective account in *The Unspeakable Confessions of Salvador Dalí*: "No more denying," I shouted at the height of my ecstasy "no more Surrealist malaise of existential angst. I want to paint a Christ that is a painting with more beauty and joy than have ever been painted before. I want to paint a Christ that is the absolute opposite of Grünewald's materialistic savagely anti-mystical one".⁸ (fig. 31). *AS*

7 Dalí, 1976, p. 217. The account of Dalí's cosmic dream is on a small gouache study for *Christ of the Cross* of 1950–51, Glasgow Art Gallery and Museums.
8 Dalí 1976, p. 217.

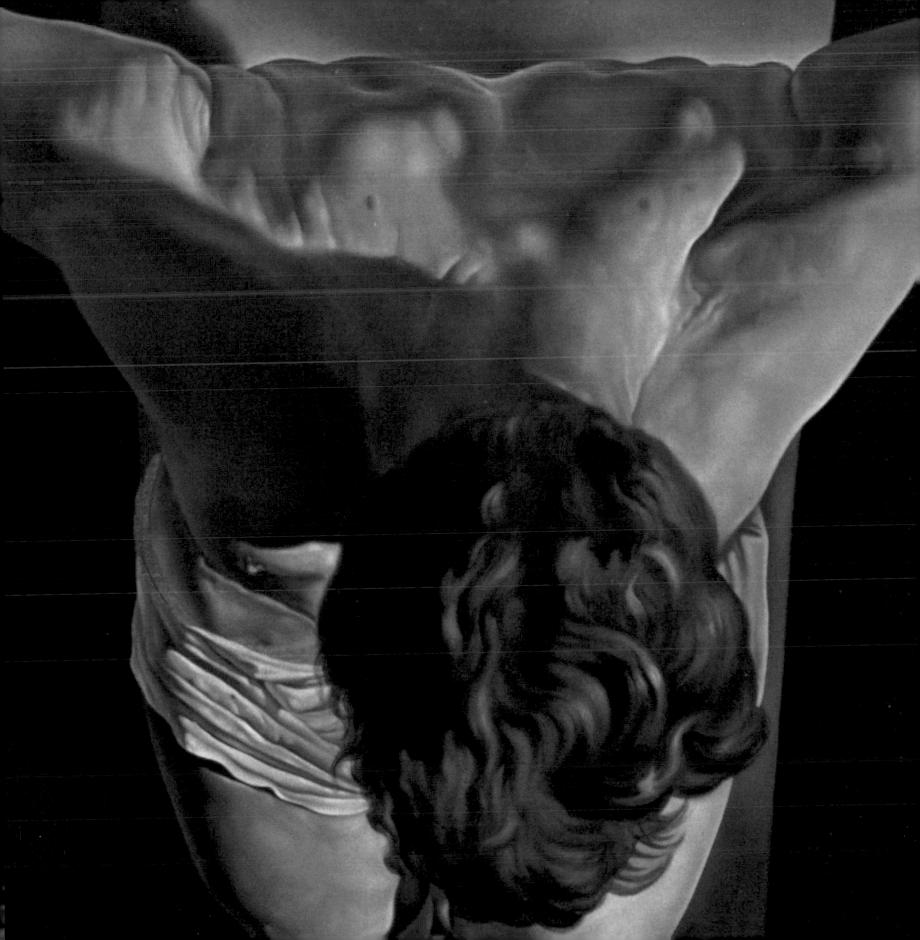

78 Christ in Glory in the Tetramorph (First Cartoon), 1953

Graham Sutherland (1903–1980) Oil on gouache on board, 201.9 x 110.5 cm. Herbert Art Gallery, Coventry, 1974.50.46

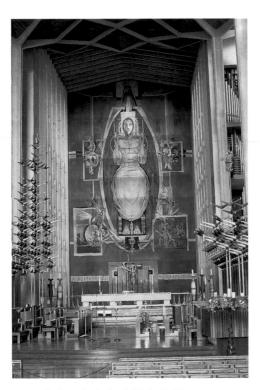

FIG 52 Graham Sutherland, Christ in Glory, 1962. Tapestry, 22.76 x 11.58 m. Coventry Cathedral.

1 Révai 1964, p. 24.

2 Berthoud 1982, 204 and 205.

3 Cooper 1961, p. 30.

A^S A COMMITTED CHRISTIAN, it must have seemed an act of religious affirmation to Sutherland when he accepted the invitation to design a gigantic tapestry to hang behind the altar of the new Coventry Cathedral (fig. 52). The old Gothic building had been almost completely destroyed by German bombing in November 1940. Sutherland had painted religious images in the past, including a *Crucifixion*, a *Deposition*, and a *Christ Carrying the Cross*, but had never had the subject-matter or style dictated to him. On this occasion the Cathedral's reconstruction committee required quite specifically a Christ in Glory as described in the Book of Revelation (REVELATION 4: 2-7), which would combine 'victory, serenity, and compassion'.¹

The challenge was to find a means of expression which both drew upon the established convention of portraying such an image, and yet in places might break entirely free from it so that it could speak directly to the contemporary viewer. Sutherland was determined that his image would 'have in its lineaments something of the power of lightning and thunder, of rocks, of the mystery of creation generally – a being who could have caused these things' and would 'look vital, non-sentimental, non-ecclesiastical, of the moment, yet for all time'.² He was attracted by the 'pent-up' force that he found in Egyptian royal figures of the Fourth and Fifth Dynasties, as well as the stillness inherent in the Pantocrator half-figures of Christ found in Byzantine Greek and Sicilian churches. To arrive at his final design, Sutherland produced no fewer than three trial cartoons, of which this is the first. The most significant difference between this cartoon and the finished tapestry is the position of Christ's arms: whereas here they are down by his sides, in the tapestry he holds them up in a gesture which Sutherland considered less submissive.

Much of the surrounding imagery also alludes to Christ's glory and power, such as the burst of light entering from above symbolising the Holy Ghost; the image of Saint Michael overcoming the Devil; the four creatures representing the Evangelists (the tetramorph), kneeling in reverence towards him; and the tiny figure of Man standing, as if for protection, between Christ's feet. Only a mournful representation of the *Pietà* at the foot of the cross recalls Christ's suffering. This scene was later replaced with a Crucifixion which the Cathedral authorities preferred, as it was a biblical subject. Interestingly, Sutherland had already alluded to the duality of Christ as suffering human and omnipotent God in his Northampton *Crucifixion* (1946), where Christ's anguished body is contrasted with the 'superbly blue' and beautiful heavens which encircle him. Sutherland explained that while Christ's death was 'the most tragic' event, 'yet inherent in it is the promise of salvation'.³

When the tapestry was unveiled on 25 May 1962, reactions were mixed. Many people found its ambiguous passages difficult to accept, especially the lack of clarity about whether or not Christ was seated. Sutherland himself commented only that it could have been worse. By contrast, Kenneth Clark described it as 'a great work of religious art', and the Cathedral architect, Basil Spence, declared that it was 'a triumph'. *SA-Q*

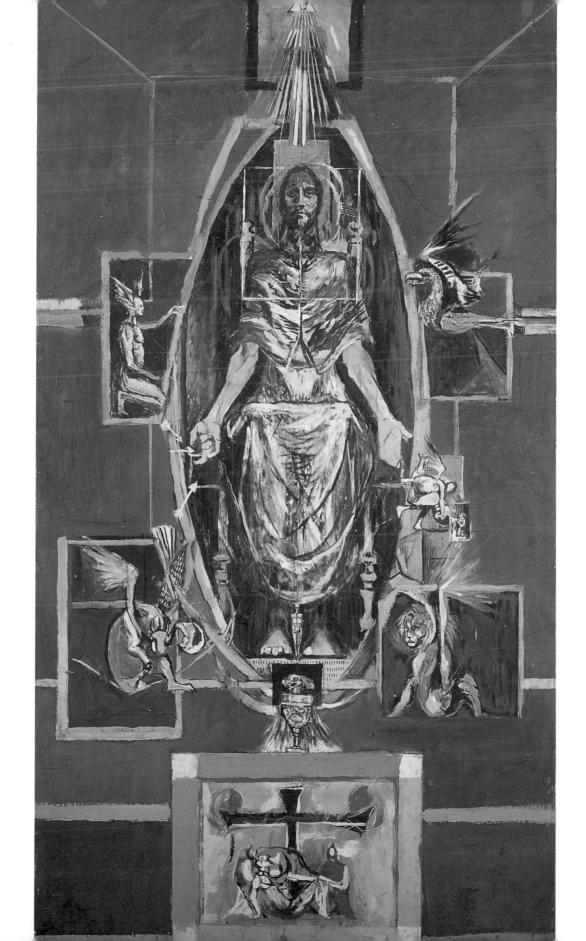

79 The Resurrection, Cookham, 1924–26

Stanley Spencer (1891–1959) *Oil on canvas, 274 x 549 cm.* London, Tate Gallery, N 04239 IN CONTRAST TO THE CRITICAL reception that greeted the acquisition of Dalí's *Christ* of Saint John of the Cross (cat. no. 77), Spencer's Resurrection, Cookham was received enthusiastically and by some even rapturously. Charles Marriott of *The Times* felt sure enough about its merits to pronounce it, 'in all probability ... the most important picture painted by an English artist in the present century'. Spencer, too, was very satisfied with it: 'I was on bedrock with this picture', he declared, 'I knew it was impossible for me to go wrong'.¹ On its completion, Spencer felt he had succeeded in both conveying outwardly, and achieving inwardly, a state of contentment and, indeed, of Resurrection as he understood it.

Although in the painting Spencer associates the Resurrection event with the Last Judgement and the meting out of just deserts, he does not portray Christ as a threatening judge but rather as a loving and merciful maternal figure, who nurses two babies cosily in his arms. Nor does he show much suffering; he reduces the punishment of the wicked to a mild rebuke which seems to be going on in one or two of the graves, and shows nearly all of the souls as righteous, experiencing feelings of the utmost happiness and peace as they clamber out of their tombs to make their way to the pleasure-boat which will take them to Heaven.

Spencer deliberately confuses the boundaries between heaven and earth – he shows Christ enthroned not in an obviously celestial sphere but in the grave-yard of Cookham Parish Church. People are both naked (as though newly resurrected) and fully clothed (as though still alive on earth) – not just so as to remain faithful to the biblical notion that on the Last Day the living will join the dead before the Judgement Throne, but also so that Spencer can explore the implications of his own understanding of 'Resurrection' as the attainment of a state of transcendence. To his mind, there were two kinds of Resurrection, a 'particular' kind which involved a person being raised after death to a state of fulfilment in heaven, and a 'general' kind which could come to anyone at any time and place on earth, and which consisted in being overwhelmed by a sense of perfect peace and love.

Here, both sorts of Resurrection appear to be experienced. The newly resurrected dead are enjoying again many of the pursuits which on earth had brought them to a state of transcendence. One woman (modelled on Spencer's mother), enjoys an intimate reconciliation with her husband as she brushes down his jacket, and another (who represents Spencer's first wife, Hilda Carline) delights in smelling a flower. She is repeated elsewhere reclining on the ivy-covered tomb and climbing over the stile leading to the River Thames. Spencer himself is visible lying in an 'open book' tomb in the foreground, enjoying a moment of utter tranquillity and delight. Spencer explained: 'No one is in any hurry ... Here and there things slowly move off but in the main they resurrect to such a state of joy that they are content... In this life we experience a kind of Resurrection when we arrive at a state of awareness, a state of being in love, and at such times we like to do again what we have done many times in the past, because now we do it anew in Heaven.'2

Quoted in Bell 1992, p. 414.
 Quoted in Carline 1978, p. 172.

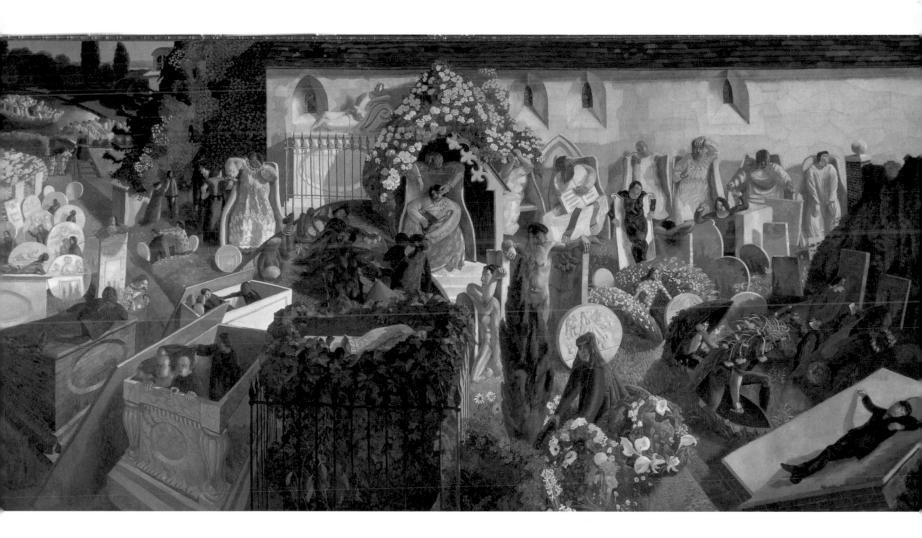

Moments of Resurrection of one sort or another preoccupied Spencer in several of his paintings and writings. The theme of souls being raised to new life appears in numerous works, including his *Resurrection of Soldiers* at Burghclere Chapel, Bucking-hamshire (1928–29), and *The Resurrection: The Hill of Zion* from his Port Glasgow series of shipbuilding murals (1946). He often made a sense of 'general' Resurrection the focus of his painting, commonly expressing this state of being as the result of the interaction of two people revelling in, and being amazed by, their love for one another. This is certainly the case in two of his most important cycles of paintings: the 'Beatitudes' series (in which pairs of sometimes very ugly lovers enjoy one another physically) and in the paintings for his unrealised 'Church House' scheme, which show people, places, or activities which had filled Spencer himself with such delight that he felt he was in Heaven.

Not that Spencer's own life was lived in a state of constant bliss; far from it. He experienced two failed marriages and much loneliness; he was often deeply frustrated as an artist because of the realisation that the majority of people, including his patrons, found his most imaginative work unintelligible, if not offensive; and he suffered from regular bouts of debilitating illness, eventually dying of cancer. It seems that the artist turned to painting in order to recapture moments of Resurrection, of joy which he had once felt, and also so that he might feel afresh a sense of transcendence as he actually applied the paint to canvas. Of the production of this painting he recalled: 'I experienced a spiritual exultation as I put this here and that there'.³ Such experiences were to be treasured, Spencer believed, as transitory tokens of the ultimate love that he, with the rest of mankind, would experience constantly in the afterlife, when reunited with Christ, who is love. *SA-Q*

3 Bell 1992, p. 59.

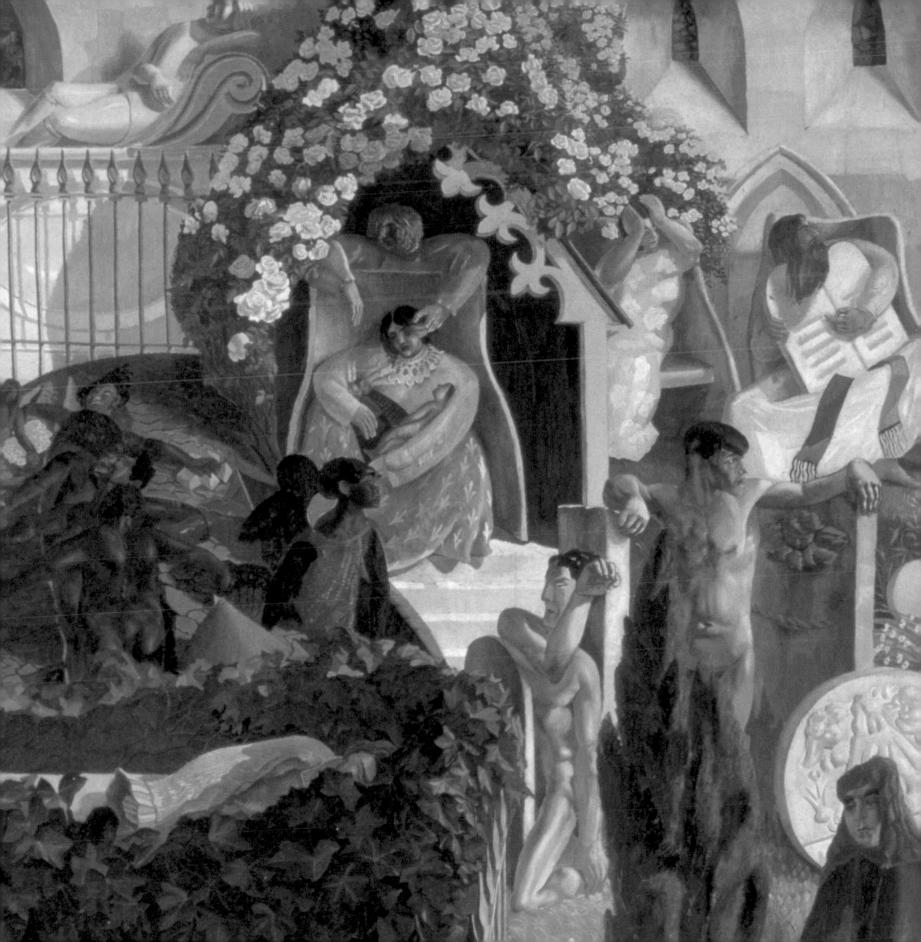

Provenance and Bibliography

1 Sign and Symbol

1. The Good Shepherd, Roman, fourth century AD PROVENANCE: Possibly from the Museo Kircheriano, the collection of antiquities, natural history and ethnological material formed by the seventeenth-century Jesuit priest, Atanasio Kircher (1602-1680).

BIBLIOGRAPHY: Unpublished.

2. Funerary slab of Aurelius Castus with the Good Shepherd, Roman, third or fourth century AD

PROVENANCE: Catacomb of St Callixtus on the Via Appia Antica, Rome.

Вівlіодгарну: Marucchi 1910, р. 57, pl. lvii, no. 6; *Inscriptiones*, iv, 1964, р. 488, no. 12572.

3. Funerary slab of Florentius with the Good Shepherd, Roman, fourth century AD

PROVENANCE: Uncertain.

ВІВLІОGRАРНУ: Marucchi 1910, p. 57, pl. LVII, no. 4; Inscriptiones, I, 1922, p. 203, no. 1623.

4. Funerary Slab with a Fish, Roman, fourth or fifth century AD

PROVENANCE: Cemetery of Pretestato (Via Appia) or Cemetery of Ciriaca (Via Tiburtina), Rome. BIBLIOGRAPHY: Marucchi 1910, p. 57, pl. LVII, no. 20; *Inscriptiones*, 1, 1922, p. 245, no. 1921; entry by G. Spinola in Donati 1996, no. 74, p.224.

5. Coin of the Emperor Constantine looking Heavenwards, Roman, AD 327

BIBLIOGRAPHY: *Roman Imperial Coinage*, v11, p. 621, no. 132.

6. Coin of the Emperor Constantine with the Monogram of Christ crowning the Labarum, Roman, AD 327

BIBLIOGRAPHY: *Roman Imperial Coinage*, v11, p. 572, no. 19; Bruun 1962, pp. 21–22; Kent 1978, no. 649, pp. 52 and 331.

7. Coin of Decentius with the Monogram of Christ and the Alpha and Omega, Roman, AD 351 BIBLIOGRAPHY: Roman Imperial Coinage, VIII, p. 163,

nos. 318 and 319.

8. Coin of the Emperor Jovian holding the Labarum with the Monogram of Christ, Roman, AD 363-4 BIBLIOGRAPHY: *Roman Imperial Coinage*, VIII, p. 393, no. 110; see also Carson 1981, p. 58, no. 1414.

9. Ring with the monogram of Christ, Roman, fourth or fifth century AD

PROVENANCE: Bequeathed to the British Museum by Sir Augustus Wollaston Franks, 1897.

Вівliography: Dalton 1901, p. 12, no. 77; Dalton 1912, р. 6, no. 32.

10. Rings with the monogram of Christ, Roman, fourth or fifth century AD

PROVENANCE: From the Castellani collection, acquired by the British Museum in 1872.

Bibliography: Fortnum 1871, p.281, no. 5; Dalton 1901, p. 12, no. 78; Dalton 1912, p. 6, no. 33.

11. Family Group with the monogram of Christ, Roman, fourth or fifth century(?)

PROVENANCE: Presumed to come from the Roman catacombs; in the Matarozzi collection; acquired by the British Museum in 1863.

Вівliography: Dalton 1901, p. 120, no. 610; Morey 1959, p. 54, no. 315.

12. Lamp with the monogram of Christ, Roman, fifth or sixth century AD

PROVENANCE: Apparently 'From the catacombs of Rome' (Sotheby's sale catalogue, London, 2 July 1929, lot 106, where it was acquired for the British Museum). BIBLIOGRAPHY: Bailey 1996, p. 76, Q3825.

13. Grave Slab with the monogram of Christ and the Alpha and Omega. Merovingian, fifth–sixth century AD PROVENANCE: Found in a sandpit near the church of St Acheul, near Amiens, in 1858; in the collection of Masse, then Charles Dufour; given to the British Museum by Sir John Evans in 1889.

BIBLIOGRAPHY: Dusevel 1858, p. 495; Corblet 1859, p. 17; Le Blant 1865, pp. 568–69 and pl. 91, fig. 544.

14. *The Adoration of the Name of Jesus*, about 1578 El Greco (1541-1614)

PROVENANCE: Don Luis Méndez de Haro y Gúzman, second Conde-Duque de Olivares (died 1675); bought by the National Gallery in 1955 from Lt.-Col. W.J. Stirling of Keir.

BIBLIOGRAPHY: Blunt 1939-40, pp. 58-69; MacLaren/Braham 1970, pp. 27-34; Braham 1981, pp. 47-8; *Felipe 11: un príncipe del renacimiento*, exh. cat., Madrid, Museo del Prado, 1998-99, cat. 156 (entry by David Davies).

15. The Nativity at Night, late 15th century

Geertgen tot Sint Jans (about 1455/65; died about 1485/95) PROVENANCE: Bought in Paris for the Richard von Kauffmann collection, Berlin, before 1901; it passed into the collection of Michiel Onnes at the castle of Nijenrode at Breukelen, north west of Utretcht; later owned by the iron founder Hans Tietje in Amsterdam; purchased by the National Gallery in 1925.

ВІВLIOGRАРНУ: Panofsky 1953, 1, pp. 325; Snyder 1960, pp. 121–23; Boon 1967, pp. 8–9; Friedländer 1969, vol. 5 pp. 21–22, no. 1; Camphell 1998, pp. 232–39.

16. The Light of the World, about 1900-1904

William Holman Hunt (1827–1910) PROVENANCE: Bought from the artist by Charles Booth; presented to St Paul's Cathedral, 5 June 1908. B1BLIOGRAPHY: Hunt 1905, 1, pp. 299–300, 307–8, 346–7, 350–1, 355–9, 404–6, 416–7; Bennett 1969, nos. 24 and 25, pp. 31–35; Landow 1983, pp. 473–76; Maas 1984, *passim*.

17. *The Bound Lamb* ('Agnus Dei'), about 1635-1640 Francisco de Zurbarán (1598-1664)

PROVENANCE: Marquesa del Socorro, Madrid; Madrid, Durán (auction house), February 1986, no. 200, lot. 47, where acquired by the Museo Nacional del Prado. BIBLIOGRAPHY: Angulo Iñíguez 1950, pp. 77–78; Soria 1953, no. 77; Guinard 1960, no. 592; Gaya Nuño/Frati 1976, no. 9; Gállego/Gudiol 1976, no. 282; Moreno 1998, pp. 92–93; Díaz Padrón 1999, pp. 153–154.

Coin of the Emperor Valens holding the Labarum inscribed with a Cross, Roman, AD 364-7 BIBLIOGRAPHY: Roman Imperial Coinage, 1x, p. 272, no.

2d; Carson 1981, p. 66, no. 1452.

19. Cross, 1897

Designed by Phillip Webb (1831-1915) and executed by Robert Catterson-Smith

PROVENANCE: Made for the chapel, designed by Webb, of the Rochester and Southwark Diocesan Deaconess's House, Clapham Common; given by the Trustees of the House to the Victoria and Albert Museum in 1970. BIBLIOGRAPHY: Lethaby 1935, p.189; London (Victoria and Albert Museum) 1971, cat. K7.

20. *Christ Crucified on the Vine*, Germany, Middle Rhineland, about 1435

PROVENANCE: Bought in Paris by the Victoria and Albert Museum in 1856.

ВIBLIOGRAPHY: Von Bode/Volbach 1918, pl. IV,

p. 6; Weckwerth 1968; Arens 1971, p.123; Beranek 1986.

2 The Dual Nature

21. The Heavenly and Earthly Trinities, 1681-82

Bartolomé Esteban Murillo (1617–1682) PROVENANCE: Don Carlos Francisco Colarte, second Marqués del Pedroso, Cadiz, in 1708; in the Pedroso collection at Seville by 1800; bought in Seville by James Campbell for the dealer Buchanan and brought to London in 1910 by 1024 it was lit the collection of Thomas Bulkeley Owen; purchased by the National Gallery in 1837. BIBLIOGRAPHY: Curtis 1883, no. 135; MacLaren/Braham 1970, pp. 60–61; Angulo Iñiguez 1981, 11, no. 192; London (Royal Academy) 1981, no. 54; Helston 1983, p. 42; Young 1986, pp. 10–13.

22. *The Holy Family with Saint John*, about 1500 Andrea Mantegna (1430/31-1506)

PROVENANCE: By 1856 in the collection of Cavaliere Andrea Monga in Verona; acquired in 1885 by J.P. Richter and in 1891 by Ludwig Mond; bequeathed to the National Gallery as part of the Mond Bequest in 1924, entered the Collection in 1946.

Вівliography: Richter 1910, 1, pp. 255-67; Davies 1961, pp. 338-9; Lightbown 1986, no. 49.

23. Saint Francis receiving the Christ Child from the Virgin, about 1583–85

Ludovico Carracci (1555-1619)

PROVENANCE: Apparently in the collection of the Pepoli family, Bologna; acquired in Florence in 1787 by Lord Hume; by descent to the Earl of Brounlow and sold at Christie's, London, 4 May 1923; Captain Langton Douglas; Prof. Dr. Otto Lanz, Amsterdam; acquired by the Rijksmuseum, Amsterdam in 1960.

ВІВLІОGRАРНУ: Bodmer 1939, pp. 43–44, no. 79; Askew 1969, p. 295; Graas 1975; Bologna/Fort Worth 1993–4, no. 14 (English edn.); Van Os 1992.

24. Cradle, about 1480-1500

Southern Netherlandish

PROVENANCE: Apparently in the collection of Baron Gustave de Rothschild; bought by Sir William Burrell from M.R. Stora in 1937.

BIBLIOGRAPHY: Wentzel 1962, pp. 1–7.

25. The Virgin and Child in an Interior, about 1430

Workshop of Robert Campin, late 1370s–1444 (Jacques Daret?)

PROVENANCE: Melanie von Risenfels (1898–1984); acquired by the National Gallery in 1987. BIBLIOGRAPHY: Urbach 1995, pp. 557–68; Reynolds in Foister/Nash 1996, pp. 183–196; Steinberg 1996, pp. 257–8; Campbell 1998, pp. 83–91.

26. The Circumcision, about 1500

Workshop of Giovanni Bellini (active from around 1459, died 1516)

PROVENANCE: Probably Muselli collection, Verona, by 1648; Duc de Gramont; Orléans collection by 1727; brought to England 1798; Lord Carlisle, Castle Howard; presented to the National Gallery by the 9th Earl of Carlisle, 1895.

В1BL10GRAPHY: Pallucchini 1959, pp. 148-9; Davies 1961, pp. 68-70; Heinemann 1962, cat. 145, pp. 42-44.

27. The Virgin with the Dead Christ (Pietà), about 1430

'The Rimini Master' (Southern Netherlandish) PROVENANCE: Given by Sir Thomas Barlow to the Victoria and Albert Museum in 1960.

Вівliography: Manchester 1947, cat. 11a; Nuis Cahill 1971, p. 13; Williamson/Evelyn 1988, pp. 187–91; *Art of Devotion*, p. 104.

28. The Madonna of the Meadow, about 1500

Giovanni Bellini, active from around 1459, died 1516 PROVENANCE: Purchased from Achille Farina, Faenza, 1858.

BIBLIOGRAPHY: Davies 1961, pp. 57–58; Robertson 1968, pp. 119–120; Cast 1969, pp. 247–257; Dunkerton et al. 1991, p. 356; Tempestini 1992, pp. 230–1, no. 82.

29. The Christ Child Resting on the Cross, 1670s

Bartolomé Esteban Murillo (1617–1682) PROVENANCE: Sale of Mr and Lady Arthur Bagnal, London, 1757, lot 89 (listed as 'Our Saviour Sleeping ... Morrillios'); bought by Charles Jennings and recorded in 1766 in his London collection; inherited by the 1st Earl Howe in 1824 through his father, a cousin of Charles Jennings; Howe Sale of 7 December 1933, Christie's, London, lot 45, where it was bought by J.G. Graves. BIBLIOGRAPHY: *The English Connoisseur* 1766, 1, pp. 36 and 81; Stirling-Maxwell 1873, p. 80; Curtis 1883, no. 157; Måle 1932, p. 331; Angulo Iñíguez 1981, 1, p. 422, and 11, no. 215; London 1982–3, cat. 60.

30. The Adoration of the Kings and Christ on the Cross, about 1465-75

Attributed to Benedetto Bonfigli (active 1445; died 1496) PROVENANCE: Conte Fabiani Sale, Gubbio, April–May, 1882; purchased from Elia Volpi, Florence, 1901. BIBLIOGRAPHY: Bombe 1912, p. 102; Davies 1961, pp. 92–3; Davisson 1971, p. 133; Mancini 1992, no. 15, p. 143.

31. The Adoration of the Kings, 1500-15

Jan Gossaert (active 1502; died 1532) PROVENANCE: Possibly commissioned by Jan de Broeder, abbot of the Benedictine Abbey of St Adrian at Geraardsbergen in East Flanders; in 1601 Albert and Isabella, the Governors of the Spanish Netherlands, bought it; later in the posession of Charles of Lorraine, Governor of the Austrian Netherlands from 1744; included in sale of his effects in Brussels in June 1781; by 1795 in the possession of the dealer and writer Michael Bryan (1787–1821) from whom acquired by Frederick Howard 5th Earl of Carlisle (1748–1825); passed by descent through the family to the widow of the 9th Earl of Carlisle, Rosalind Frances Stanley (1845–1921), from whom acquired by the National Gallery in 1911.

BIBLIOGRAPHY: Friedländer 1948, p. 7; Panofsky 1953, I, p. 277; Steppe 1965, pp. 39–46; Davies 1968, pp. 63–66; Friedländer 1976, vol. 14, p. 27; Campbell, Foister, Roy 1997, pp. 87–97.

32. The Adoration of the Kings, 1564

Pieter Bruegel the Elder (active: 1550/1; died: 1569) PROVENANCE: Probably in the Imperial collection at Vienna in the 1610s; Georg Roth, Vienna, by 1898; bought from the Roth Collection by Guido Arnot, from whom purchased by the National Gallery with contributions from the NACF in 1920.

Вівlіодкарну: Friedländer 1976, vol. 14, pp. 27–35; Pevsner 1948, pp. 215–17; Davies 1968, pp. 21–22; Grossman 1973, pp. 195–96; Pinson 1994, pp. 109–27.

3 The True Likeness

33. *The Procession to Calvary*, probably about 1505 Ridolfo Ghirlandaio (1483–1561)

PROVENANCE: Church of San Gallo, Florence, until 1529; said to have been removed to Santo Spirito in Florence and then to the Palazzo Antinori da San Gaetano also in Florence; bought by the National Gallery from the heirs of the Antinori family in 1883.

BIBLIOGRAPHY: Gould 1975, p. 100; Chiarini 1986, p. 44.

34. Saint Veronica with the Sudarium about 1420

Master of Saint Veronica (active early fifteenth century) PROVENANCE: Said to have been in the church of St Lawrence, Cologne (demolished in 1817); later in the hands of a priest whence it passed to the Cologne dealer, Spanner; apparently acquired from him by Johann Peter Weyer by 1851; bought by the National Gallery at the Weyer sale, 25 August 1862, lot 116.

BIBLIOGRAPHY: Levey 1959, pp. 95–6, London 1977, cat. no. 6, p. 32; Dunkerton et al. 1991, p. 242; Cologne 1995, cat. no. 147, pp. 560–61.

35. Two Angels Holding the Veronica, 1513

Albrecht Dürer (1471-1528) PROVENANCE: Bequeathed to the British Museum in 1799 as part of the Cracherode collection. Вівliography: Panofsky 1953, no. 132; Hollstein 1962, no. 26; Boston 1971, no. 183; Strauss 1981, no. 69; Koerner 1993, pp. 91–92.

36. *The Veil of Saint Veronica*, about 1635 Francisco de Zurbarán (1598–1664)

PROVENANCE: Bequeathed to King Louis Philippe from the collection of Frank Hall Standish, Paris, in 1842; bought by William Stirling-Maxwell of Keir at the Louis-Philippe and Standish sale, Christie's, London, 27 May 1853, lot 230; bought by the Nationalmuseum, Stockholm, in 1957. BIBLIOGRAPHY: New York 1987, no.54 with full bibliography.

37. Portrait of a Young Man, 1450-60

Petrus Christus (active 1444; died 1475/6) PROVENANCE: In an Italian collection in the late eighteenth or early nineteenth century; bought in 1863 by Thomas Baring from the dealer Henry Farrar; Thomas George Baring, Lord Northbrook; in the collection of George Salting by 1895; entered the National Gallery as part of the Salting Bequest, 1910.

ВІВLІОGRАРНУ: Davies 1968, pp. 33–34; Belting 1994, pp. 542–4; Campbell 1998, pp. 104–9 with bibliography.

38. *The Face of Christ*, late fifteenth century German/Netherlandish

PROVENANCE: Bought in Munich in about 1922 by Dr J.H. Maasland and given by his widow, Mrs M.A.J. Maaslandvan Troostenburg de Bruyn, to the Aartsbisschoppelijk Museum, Utrecht, 1972. BIBLIOGRAPHY: Unpublished.

39. The Veil of Saint Veronica, 1649

Claude Mellan (1598–1688) Provenance: Bequest of George Grote, 1872 Bibliography: Paris 1988, nos. 106–8; Préaud 1988, no. 21.

40. Diptych with the Head of Christ and the Lentulus Letter, late fifteenth- or early sixteenth-century Southern Netherlandish(?) PROVENANCE: Said to be from the St Lambertuskerk, Swolgen. BIBLIOGRAPHY: BOUYY 1965, pp. 45–6.

41. *Icon of the Mandylion of Edessa*, eighteenth century Perhaps made in Italy

PROVENANCE: Bought by Albert, Prince Consort, as part of the Oettingen-Wallerstein Collection, 1851. BIBLIOGRAPHY: Waagen 1854, no. 4, pp. 3–4; Cust/ Dobschütz 1904; Drandakis 1974, pp. 38–39.

42. The Ostentation of the Holy Shroud of Turin, 1689–90

Pietro Antonio Boglietto, active late seventeeth century BIBLIOGRAPHY: *L'Ostensione della S. Sindone*, exh. cat., Turin, 1931, cat. no. 13, pl. xxv111b; Wilson 1978, reproduced between pp. 146 and 147; E. Bertana and others, *La Sindone di qua dai monti: Documenti e testimonianze*, Turin, 1978, p. 51, and entry by A. Bo Signoretto, pl. xv; B. Cilento and M. Macera, *La collezione sindonica della Cappella Reale*, Turin, 1998, cat. no. R.880–6

4 Passion and Compassion

43. Reliefs of the Passion and Resurrection, Roman,
AD 420-430
1 Christ Taking up his Cross
2 The Crucifxion
3 The Empty Tomb
4 Christ's Commission to the Apostles
PROVENANCE: Purchased by the British Museum from the collection of William Maskell in 1856
BIBLIOGRAPHY: Maskell 1905, pp. 89-93; Dalton 1909, no.
7, pp. 5-6; Weitzman 1979, cat. no. 452; Buckton 1994, cat. no. 5; Kötzsche 1994, pp. 80-90.

44. The Virgin and Child and The Man of Sorrows, about 1260

Anonymous Umbrian(?) Master

PROVENANCE: NG 6572: Ruef, Munich, 14–15 December 1989, lot 113 (as north Italian, 19th century); acquired by the National Gallery from a private collector, 1999. NG 6573: Brussels, Adolphe Stoclet Collection (bought from Gnecco, Genoa, 26 October 1926); subsequently collection of Madame Feron-Stoclet; acquired by the National Gallery from the heirs to the Feron-Stoclet Collection, 1999.

Вівliography: Belting 1990, pp. 166, 174–85; Cannon 1999, pp. 107–12; Gordon 1999, p. 16.

45. The Crowning with Thorns, about 1490-1500

Hieronymus Bosch (living 1474; died 1516) PROVENANCE: Possibly owned by the Portuguese humanist, Damião de Góis in 1572; bought in Spain before 1867 by Hollingworth Magniac; inherited by his eldest son Charles Magniac in 1867; sold at the Magniac sale, Christie's, London in 1892 and bought by Robert Thompson Crawshay; purchased by the National Gallery from the Sangiorgi Gallery, Rome, 1934. BIBLIOGRAPHY: Davies 1953, pp. 18–21; Marrow 1977, p. 178; Tudor-Craig/Foster 1986; Campbell 1999.

46. Christ presented to the People (Ecce Homo), about 1525-30

Antonio Allegri known as Correggio (about 1494; died 1534)

PROVENANCE: Probably the picture engraved by Agostino Carracci as in the Prati collection, Parma, in 1587; recorded in the Colonna Gallery, Rome, in 1783; bought from there by Alexander Day before 1802 when he sold the picture to Ferdinand IV of Naples; bought by the National Gallery from the 3rd Marquess of Londonderry, 1834. BIBLIOGRAPHY: Gould 1975, pp. 61–3; Gould 1976, pp. 216–219; Ekserdjian 1997, pp. 163–66.

47. Christ as the Man of Sorrows, 1520s

Style of Jan Mostaert

PROVENANCE: Henry Willett, Brighton, until his death in 1905; acquired by Henry Wagner and presented to the National Gallery in 1924.

Вівliography: Friedländer 1972a, vol. 10, р. 70; Davies 1968, pp. 133-34.

48. *Christ on the Cold Stone*, about 1500

Eastern Netherlandish

PROVENANCE: Possibly formerly in the church of Zeddam or Terborg (Eastern Netherlands); transferred to the Roman Catholic Parish Church of St Matthew in Azewijn in the nineteenth century; donated to the Utrecht Museum in 1926.

Вівliography: Bouvy 1962, no. 186, pp. 110–11

49. Saint Francis embracing the Crucified Christ, about 1620

Francisco Ribalta (1565-1628)

PROVENANCE: Painted for the Franciscan Capuchin Convent of the Sangre de Cristo in Valencia; following the secularisation of the convent in 1835, it passed to the Museo de Valencia, where it was first catalogued in 1847. BIBLIOGRAPHY: Fitz Darby 1938, pp. 118–19; Kowal 1985, no. F. 40, pp. 254–55; Benito Domenech 1987, no. 39.

50. The Stigmatisation of Saint Catherine of Siena, about 1630

Rutilio Manetti (1571–1639) BIBLIOGRAPHY: Avignon 1992, cat. no. 65.

51. The Deposition, about 1325

Ugolino di Nerio (active 1317; died 1339/49?) PROVENANCE: The altarpiece was probably commissioned by the Almanni family; this panel was brought to England at beginning of the nineteenth century, with several other fragments from the altarpiece, by William Young Ottley; his son, Warner Ottley; Warner Ottley sale, June 1850 where acquired by the Reverend John Fuller Russell; Fuller Russell sale, April 1885, where bought by Henry Wagner; presented by hlm to the National Gallery in 1918. BIBLIOGRAPHY: Coor-Achenbach 1955, pp. 155, 160-1; Cannon 1982, pp. 87-91; Gordon/Reeve 1984, pp. 36, 44; Davies/Gordon 1988, pp. 533-39; Bomford/Gordon 1989, pp. 98-123.

52. Lamentation over the Dead Christ, 1455-1460

PROVENANCE: Possibly a trial piece for the western portal of Siena Cathedral (1457–59), a project that was aborted after only a couple of relief panels in wax had been produced. Palazzo Mocenigo di S. Luca, Venice; later owned by Armand Baschet, Paris; acquied by the South Kensington Museum in 1863.

BIBLIOGRAPHY: Janson 1957, pp. 206-8; Pope-Hennessy 1964, 1, pp. 75-6; Bennett/Wilkins 1984, pp. 14-15, 98-100; Bellosi 1993, cat. no. 21; Pope-Hennessy 1993, p. 192; Rosenauer 1993, pp. 258, 260, cat. no. 60, p. 289; Penny 1994, pp. 11-15.

53. The Entombment, (probably 1450s)

Dirk Bouts (1400?-1474)

PROVENANCE: Foscari collection, Venice; acquired in the early nineteenth century by Diego Guicciardi (1756-1837) and kept in Milan; purchased by the National Gallery from the Guicciardi family in 1860.

Вівliography: Davies 1953, pp. 24–27; Davies 1968, pp. 15–16; Bomford 1986, pp. 39–57; Dunkerton 1991, pp. 296–297; Campbell 1988, pp. 38–45.

5 Praying the Passion

54. Christ after the Flagellation contemplated by the Christian Soul, late 1620s or carly 1630s

Diego Velázquez (1599–1660)

PROVENANCE: Bought in Madrid by John Savile Lumley (later Lord Savile, 1818–1896) from the painter dealer José Bueno; presented by him to the National Gallery in 1883. BIBLIOGRAPHY: Jameson 1881, pp. 81–83; 'The latest addition to the National Gallery' in the *The Times*, 16 August 1883, p. 7; López-Rey 1963, no. 12; MacLaren/Braham 1970, pp. 119–21; Glendinning 1989, p. 123; Harris 1982, p. 117; Moffitt 1992, pp. 139–154; Brigstocke 1999, pp. 17–19 and 25.

55. Prayer-nut with the Man of Sorrows, *c*.1500 South Netherlandish

PROVENANCE: Acquired by the Victoria and Albert Museum from the Webb collection in 1874. BIBLIOGRAPHY: List of the Objects in the Art Division South Kensington Museum aquired during the year 1874, London, 1875, p. 20.

56. Eight scenes from the 'Small Passion', 1509-11 Albrecht Dürer (1471-1528)

Woodcuts, each c.126 x 97 mm., comprising The Flagellation, Christ Crowned with Thorns, 'Ecce Homo', Pilate Washing his Hands, The Bearing of the Cross, Saint Veronica with the Sudarium and Saints Peter and Paul, The Nailing to the Cross, The Crucifixion. PROVENANCE: First four prints bequeathed by Joseph Nollekens via Francis Douce, 834; second four presented by William Mitchell, 1895.

B1BLIOGRAPHY: Berliner 1928; Meder 1932, nos. 125-61, pp. 129-50; Winkler 1941; Panofsky 1948, 1, pp. 139-45; Kisser 1964; Munich 1971, cat. no. 374; Wölfflin 1971, pp. 175-00; Washington 1971, cat. nos. 156-93; Strauss 1980, nos. 106-42, pp. 342-415, no. 155, pp. 445-46; Fehl 1992; London 1995 pp. cat. nos. 27-29.

57. Portable Passion Polyptych, mid-sixteenth century Netherlandish

PROVENANCE: Enríquez de Ribera collection, Spain, in the sixteenth century; Julius Wernher, Luton Hoo. BIBLIOGRAPHY: Unpublished.

58. Mass of Saint Gregory, 1490s(?)

Israhel van Meckenem (about 1440–1503) PROVENANCE: Bought by the British Musuem from William Smith in 1845.

Вівіюдварну: Lehrs 1934, no. 354; Breitenbach 1974, pp. 21–26; Koreny/Hutchinson 1981, no. 102, p. 101; Mâle 1986, pp. 95–96; *Art of Devotion*, pp. 110–12.

59. The Man of Sorrows as the Image of Pity, second half of the fourteenth century

Venetian(?)

PROVENANCE: Charles Butler Sale, London, 25 May 1911; bought by Henry Wagner, by whom presented to the National Gallery in 1924.

BIBLIOGRAPHY: Davies/Gordon 1988, p. 118

60. *The Image of Pity*, about 1500 English

PROVENANCE: The prayer book comes from the Briggitine convent of Syon, near Isleworth; acquired by the Bodleian Library from the collection of Richard Rawlinson (died 1755).

ВівLIOGRAPHY: Dodgson 1928–29, pp. 96, 99–101, pl. xxxv ©; Jackson, Ferguson and Pantzer 1976, p. 3; Duffy 1992, p. 214, fig. 85.

61. Devotional Booklet, about 1330-40

German (Lower Rhine or Westphalia) PROVENANCE: Purchased from John Webb, London, 1872 BIBLIOGRAPHY: Koechlin 1924, 1, pp. 194, 198, 207, 210; 11, no. 526: 111, pl. XCIV; Longhurst 1927–29, 11, pp. 24–25; Berliner 1955, p. 51; Martin 1961, p. 17; Wentzel 1962, pp. 193–212; Wixom 1972, pp. 96–99; Hamburger 1989, p. 30; *Art of Devotion*, pp. 114–15, p.182; Williamson 1996, pp. 212–13; Detroit 1997, pp. 193–97.

62. Angel holding a Shield with the Wounds of Christ, 1475-85

Netherlandish

PROVENANCE: Said to come from the Monastery of Saint Cecilia in Utrecht; donated to the Bisschoppelijk Museum, Haarlem, by G.B. Brom, 1876.

Вівілодгарну: *Gids in het Bisschoppelijk Museum Haarlem*, Haarlem, 1913, p. 24, no. 383.

63. Ring with the Five Wounds of Christ and the Image of Pity ('The Coventry Ring'), fifteenth century English

PROVENANCE: Found at Coventry in 1802; Thomas Sharp; entered the British Museum in 1897 with the Franks Bequest.

BIBLIOGRAPHY: Sharp 1817; Dalton 1912, no. 718; Evans 1922, p. 126; Dalton/Tonnochy 1924, p. 151; Gray 1963, p. 165.

64. Prayer Roll, late fifteenth century

English

PROVENANCE: Before 1509, possibly the William Thomas mentioned in the inscription on the second membrane; the subsequent history is unknown until it was supposedly found in Liverpool shortly before 1858.

Вівliography: Charlton 1858; Ker/Piper 1992, IV, по. 29, pp. 538-40.

65. Prayer sheet with the Wounds and the Nail, late seventeenth century

Issued by J.P. Steudner in Augsburg, Germany. BIBLIOGRAPHY: Coupe 1966, no. 160; Hamburg 1983, no. 138.

6 The Saving Body

66. Noli me Tangere, about 1515

Titian (active about 1506; died 1576)

PROVENANCE: Muselli collection, Verona, by 1648; brought to Britain after purchase from the Orléans collection, 1792; bequeathed to the National Gallery by Samuel Rogers, 1856.

Вівliography: Gould 1975, pp. 275-78; Hope 1980, pp. 20-22; MacGregor 1995.

STEINBERG 1996 L. Steinberg, *The Sexuality of Christ in Renaissance Art and Modern Oblivion*, 2nd rev. edn., Chicago and London, 1996.

STEPPE 1965 J.K. Steppe, 'Tableaux de Jean Gossaert dans l'ancienne Abbaye de Saint Adrien B Grammont', in *Jean Gossaert dit Mabuse*, exh. cat., Museum Boymans-van Beuningen, Rotterdam; and Groeningenmuseum, Bruges, 1965, pp. 39-46.

STERLING 1971 C. Sterling, 'Observations on Petrus Christus', *The Art Bulletin*, 53 (1971), pp. 1–26.

STIRLING MAXWELL 1873 W. Stirling Maxwell, Essay Towards a Catalogue of Prints Engraved from Works of Velázquez and Murillo, London, 1873.

STOICHITA 1991 V.I. Stoichita, 'Zurbarán's Veronica', Zeitschrift für Kunstgeschichte, 54 (1991), pp. 190–206.

STOICHITA 1995 V.I. Stoichita, *Visionary Experience in the Golden Age of Spanish Art*, London, 1995.

STRAUSS 1980 W.L. Strauss, Albrecht Dürer, Woodcuts and Woodblocks, New York, 1980.

STRAUSS 1981 W.L. Strauss, The Intaglio Prints of Albrecht Dürer: Engravings, etchings and drypoints, New York, 1981.

SULZBERGER 1925 M. Sulzberger, 'Le symbole de la croix et les monogrammes de Jésus chez les premiers Chrétiens', *Byzantion*, 2 (1925), pp. 337-448.

TEMPESTINI 1992 A. Tempestini, *Giovanni Bellini: catalogo* completo, Florence, 1992.

The English Connoisseur; The English Connoisseur. Containing an account of whatever is curious in painting, sculpture ... in the palaces and seats ... of England, 2 vols., London, 1766.

THUILLIER 1982 R. Thuillier, *Graham Sutherland Inspirations*, Guildford, 1982.

THURSTON 1900 H. Thurston, *The Holy Year of Jubilee*, St Louis, 1900 (reprint 1980).

TIETZE/TIETZE-CONRAT 1944 H. Tietze and E. Tietze-Conrat, *The Drawings of the Venetian Painters in the 15th and 16th Centuries*, New York, 1944.

TORR 1898 C. Torr, On Portraits of Christ in the British Museum, London, 1898.

TORRES MARTÍN 1963 R. Torres Martín, Zurbarán el pintor gótico del siglo xv11, Seville, 1963.

TUDOR-CRAIG 1998 P. Tudor-Craig, 'Times and Tides', History Today, 48 (4), (May 1998), pp. 8-10.

TUDOR-CRAIG/FOSTER 1986 P. Tudor-Craig and R. Foster, 'Christ crowned with thorns', *The Listener*, 9 October 1986, pp. 12–13.

UPTON 1990 J.M. Upton, *Petrus Christus: His Place in Fifteenth-Century Flemish Painting*, University Park and London, 1990.

URBACH 1995 S. Urbach, 'On the iconography of Campin's Virgin and Child in an Interior: the Child Jesus comforting his mother after the Circumcision' in Flunders in a European Perspective, Manuscript Illumination around 1400 in Flanders and Abroad, Proceedings of the International Colloquium, Leuven, 7–10 September 1993, M. Smeyers and B. Cardon, eds. Corpus of Illuminated Manuscripts, vol. 8, Low Countries series 5, Leuven 1995 pp. 557–68.

UZIELLI 1899 G. Uzielli, Le misure lineari medioevali e l'effigie di Cristo, Florence, 1899.

VALDIVIESO 1998 E. Valdivieso, *Zurbarán*, exh. cat., Museo de Bellas Artes, Seville, 1998.

VALDIVIESO/SERRERA 1985 E. Valdivieso and J.M. Serrera, *Pintura Sevillana del Primer Tercio del Siglo xv11*, Madrid, 1985.

VAN OS 1992 H.W. van Os, C.O. Jellema and A.W.A. Boschloo, *Meeting of Masterpieces: Titian – Ludovico Carracci*, dual-language (Dutch – English) exhibition booklet, Rijksmuseum, Amsterdam, 1992.

Vatican Collections; The Vatican Collections, The Papacy and Art, exh. cat., The Metropolitan Museum of Art, New York, 1983.

V1RG1L 1974 Virgil, *Georgics*, Book 11, Loeb Classical Library, Virgil, vol. 1, Cambridge (Mas.), 1974.

Von Bode/Volbach 1918 W. Von Bode and W.F. Volbach, 'Mittelrheinische Ton-Und Steinmodel aus der ersten halfte des xv. Jahrhunderts', *Jahrbuch der Koniglich Preuszischen Kunstsammlungen*, 39 (1918), pp. 89–136.

VOORHELM SCHNEEVOGT 1873 C.G. Voorhelm Schneevogt, Catalogue des estampes ... d'après Rubens, 1873.

VORAGINE 1993 Voragine, Jacobus de, *The Golden Legend*, *Readings on the Saints*, trans. by W. Granger Ryan, Princeton, 1993.

WAAGEN 1854 G. Waagen, Descriptive Catalogue of a collection [Oettingen-Wallerstein] of Byzantine, Early Italian, German, Flemish and Dutch Pictures now at Kensington Palace, London, 1854.

WASHINGTON 1971 Dürer in America: His Graphic Work, exh. cat., C. W. Talbot, ed. National Gallery of Art, Washington, 1971.

WASHINGTON 1985 The Treasure Houses of Britain: five hundred years private patronage and art collecting, exh. cat., National Gallery of Art, Washington, 1985. WECKWERTH 1968 A. Weckwerth, 'Finiges zur Darstellung des Reben-Christus', *Raggi* 8 (1968), pp. 18–24.

WEITZMANN 1971 K. Weitzmann, Studies in Classical and Byzantine Manuscript Illumination, H. L. Kessler, ed. Chicago, 1971.

WEITZMANN 1979 K. Weitzmann, ed., Age of Spirituality. Late Antique and Early Christian Art, Third to Seventh Century, exh. cat., Metropolitan Museum of Art, New York, 1979.

WENTZEL 1960 H. Wentzel, 'Eine Wiener Christuskindwiege in München und das Jesuskind der Margaretha Ebner', *Pantheon*, 19 (1960), pp. 276–83.

WENTZEL 1962 H. Wentzel, 'Ein Christkindbettchen in Glasgow: Addenda aus der Burrell Collection', *Pantheon* 20 (1962), pp. 1–7.

WENTZEL 1962 H. Wentzel, 'Ein Elfenbeinbüchlein zur Passionsandacht', *Wallraf-Richartz-Jahrbuch*, 24 (1962), pp. 193–212.

WILKINS 1969 E. Wilkins *The Rose-Garden Game*, London, 1969.

WILLIAMSON 1996 P. Williamson, *The Medieval Treasury: The Art of the Middle Ages in the Victoria and Albert Museum*, 2nd edn., London, 1996.

WILLIAMSON/EVELYN 1988 P. Williamson and P. Evelyn, Northern Gothic Sculpture 1200–1450, London, 1988.

WILPERT 1929-36 J. Wilpert, I sarcofagi cristiani antichi, 5 vols., Rome, 1929-36.

WILSON 1978 I. Wilson, The Turin Shroud, London, 1978.

WINKLER 1941 F. Winkler, 'Dürers Kleine Holzschnittpassion und Schäufeleins Speculum-Holzschnitte', *Zeitschrift des deutschen Vereins für Kunstwissenschaft*, 8 (1941) pp. 197–208.

WINSTON-ALLEN 1997 A. Winston-Allen, Stories of the Rose: the making of the rosary in the Middle Ages, University Park, Pennsylvania State University Press, 1997.

WINTER 1977 D. Winter, *After the Gospels*, London and Oxford, 1977.

WIXOM 1972 W.D. Wixom, 'Twelve Additions to the Medieval Treasury', *Bulletin of the Cleveland Museum of Art*, 59 (April 1972), pp. 87-111.

WÖLFFLIN 1971 H. Wölfflin, *The Art of Albrecht Dürer*, trans. by A. and H. Grieve, New York, 1971.

YOUNG 1986 E. Young, 'The Two Trinities in the School of Seville and an unknown version by Zurbarán', *Apollo*, 123 (1986), pp. 10–13.

218 GENERAL BIBLIOGRAPHY

Photographic Credits

Amsterdam

Rijksmuseum (© Rijksmuseum-Stichting Amsterdam): cat. no. 23

Avila

Monastery of the Incarnación, (© With permission from the sisters of the Monastery of the Incarnación): fig 51

BASEL

Oeffentliche Kunstsammlung Basel, Kunstmuseum (© Oeffentliche Kunstsammlung Basel. Photo: Martin Buehler): fig 31

Birmingham

Birmingham Museums and Art Gallery (© Birmingham Museums and Art Gallery): cat. no. 75

COVENTRY

Coventry Cathedral (© The successors of Graham Sutherland. Photo: Edward Ockendon): fig 52 Herbert Art Gallery & Museums (© The successors of Graham Sutherland. Photo: Herbert Art Gallery & Museums): cat. no. 78

Edinburgh

National Galleries of Scotland (© National Galleries of Scotland): cat. no. 70; (© Estate of Jacob Epstein): fig 49

FLORENCE

Church of S. Egidio (© With permission from the Soprintendenza per i beni artistici e storici per le province di Firenze, Prato e Pistoia. Photo: Witt Library, The Courtauld Institute of Art): fig 29

GLASGOW

The Burrell Collection (© Glasgow Museums): cat. no. 24 The St Mungo Museum of Religious Life and Art (© Glasgow Museums): cat. no. 77

HAMBURG

Hamburger Kunsthalle, Bibliothek (© Hamburger Kunsthalle, Fotowerkstatt Elke Walford): contents page

HAMPTON COURT

The Royal Collection (© 2000, Her Majesty Queen Elizabeth 11. Photo: National Gallery, London): cat. no. 41

London

The British Museum (© Copyright The British Museum): cat. nos. 5, 6, 7, 8, 9, 10, 11, 12, 13, 18, 19, 35, 43, 56, 58, 63, 74; figs 6, 14, 33

Imperial War Museum (© The Trustees of the Imperial War Museum): fig 28

The National Gallery (© National Gallery, London): cat.

non 14, 15, 21, 22, 25, 26, 28, 30, 31, 32, 33, 34, 37, 44, 45, 46, 47, 51, 53, 54, 59, 66, 67, 69, 71; figs 1, 7, 8, 10, 12, 15, 32, 40, 45, 46

St Martin Ludgate (© Photo: National Gallery): fig 2 *St Paul's Cathedral* (© St Paul's Cathedral, London): cat. no. 16

Tate Gallery: cat. no. 79 (© Tate Gallery, 2000 London); cat. no. 76 (@ Entute of Stanley Spencer 2000. All rights reserved DACS.)

University College London, The Strang Print Room (© College Art Collections, University of London): cat. no. 39 University of London, Senate House, Historical Collections (© Historical Collections. Photo: B&N Microfilm, Preservation Microfilming): fig 9

The Victoria and Albert Museum (© V&A Picture Library): cat. nos. 19, 20, 27, 52, 55, 61, 68, 72, 73 *The Wellcome Trust* (© Wellcome Trust Photographic

Library): fig 22

The Wernher Collection (© With permission from the Trustees of the Luton I Ioo Foundation. Photo: National Gallery, London): cat. no. 57

Madrid

Museo Nacional del Prado (© Museo del Prado): cat. no. 17

MANCHESTER

The Manchester Museum (© The Manchester Museum, The University of Manchester): fig 11

Munich

Alte Pinakothek (© Bayerische Staatsgemaldesammlungen, Alte Pinakothek): fig 24

Bayerische Staatsbibliothek (© Bayerische Staatsbibliothek): fig 21, 25.

Staatliche Graphische Sammlung (© Staatliche Graphische Sammlung): fig 27

Kettering

Boughton House (© By kind permission of His Grace the Duke of Buccleuch, K.T. from his collection at Boughton House, Northampshire, England): fig 20

NAMUR

Musée des Arts Anciens (© Musée Provincial des Arts Anciens du Namurois. Collection Societé Archéologique de Namur): fig 16

NUREMBERG

Germanischer Nationalmuseum (© Germanischer National museum Nürnberg): cat. no. 65

Oxford

Bodleian Library (© The Bodleian Library, University of Oxford (MS Rawl D 403; fol-2v): cat. no. 60

PARIS

Musée du Louvre (© Photo RMH-Herve Lewandowsky): fig 4

Rome

Catacomb of Priscilla (© Photo: Florence SCALA): figs 3, 13

Church of S. Clemente (© Photo: Florence sCALA): fig 4 Church of Santa Croce in Gerusalemme (© With permission from the Soprintendenza beni artistici e storici di Roma. Photo: National Gallery, London). fig 39 Museo Nazionale di Roma (© Soprintendenza Archeologica di Roma: Servizio di Fotoriproduzione): cat. no. 1

Sheffield

Sheffield Galleries and Museums Trust (© Sheffield Galleries and Museums Trust): cat. no. 29

SHERBORNE, Dorset Sherborne Castle, Mr John Wingfield Digby (© Sherborne Castle Estate): cat. no. 42

STOCKHOLM Nationalmuseum (© The National Art Museums of Sweden): cat. no. 36

St Petersburg

The State Hermitage Museum (© With permission from The State Hermitage Museum. Photo: National Gallery, London): fig 42

UTRECHT

Museum Catharijneconvent (© Museum Catharijneconvent. Photo: Ruben De Heer): cat. nos. 38, 40, 48, 62; figs 17, 35

VALENCIA

Museo de Bellas Artes (© Museo de Bellas Artes de Valencia. Photo: Franscisco Alcantara Benavent): cat. no. 49

VATICAN CITY

Vatican Museums (© Vatican Museums, Archivio Fotografico Musei Vaticani): cat. nos. 2, 3, 4, (© Photo Florence SCALA): fig 5

VENICE

Galleria dell' Accademia (© Soprintendenza per i beni artistici e storici per Venezia e Laguna. Photo: Osvaldo Boehm S.N.C.) fig 18

Private Collections

cat. nos. 50, 64 (Photo: National Gallery, London): figs 26, 34; figs 23, 30 (© With permission from the British Association of the Turin Shroud & D. Armitage); fig 44 (© 1999 Christie's Images LTD); fig 50 (© The Artist. Photo: National Gallery, London. Courtesy of the Anthony Reynolds Gallery, London) Lenders

The Royal Collection © 2000, Her Majesty The Queen, cat. no. 41 The Dean and Chapter of St Paul's Cathedral, London, cat. no. 16 John Wingfield Digby, cat. no. 42 Amsterdam, Rijksmuseum, cat. no. 23 Birmingham Museums and Art Gallery, cat. no. 75 Compton Verney House Trust (Peter Moores Foundation), cat. no. 67 Coventry, Herbert Art Gallery and Museum, cat. no. 78 Edinburgh, National Gallery of Scotland, cat. no. 70 Glasgow Museums: The Burrell Collection, cat. no. 24 Glasgow Museums: The St Mungo Museum of Religious Life and Art, cat. no. 77 London, British Museum, Department of Coins and Medals, cat. nos. 5, 6, 7, 8 and 18 London, British Museum, Department of Medieval and Later Antiquities, cat. nos. 9, 10, 11, 12, 13, 43, 63 London, British Museum, Department of Prints and Drawings, cat. nos. 35, 56, 58 and 74 London, Trustees of the Tate Gallery, cat. nos. 76 and 79 London, Victoria and Albert Museum, cat. nos. 19, 20, 27, 52, 55, 61, 68, 72 and 73 Madrid, Museo Nacional del Prado, cat. no. 17 Nuremberg, Germanischer Nationalmuseum, cat. no. 65 Oxford, Bodleian Library, University of Oxford cat. no. 60 Sheffield Galleries and Museums Trust, cat. no. 29 Soprintendenza Archeologica di Roma, cat. no. 1 Stockholm, Nationalmuseum, cat. no. 36 University of London, College Art Collections, cat. no. 39 Utrecht, Museum Catharijneconvent, cat. nos. 38, 40, 48 and 62 Valencia, Museo de Bellas Artes, cat. no. 49 Vatican City, Vatican Museums, cat. nos. 2, 3 and 4 The Wernher Collection, cat. no. 57 Private collection, cat. nos. 50 and 64